Commercial Photoshop Retouching
In the Studio

Commercial Photoshop Retouching
In the Studio

 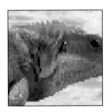

Glenn Honiball

O'REILLY®

BEIJING • CAMBRIDGE • FARNHAM • KÖLN • PARIS • SEBASTOPOL • TAIPEI • TOKYO

Commercial Photoshop Retouching: In the Studio

by Glenn Honiball

Copyright © 2005 O'Reilly Media, Inc. All rights reserved.
Printed in the United States of America.

Published by O'Reilly Media, Inc., 1005 Gravenstein Highway North, Sebastopol, CA 95472.

O'Reilly books may be purchased for educational, business, or sales promotional use. Online editions are also available for most titles (*safari.oreilly.com*). For more information, contact our corporate/institutional sales department: 800-998-9938 or *corporate@oreilly.com*.

Print History:		**Editor:**	Colleen Wheeler
August 2005:	First Edition.	**Production Editor:**	Philip Dangler
		Cover Designer:	Mike Kohnke
		Interior Designer:	David Futato

The O'Reilly logo is a registered trademark of O'Reilly Media, Inc. The Digital Studio series designations, O'Reilly Digital Studio, *Commercial Photoshop Retouching: In the Studio*, the cover images, and related trade dress are trademarks of O'Reilly Media, Inc.

Many of the designations used by manufacturers and sellers to distinguish their products are claimed as trademarks. Where those designations appear in this book, and O'Reilly Media, Inc. was aware of a trademark claim, the designations have been printed in caps or initial caps. Adobe Photoshop™ is a registered trademark of Adobe Systems Inc. in the United States and other countries. O'Reilly Media, Inc. is independent of Adobe Systems, Inc.

Cover photos: iStockPhoto.com.

RepKover™ This book uses RepKover™, a durable and flexible lay-flat binding.

0-596-00849-X
[C]

Contents

Preface

I retouch photographs for a living. *Commercial Photoshop Retouching: In the Studio* is a collection of techniques and advice for using Photoshop to retouch pictures in a professional environment. Of course, the techniques discussed can be applied to any image for any purpose, but the specific examples here are the types of things I might be asked to do for a client on any given day. It's my hope that you can use what you learn here in your work at a pre-press shop, an ad agency, or an in-house design department. Or you can use them on your own images to really make them stand out from the crowd.

My Assumptions About You

I'm assuming that you want to create professional-looking retouched images in the most efficient and realistic way. When I say efficient, I mean that while Photoshop CS2 is a powerful application chock full of fancy tools, sometimes I find that the easiest and quickest way of getting the job done is with simple tools, a creative sensibility, and a technique honed in the trenches of meeting client deadlines. When I say realistic, I mean that although your images may contain fantastic or unreal subject matter, they shouldn't look obviously retouched.

I'm also assuming that you have a general familiarity with Photoshop. You don't need to be completely up to speed with CS2, but you need to have a general idea of how to open files, find the needed tools, initiate basic commands, and use the tools in Photoshop with some comfort and confidence. You don't need to have the latest, or even second-most recent version of Photoshop. While I have discussed a couple of features of CS2 where they are applicable, in general I am "old school." And most of the techniques I use can be done with older versions of Photoshop.

I should also mention that I use a Mac. Just so you know, I actually started off on a Mainframe computer running a proprietary computer language, then to a DOS-based PC, Windows, then Unix, and finally Mac. I assume if you use a PC, you are savvy enough to figure out that you can generally substitute the Control key for the Apple (Command) key. The key thing I'm trying to teach this book is the technique, not the specific shortcuts for tools.

Contents of This Book

NOTE

If you need to get up to speed with Photoshop, try Deke McClelland's Adobe Photoshop CS2: One on One *(O'Reilly). You really only need a general familiarity with Photoshop to get started with this book, but if you don't even have that, Deke's book is a great place to start.*

This book is divided into nine chapters, each covering a general category of client requests. If you have a client who wants you to fix the color of an image, create something that doesn't currently exist in an image, or prepare an image for use in a special medium, you should be able to find a chapter that helps you do the job. After a brief orientation to the studio of a professional retoucher in the first chapter, the next five chapters cover general types of image manipulation. The last three chapters give special advice on how to prepare images for "unusual" mediums such as billboards, newspapers, and product packaging. Here's a basic run-down of what the chapters are about:

Chapter 1, The Professional Retoucher's Studio

Tries to give you a sense of what a day in the retoucher's professional life might entail. In this chapter, I've sketched out the basic physical environment in which I work, the workflow of a typical retouching job, and some thoughts about becoming a professional retoucher. If you want to go straight to retouching images, start with Chapter 2.

Chapter 2, Shadows and Light

Discusses the basic category of projects that require manipulation of light. I'll give you some techniques for understanding "imaginary" light sources, creating realistic shadows, and avoiding common shadow mistakes.

Chapter 3, Corrections: Improvements on Reality

Covers how to make corrections that really improve the power of an image. We'll go over some basic correction techniques, discuss adding texture and shape to flat images, and cover some overall color corrections.

Chapter 4, Something from Nothing

Helps you understand how to approach those jobs in which you or your client wants to put something in the image that isn't currently there. This might mean adding steam to a cup of coffee, adding motion to a sports car, or adding shine to a previously dull object.

Chapter 5, Special Color Requests

Discusses how to use special colors and manipulate colors to get the output you or your client are seeking. Here, we'll go over creating touch plates, converting files in and out of CMYK color profiles, and changing the overall color of an image entirely.

Chapter 6, Merging Images

Goes over how to create realistic, if sometimes fantastic, compositions. We'll discuss the basic techniques of properly selecting the components of your composition, how to prepare your "canvas," and how to put the pieces together so that the "seams" don't show.

Chapter 7, Low Resolution on a Grand Scale
> Covers the typical commercial retouching request of taking an image intended for a magazine or brochure and making it usable at poster or even billboard size. I'll go over how to interpret a spec sheet for this kind of job, how to assess potential problem areas, and how to improve the file so that it survives magnification.

Chapter 8, Preparing Images for Newsprint
> Discusses the particular problems and techniques for avoiding those problems when your image's final destination is the local newspaper. We'll start by getting an overall understanding of the particular needs of images heading for newsprint, then follow with specific instructions for preparing color and black and white images.

Chapter 9, Preparing Images for Use on Packaging Materials
> Considers the particular retouching challenges and Photoshop tools that can help you prepare an image intended for industrial packaging. Here, we'll go over spec sheets for flexographic presses, how to prepare the file for best results, and the particular solutions for avoiding pitfalls in this medium.

> --- **NOTE** ---
> *There are also plenty of notes and sidebars full of my observations from years of working in my retouching studio.*

Conventions Used in This Book

As I mentioned, this book was written by a Mac user. But that doesn't mean that PC users should be confused, because most menu commands in Photoshop are identical. Menu commands discussed in this book are separated by the → symbol; for instance, Image→Adjustments→Curves means choose the Image menu in Photoshop, then click on Adjustments, and then Curves.

Plain text
> Indicates menu titles, menu options, menu buttons, and keyboard accelerators (such as Alt and Ctrl).

Italic
> Indicates new terms, URLs, email addresses, filenames, file extensions, and pathnames.

Comments and Questions

Please address comments and questions concerning this book to the publisher:

> O'Reilly Media, Inc.
> 1005 Gravenstein Highway North
> Sebastopol, CA 95472
> (800) 998-9938 (in the United States or Canada)
> (707) 829-0515 (international or local)
> (707) 829-0104 (fax)

We have a web page for this book, where we list errata, examples, and any additional information. You can access this page at:

http://www.oreilly.com/catalog/comretouch

To comment or ask technical questions about this book, send email to:

bookquestions@oreilly.com

For more information about our books, conferences, Resource Centers, and the O'Reilly Network, see our web site at:

http://www.oreilly.com

Acknowledgments

I would like to thank all of my friends and family for letting me ignore them for months on end while I wrote this book. I welcome you back.

I'd also like to thank Jeff Greene for his technical insights, and the kind folks at iStockPhoto for many of the source images found in this book.

To find out more about retouching and to see some of these techniques in action, please stop by my web site and take a look at some of the ways I put the stuff in this book to use for clients:

www.retouch.ca

The Professional Retoucher's Studio

Sometimes it's awkward to explain to people what I do for a living. I assume because you are reading this book and interested in retouching images in a professional environment (or just adding a professional touch to the images in your personal environment), that you have a vague idea of what I do all day. While the rest of this book is specifically about the general retouching techniques I use in Photoshop in my daily work, in this chapter, I've tried to give you some insight into the workspace, workflow, and workday of a professional image retoucher. If you're eager to get to image manipulation, Chapter 2 jumps right in. But if you're planning on spending any time retouching photos professionally (or as a dedicated hobbyist), consider the following information. Knowing the basic setup and activity of a retoucher's studio can save you time and stress down the line.

The Photo Retoucher's Work Environment

I'll start this chapter by telling you how I set up my workspace and how I get comfortable at my workstation. Being comfortable is very important, especially when you retouch for long hours. I have had some 16-hour days in my career. That's a lot of time on the mouse! And after nearly 20 years of retouching, I haven't ever had any neck, back, or arm ailments, including carpal tunnel syndrome.

Setting Up Your Workstation

In general, you should set up your workstation for what feels right for you. Here are some tips that I would recommend for your workstation.

First, I like to have my monitor up a bit higher than most people would; I lower my chair to achieve this. I would rather be looking up slightly than looking down at a monitor. When looking down on a monitor, I tend to get a sore neck. This way, when I'm looking straight at the monitor, I am looking at the middle of the screen, and I believe this position shown Figure 1-1 has prevented me from getting a sore neck.

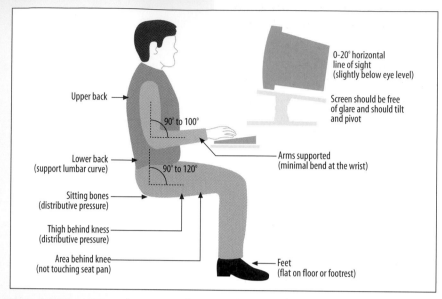

Figure 1-1. Set up your workspace to avoid stress and injury

Second, when sitting at a computer desk, I like the corner position for my computer, which offers more room to stretch my legs and support my elbow. A corner placement also allows you plenty of room for the placement of a monitor, particularly if it is a large CRT monitor, which some people prefer. (Of course, if you use a flat screen monitor, this isn't an issue.)

Also, I find that I can work on a computer for a long period of time if my arm is supported properly to the elbow. I have seen many computer setups where the keyboard, mouse, and monitor are placed on the straight portion of a desk. This offers little, if any support for your arms and I find it very awkward to work on, becoming very tiresome within a short period of time. I believe that people are much more prone to injury as well with a setup like that. I usually have an angled footrest as well, just enough to elevate my feet.

A Brief History of Retouching Technology

Over the past 20 years, I have worked with many input devices, and I have to admit, Photoshop is wonderful! Although each version of Photoshop brings new bells and whistles, because I learned retouching in the early days, most of my techniques still rely on the basics.

Retouching in the Paleolithic era

The first system I worked on was a hellish Chromacom system. The Chromacom system was terribly expensive, costing in excess of a million dollars. (It's no wonder that system time for retouching typically cost in the neighborhood of $650.00 per hour!) The Chromacom system's input device was a large digitizing tablet, about 24" by 24", that used a corded "mouse" with four function buttons, and the mouse was built like a small brick. It had an extruded clear plastic shape on the end with crosshairs that allowed for digitizing accurate points on the tablet, similar to a device typical of today's CAD systems. There was no ball or infrared beam on it; instead, it used embedded coils of wire that interacted with the metal tablet. The software was proprietary and cumbersome to use, with a steep learning curve. Commands were in German. A second monitor was needed so that the operator could type in the necessary commands to make available the

various brushes and tools. And worst of all, layers and undo commands were nowhere to be seen. Put succinctly, if there was retouching back in the caveman days, this would have been it!

I then migrated to a wireless pen, which I used on a Silicon Graphics Indigo 2 machine. The SGI ran two retouching programs: Barco Creator and Alias Eclipse. Again, each program had limited layering and undo options. The wireless pen was quite a step up from using the brick. It had a very natural feel to it, and it was something that an artist could relate to. Hey, it was even pressure sensitive!

Dawn comes in with the arrival of Photoshop and the mouse

I was introduced to a mouse at the same time as Photoshop for the Macintosh, and I couldn't understand how anyone could retouch with a mouse. The initial Macintosh mouse felt rather flimsy. In addition, it looked like a small shoebox, and it had only one big button on it. On the other hand, Photoshop was great: all I had to do was click on the menu items for the various tools and brushes, and it had an undo feature. (Although I had convinced myself that I'd never make a mistake, I could see that an undo command would be a nice feature for other people to have!)

> **NOTE**
>
> *The Photoshop techniques in this book can be employed with either type of input device: mouse or stylus.*

People are often surprised when they see me working with a mouse. Well, believe it or not, I don't use a mouse pad either. Depending on the table, the surface I work on is typically fine for most mice. (I dislike the height of the mouse pad and the fact that I "must" keep my mouse to a confining spot on the desk.) So, which input device should you use? Well, I can't say I recommend the Chromacom anymore. However, I do admit that I now rely on a corded mouse for all of my retouching. I have heard people swear by stylus pens, but for me, the mouse works just fine. I guess the point is, you'll get used to whatever you're presented with.

Hardware and Software Choices

I've worked on Macintosh, PCs, and Unix machines over the past 20 years, and my system of choice is a Macintosh. When Macintosh computers first came out in the mid-1980s, they were not taken seriously. They weren't very powerful, and applications for them were weak. However, after several years of development, the improvements in both applications and the system interface appealed to the artsy folks at many agencies and design houses. Eventually, Macs filtered their way in to the separation film houses and became a serious retouching tool. The relative cost of a Macintosh system was far cheaper than the traditional high-end systems, and the slick interface attracted many artistic people, including me, to the platform.

Every year, the latest and greatest computers roll out. To be perfectly honest with you, I really haven't noticed a huge difference between retouching on a

G4 computer and a top-of-the-line G5. Sure, the filters are speedier on the newer computers, and the network speeds have increased, but for your basic photo retouching, I find it hard to justify the newer machines. People may have other experiences, but having worked on as many machines as I have, I don't feel any great need to rush out and get the latest machine. I still rely on an older G4 for most of my retouching.

While this book was written using Photoshop CS2, many of the techniques have been part of my repertoire for so long that they are somewhat version independent. If you have a slightly earlier version of Photoshop, you should still be able to effect the same changes in almost all cases.

Output Choices: Monitors and Printers

Here's an important point to remember: each of your output devices must be calibrated properly, or crucial color calls will be off.

I always calibrate my monitor and generate a profile for it. You should, too. I like the ColorVision SpyderPRO (Figure 1-2), but GretagMacbeth makes good units as well. You should always make an effort to get your monitor looking its best. I won't go into color management details (it would take a whole book itself), but a properly calibrated monitor will certainly help you create better looking, more accurate images on screen (and far less finger-crossing upon output).

Figure 1-2. The ColorVision Spyder

You may be wondering about using a second monitor. Well, I tried a second monitor for the palettes for a while and, while it certainly frees up your image area, I quickly discovered that I kept taking my eyes off my image area—and I wasn't as productive. Some people swear by a second monitor. And while larger screens are pretty cheap these days, I do think that there's a point at which an image is *too* large on a screen. And if the screen is too large, you start to feel like you're in the front row of a movie theater: your head continually shifts from side to side trying to take it all in. So, let's dispel the large screen monitor myth right now. I'm perfectly happy with a 20" monitor and wouldn't want to work on anything below that. By the way, my present monitor is a CRT and not an LCD monitor. The LCDs look pretty cool, but for the money, the CRTs are still a better deal!

> **NOTE**
>
> *Should you replace your monitor? If you are unable to adjust your monitor and achieve the proper calibration adjustments asked for when calibrating your monitor, it is time to replace your monitor.*

If you use an inkjet printer for your color proofs, make sure you have an accurate color profile for your machine. I would suggest getting a custom profile generated for your printer for each type of paper stock you print on—even if you have a supplied profile for the printer—as printers typically vary on output even if they are of the same model.

Manufacturers of printers often make available profiles on their web sites that can be downloaded for your particular printer. Another way to get a profile is to have one made specifically for your printer. There are services on the Internet that can do this for you. You download their print target

and print it out on your printer, then send the printed target to them and have them read how the color chips on the test sheet print out. From that information, they can generate a profile.

Understanding Color by the Numbers

Since I started my career in the pre-press industry, I've worked with many experienced industry professionals who taught me to learn *color by the numbers*. By this, I mean that it was typical to read the color values of an area of an image on screen with a densitometer-type tool and relate that to an actual color sample a client has supplied or a color that was to be matched or created. Today, this knowledge is a big bonus—I rely on it everyday. You can read the numbers of a given sampled color in the Info palette in Photoshop (Figure 1-3).

Figure 1-3. The Info palette in Photoshop

Sadly, many people new to retouching or color correction more often rely on a visual color check, either on screen or on whatever comes out of their desktop printer. With no color background, they often struggle to achieve the correct color. Also, many regular and digital photographers are growing up on RGB and have difficulty with the CMYK color space. The world prints in CMYK for the most part, so it is a good idea to get familiar and comfortable with it. I would encourage any retoucher to pick up a color book, or even make one up and study it.

A *color swatch book* is a printed book with varying values of cyan, magenta, yellow, and black (CMYK) printed in various combinations of the four colors in varying degrees of values, which can range from 0 to 100% in dot values in steps typically of 5%. Reading a color book is like reading a telephone book: it looks boring, but it's great to

have one on hand for referencing color, particularly if you are given a color to match or subtle corrections have to be made to an existing color. A simple check in the color swatch book (like the one in Figure 1-4) will allow you to look up the color and determine which way to numerically swing it.

Color books are generally produced in house by pre-press houses and are very time consuming to make up and expensive to produce. Pantone produces swatch books that have CMYK values and the Pantone PMS color equivalents on them, which is nice because the special colors are there too. They are expensive though. However, I did find a very inexpensive publication that offers a color book, which is available from Amazon.com: *Process Color Manual, 24,000 CMYK Combinations for Design, Prepress, and Printing* by Michael Rogondino. At around $24.00 dollars, I'd consider it a bargain.

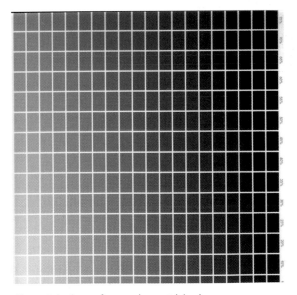

Figure 1-4. A page from a color swatch book

Custom profiles are the most accurate. One good source for a custom profile is *www.cathysprofiles.com/*. She is very reasonably priced and has the equipment to create a profile properly. The other way to generate a profile is to purchase the device that reads the target output, called a spectrophotometer, and get your hands on some profiling software, but be warned: a spectrophotometer can cost thousands of dollars. Unless you are getting profiles for all kinds of devices day in and day out, it probably isn't worth the investment. Remember, too, that you must have a custom profile for each different type of paper stock you will be using on your printer. The two most common paper types are typically magazine stock and newsprint, although your needs may differ.

Use the best inks for your printer, and choose a paper stock that best reflects what the final printed piece will be output on, whether that be newspaper stock or coated magazine stock. Short of going with a full-fledged high-end proofing system, a good Raster Image Processor (RIP) is the best way to go with a quality inkjet printer. A RIP is basically a glorified printer driver that replaces the factory printer driver that came with your printer. A RIP allows for many more output options than the standard supplied driver offers.

> **NOTE**
>
> *RIP is essentially a high-performance engine that converts image data into information that a printer can use, and therefore print. RIP vendors write their own algorithms to enhance the output and versatility of the stock software supplied with the printer. RIP software has numerous advantages over the drivers included with many printers. In fact, many wide-format printers ship with a custom written RIP, which gives professionals the added productivity they need right out of the box.*

Other Necessary Equipment

Apart from having my G4 Mac, monitor, keyboard, and mouse, I also have a DVD/CD burner, FTP software for transferring files to anyone in the world, a Firewire backup drive, a scanner for scanning transparencies, a flatbed scanner, and of course, lots of drive space.

The Workflow of a Typical Retouching Job

First, let's get familiar with the relationships. If you work as a photographer, either in an ad agency or a small design house, you may deal directly with the client who is going to approve your work. If you work for a pre-press or film house, you typically deal with the client indirectly, through a coordinator and a sales person. In this case, there will be an account representative who acts as the liaison between the film house and the client or agency. That representative interprets the client's instructions and relays that information to an internal production coordinator at the film house. From there, the

> **NOTE**
>
> *You may want to keep a few demonstration files on hand in case you have to show a client or clients a few of the things that can be retouched on a file. I like to use human faces, as everyone can relate to an image like that, and it's fun to change eye color or put a smile on someone's face with the Liquify tool. It's amazing how many people are not aware of the capabilities or what is really done to ad images.*

production coordinator processes the job throughout the shop and ensures that the job makes it through the various departments for processing. The basic players and their relationships are outlined in Figure 1-5.

Obviously, each job is unique, but the following sections outline the basic process of a retouching job.

Run a Pre-Flight Check

A typical job will include a *pre-flight check* of the client's files to make sure that all of the elements needed to do the job are there. This may include page layout files, typically assembled in QuarkXPress or InDesign. It is necessary to make sure the necessary fonts, images, and logos are included in the job file. A quick call to the client at this stage can save a lot of embarrassment later by discovering any errors right off the bat.

Images used in ads are typically supplied in two forms: the ad agency has used a photographer to shoot and retouch the image, or the ad agency has purchased the image from a photographer and will do the retouching in house.

Or perhaps the photographer has shot the image and the ad agency is relying on a pre-press or film house or a retouching specialist to retouch the image. The image can be supplied two different ways, as well: digitally from a camera or a transparency from a film-based camera. Years ago, the quality of images coming straight out of a digital camera were not great, so the images were shot as transparencies, either 35mm, 2.25", 4" by 5", or 8" by 10", depending on the type and size of the camera used. These transparencies were then scanned and digitized for use on a computer. Of course, times have changed, and the quality of digital cameras has improved. As such, more and more images are supplied right off the digital camera.

Figure 1-5. The relationship between the client and various suppliers

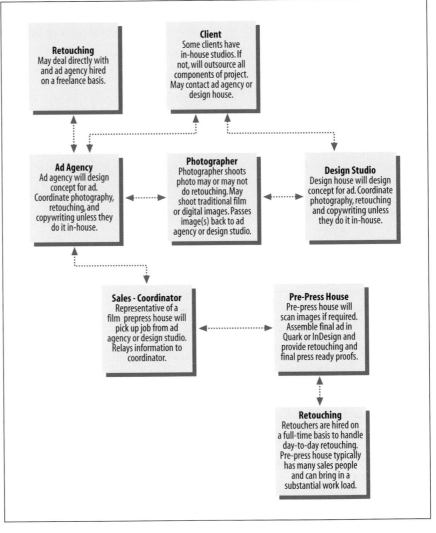

Digital Cameras Versus Scanners

One of the nice benefits of digital camera images is that there is no dust or dirt to clean up on the images! Scanned images always pick up some form of dirt or dust on the way in, which would have to be cleaned up in retouching. (Hey, at least it gave us something to do!) Quality scanning of transparencies or prints usually involves the use of a drum scanner. Flatbed scanners can be used for scanning transparencies, but the quality is not as good as with a drum scanner. Some clients realize this and will insist on drum scans.

High-end drum scanners cost thousands of dollars and require regular maintenance and servicing; it's like owning a Ferrari! Of course, the cost of the scanners is reflected in the cost of the scans; clients no longer want to pay the high prices for these quality scans, and as such, they have either demanded digital shots or insisted on lower prices from the high-end shops supplying the scans. Images coming from a digital camera don't suffer from these artifacts.

Make Sure You Understand Your Instructions

Once we have the images to be retouched in one form or another, it is the job of the retoucher to interpret retouching instructions supplied by the client. The retouching instructions can come in two forms, either from the internal coordinator who has been in direct contact with the client or sales representative and has a marked up first proof, or by having the client come into the shop or studio to sit down with the retoucher and relay the verbal instructions into onscreen changes. Yes, you have to be comfortable working with someone breathing down your neck as you retouch sometimes. I have found that if you take control of the situation and show that you are confident with your retouching, you won't have a problem.

Don't Be Afraid to Offer Suggestions

I should point out up front that, in my experience, when an art director or client is with you and they are trying to achieve a desired result, they really do appreciate your input and suggestions! A photo retoucher that just goes through the motions without showing any creative flair, offering little advice or suggestion, is a person I would classify as a *mechanical* retoucher. Trust me, you do not want to be a mechanical retoucher. You should make yourself open to suggestions, and be able to understand and relate information into tangible results with a creative flair.

Review the Initial Proof

Clients typically arrive with (or send in) proofs of the images to be retouched. These proofs have been supplied to them from an initial scan done by a film house, or they have generated the proofs themselves. The client will go through the proof and mark up the changes and corrections he wants you to make. These marks can vary widely. I have seen an instance when a client has circled every single piece of dirt (as opposed to just giving a general indication of an area to be cleaned up). Others make simple, general requests like the one in Figure 1-6. I've also been in situations when bubbles on a frosty glass needed to be changed and moved around. And I've even had instructions that are vague at best, like the image is "too sweet." In many cases, a lot can be left up to the imagination, and it will be your job to figure it out. Some clients are coherent, clear, and concise; others seem quite reserved, artsy, or just may not really know exactly what they want. Hopefully, after reading this book, you can help your client find what she is looking for and run with it.

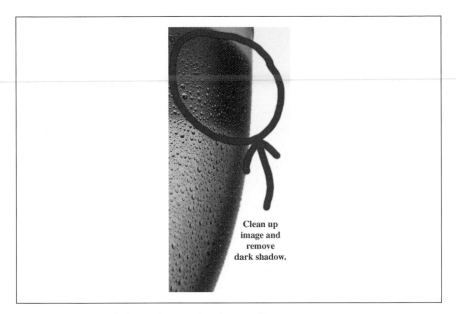

Clean up
image and
remove
dark shadow.

Figure 1-6. Image marked up with instructions for retouching

Create New Proofs for Each Set of Corrections

As each set of corrections is made, I output a new proof and recheck for previous corrections and, if necessary, make new ones. I have seen instances when an image has been sent through for over a dozen changes, each time the client finds something new to change. And while this is a great way to make extra money on the job, it can get rather frustrating for the retoucher and everyone else involved. Keep a cool head.

Some clients still prefer to have high-end proofs output. The belief is that they are more accurate and stable in color than lower-end inkjets proofs and more accurately represent what will happen on a printing press. This is basically true; however, there's a catch: the costs of the high-end proofs are much greater than a lower-end proofs from ink jets. High-end proofs are typically output on large, expensive machines that cost tens of thousands of dollars. Materials are proprietary to those machines and also expensive.

Other clients, in an effort to save a few dollars, are prepared to accept a lower-end proof, perhaps with one that you have set up yourself. If you think you may want to set yourself up with a proofing system and don't have the space or the hundred thousand plus dollars to implement a high-end proofing system, this may be the way to go. Just make sure that you set yourself up properly. I have seen many clients supply gorgeous-looking outputs from ink jet printers, only to find that such colors cannot be matched on a high-end output. Why? Because the color gamut on the inkjet system in no way relates to the real-world press condition. Uncalibrated,

poorly implemented desktop ink jet printers make images look *too* good with their vibrant inks. Hence the expectations of clients are dashed when the reality of the printing press comes into play.

Know the Deadlines

Retouchers typically have to work under tight deadlines; images are expected to be completed in hours, not days. Ad insertion dates for magazines and newspapers are expected to be met. A missed insertion date can cost thousands of dollars and can be charged back to either the film house or the ad agency serving the client. You have to be able to work well under pressure and produce timely results. In the following chapters, I'll discuss techniques I use to produce quality work in the short periods of time.

Here's a tip: as the required retouching for an image is being explained to me, I begin to form a mental picture of the final result before I start any retouching. I will think of all the subtle changes that will have to be made. Most often, I have completed the image in my head before the work even gets started. I won't let myself get bogged down with all the technical aspects of the job, as this tends to hamper the creative process. I'll never mention to a client that something isn't possible because it will go over spec; clients just don't want to hear that. I'll massage the technical aspects into the image at the end of the job.

Art directors seem to come in two different flavors: those who know exactly what they are looking for and those who have no idea. The ones that do typically have been in the business for a long time and are sure of the changes and corrections they wish to make. This can make your job much easier as a retoucher, because you know exactly what it is you have to do. The art directors that don't really know what they are looking for tend to waffle and have you go in circles. They tend to be newer to the business and lack experience. In either case, you have to be prepared for anything they may throw at you.

Present the Final Image to the Client

Once an image has been retouched and the art director is happy with it, the image is then presented to the *creative director or client*. The creative director is the person who oversees the entire ad concept and makes sure it conveys the correct message.

At this point, the image may come back to me for further alterations. Otherwise, the image is then presented to the final client. Two obvious things can happen at that point: the client either loves it or hates it. I have had situations when there is a total change to the image and direction of the ad, and it must be recreated from scratch. In other cases, there are minor changes or none at all. It is typical to get an approval on the image within a couple of rounds.

> **NOTE**
>
> *Many publications accept—in fact, many only accept—final electronic files that are generated directly onto the printing plates. This eliminates the need to have film produced to create or burn the printing plates. This obviously saves a lot of material, time, and money. Some prepress houses will have a direct-to-plate machine and stock many of the popular plates for various printing presses.*

If the image is approved, it will be passed on for further processing. This usually means mating the image(s) with the page layout file, and from there, it is either sent for final film or, most often, it is sent electronically to the correct publication house.

Regardless of the version of Photoshop or the computer platform you are using (unless it is really old!), the techniques described in this book rely on basic tools to complete the tasks described. I have found that with each update of Photoshop, I will typically try the new functions, but often I end up relying on the more basic tools to perform my corrections. In other words, the program version number isn't a big issue with me, it's what I do with the tools that matters.

Becoming a Professional Retoucher

I enjoy doing retouching especially when the job is really challenging. Making the impossible possible. But most of my day is spent doing routine work, the bread and butter stuff, so at the end of the day it is actually a job. If you were having fun all the time, it would be called a holiday! The following sections cover some of my basic observations about the profession.

Getting Training Isn't as Easy as It Used to Be

It used to be common for companies to train people on the job. These days, it seems that companies want to hire someone who can hit the ground running. I guess that leaves the training up to you. I believe that anyone with an interest can learn retouching with Photoshop, as long as the desire is there. Many schools have Photoshop night courses, and those may be an inexpensive option. If you work well on your own, reading a book like this is a good option. You know yourself well enough to know how you best learn.

What Kind of Background Do You Need?

I do feel that the best retouchers are people who have an artistic background. I say this because you have to be able to imagine the look of an image before you even retouch it, such as where a shadow falls and how it interacts with the rest of the image. Whether you model with clay or sketch cartoons, I don't think it really matters as long as you have the artistic sensibility. As long as you know what you want to achieve, the rest will fall into place. I think you should have good listening and communication skills as well. Being able to interpret what people tell you and convey your ideas and thoughts are important.

There are many retouching opportunities out there. The only downside I see is that many, many people want to get into it. It is like computer animation. It seems cool to do. When retouching started, it was limited to high-end proprietary systems that were very, very expensive. The time charged out

for retouching was also very expensive because there was really nowhere else to get the retouching done. These days, anyone with a few hundred dollars can pick up a computer and Photoshop, and they are in business. Also, many people fresh out of school with few responsibilities can afford to work for less. Many ad agencies know this, and people starting out in ad agencies will work there just to build up a name for themselves, gain some work experience, and develop a portfolio. Not a bad idea if you can afford to do it.

I find that many people just starting out do not have a pre-press, print, or color background and do not fully understand the correct way to prepare image files for various print media. Many images that come to me have to be readjusted to suit the needs of the print application. Of course, experience can be gained, but it is like anything else—it takes time to develop. Reading this book is a start.

Gaining Experience and Building a Portfolio

As I mentioned, working for someone else is a good way to develop a portfolio and build some credibility. When you work in the industry, you will also develop some contacts, and your name can get around if you're good (actually, it gets around if you're bad, too).

Sources for retouching employment include ad agencies, design houses, and companies that have in-house art departments. Companies with in-house art departments seem to be a growing trend, as they can keep everything under one roof. This may include photography, scanning (dying off) design, and retouching to final files that are ready for print.

> **NOTE**
>
> *You could contact some beginner photographers and see if you can work with them on projects, as their work may not be as high end and the projects may be a little more laid back to work on.*

Photographers are another good source for retouching. Photographers deal directly with ad agencies and are right there from the onset. Depending on the photographer, many are too busy to do their own retouching, so they will farm it out. If they have to sit and retouch something for hours on end when they could be shooting, it may be more cost effective for them to farm the retouching out. Also, many old-school photographers may not be up to speed on the retouching end, so there is your in. Many photographers these days are quite computer savvy and are familiar with digital cameras in addition to or as opposed to film-based cameras and use Photoshop on a daily basis. Having said that, if they become overloaded with retouching work, this could be another source for work.

If push comes to shove, you could approach photographers and ad agencies and ask them if you could redo a job that has been done before just to show them what you can do. The only problem you may run into is that most of the images these people have are client images, and they may be reluctant to hand them out. You could go and get some stock photography sources like iStockPhoto (*www.istockphoto.com*), download some images, and retouch them.

> **NOTE**
>
> *The problem with doing work for many agencies and photographers is that the ad deadlines are very, very tight. Many times jobs are wanted the next day or sooner. It's tough for them to rely on someone they don't know to do their retouching. Again, I think your best option is to redo work if they'll let you and keep track of the time you spend doing the retouching. That way, you can give the potential clients correct timing for jobs.*

You could also do what my father used to do. Being an ad man, he used to look through magazines, find lousy looking ads, and redo them the way he thought they should look. He used to get many accounts by impressing them with what he had done or had redone.

So now, let's get on to the hands-on business of retouching with Photoshop.

Shadows and Light

2

Shadows set objects into their surroundings. Often a client will ask to me create a shadow where one doesn't currently exist (because an object has been close-cropped onto a blank background) or fix an existing shadow that looks out of place (because an object has been cropped out of its natural environment and placed onto a new background). Or perhaps existing objects in the new scene may affect the way a shadow interacts with its new surroundings. When this happens, it is typical for an object to look out of place in its environment. Retouching can "fix" reality.

In a typical production environment, you might encounter a variety of these types of retouching scenarios: taking an image that was shot in a studio and placing it into a natural outdoor scene; dropping an image into a scene with a different background altogether, which may have been lit differently; cropping an image from an outdoor scene and bringing it indoors. In each case, the color and look of the shadow may have to be adjusted to reflect the changes in the color or feel of the image being brought in and its new surroundings.

Creating realistic shadows from scratch can present a real challenge. First of all, you have to create something that doesn't exist yet, or at least doesn't exist in the form you want it to. The shadow has to be brushed in with typically no point of reference and is totally dependent on the imagination of the person retouching the image. (If you have a limited imagination, this can be a problem, but we'll discuss means of getting around that in this chapter.)

I will typically start my shadow off by first determining where my shadow is going to fall based on the theoretical light source and the way that light would have been striking the object. The source of light will determine where the shadow will be placed, based on the time of day and the mood of the shot. We'll also want to determine the length and softness of the shadow.

Imagining the Light That Should Have Been

The problem some people face is that they don't fully understand photographic lighting and therefore can't build a good mental picture ahead of time of how the final shadow on the image should look. Before doing any retouching, you should have a clear mental picture of the final outcome before you even start to alter the image. Otherwise, you risk failing to create the final look you're after. It's like making a movie—you don't film anything that just happens to come by, but create a storyboard before any shooting takes place so that you know the shots you'll need in advance.

The first thing you must do before creating a shadow is determine where or what kind of light source *would have created* the shadow you want. What kind of light source is "present" in your final image? Basically, we have a couple of different potential light scenarios: indoor or studio lighting and outdoor natural lighting.

Studio lighting

In a studio, a photographer can have total control over the lighting process, choosing which types of lighting sources to use and which methods of reflecting that light to employ (Figure 2-1). The idea is to light the object in such a way that all the desired details of the object are evident or the proper mood is achieved.

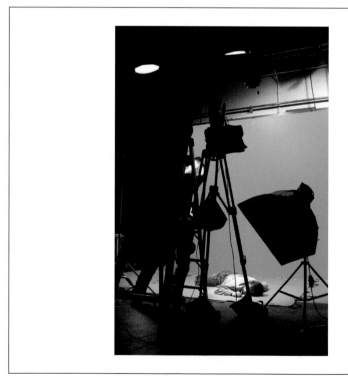

Figure 2-1. In a photographic studio lighting setup, the photographer has complete control over where the lighting comes from and how it is reflected

Outdoor or natural lighting

 With outdoor lighting, there is basically one source of light: the sun (Figure 2-2). Shadows created from the sun are quite directional, so it's often easier to see where the shadow direction will fall than it is when light is coming from all around in the studio. Outdoor lighting can be controlled to some degree to highlight various details in an object by using various reflectors, as is done in a studio.

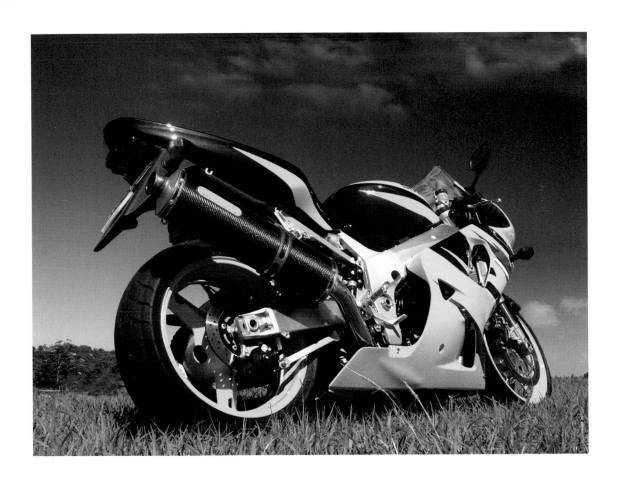

Figure 2-2. The sun shines down and creates a shadow under the motorcycle

Understanding Changes in Outdoor Lighting

The tricky feature of outdoor lighting is that it changes as the day changes. On cloudy days, shadows are soft and diffused, as in Figure 2-3. Early morning sunny days have long soft warm shadows (Figure 2-4). Midday sunny day shadows are dark, hard, and short (Figure 2-5). Evening shadows are cooler, longer, and softer (Figure 2-6). To be realistic, the type of shadow you create on an object will have to reflect these changes that happen during the day.

Figure 2-3. On a cloudy day, the shadows are soft and diffused

Figure 2-4. Morning shadows are long and warm

Figure 2-5. Midday shadows are short and hard

Figure 2-6. Evening shadows are soft and cool

Merging Multiple Light Sources

Some lighting challenges may require you to take a variety of images from different sources and merge them together. For example, look at the two differences between the SUV in Figure 2-7 and Figure 2-8. The original image in Figure 2-7 was shot in a studio. The windows in the studio shot are not reflecting much of anything. When the car is dropped in the winter scene in Figure 2-8, reflections from the nearby forest are added because the window glass is shiny and reflective. The windows are also made transparent to a degree to show the background through the glass, and some white highlights are added to the windows to reflect some of the snow that is in the shot. The outdoor scene has a blue feel to it, so the shadow is a cooler blue tone. In such cases, you'll have to determine the original source lighting of each object and create the appropriate shadows to complement each image, reworking each image shadow so that it falls in line with the others.

Ultimately, you do not want the shadow you create to look as though it was just stuck onto the image. The final outcome should look as though it wasn't even retouched. (This may often mean correcting the image as well as the shadow to reflect its new surroundings, but first we'll concentrate on creating shadows.)

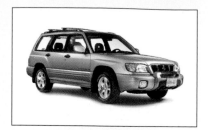

Figure 2-7. An SUV shot in a studio

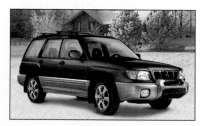

Figure 2-8. The same image moved to a new location by retouching

> **NOTE**
>
> *Depending on the overall color of the whole image, color may be introduced into the shadow as well, although I try to stay with a black-only shadow if I can for reasons that will be explained shortly.*

Creating a Simple Shadow

Let's start our shadow work by creating a basic shadow for some strawberries. Our unretouched image, Figure 2-9, is a good example; most shadows I am asked to create are this type of simple basic shadow. Having said that though, one must pay special attention to the shape, size, and density of the shadow, as such a simple shadow on a stark background will look really out of place if it isn't correct. Using some basic techniques, we can give these strawberries a realistic shadow, as revealed in Figure 2-10.

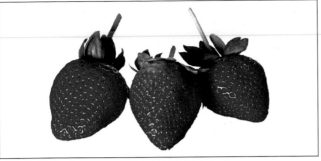

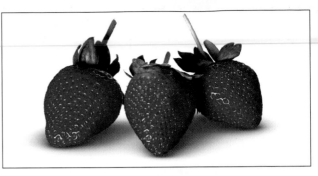

Figure 2-9. Before: Shadowless strawberries in space

Figure 2-10. After: Strawberries with the proper shadow

Isolating the Image

To start, we'll need to isolate the image of the strawberries. If the image is being removed from a background and put on a white or tinted background, I usually crop the image with the pen tool. As you can see in Figure 2-11, I usually add a small amount of softness to the pen tool selection (Select→ Feather), depending on what the rest of the image looks like. In this case, I've added a Feather Radius of 0.2.

> **NOTE**
>
> *It is very important to make sure that when an object is close-cropped out of an existing background, you take special note of the original softness of the image. If you crop an image out without any softness at all, the edge of the cropped image will look like it has been cut out with a knife and simply stuck down on the new background.*

Figure 2-11. Use the Feather command to add softness to an image when selecting

A good rule of thumb for determining the correct softness is to have a look at the original image, zoom in to a large degree, and see how the pixels of the image feather off into the background. Although this is not all that measurable in terms of an exact measurement, it will give you a visual cue as to the amount of softness you should add. Adding softness is a very visual thing, and to use the exact amount each time may not work for all images. You'll have to experiment. It is not unusual for me to make more than a couple of attempts before I figure out exactly where I want the softness setting to be.

Note that adding softness to the image may add a small "halo" around the edges of the image, particularly around the darkest areas. When a dark shadow is added, there may be an edge between the shadow and the cup, as you can see in Figure 2-12. You may have to edit this later.

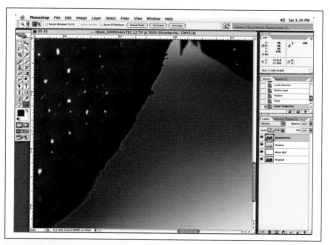

Figure 2-12. Note the halo effect around the edge of the strawberries

Figure 2-13. Add the selected image to a new multiplied shadow layer

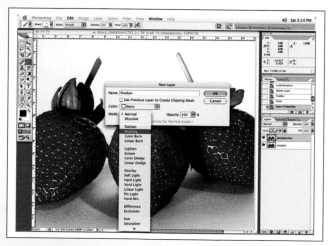

Add the Isolated Image to a New Layer

Put the isolated image onto a new "Shadow" layer, as shown in Figure 2-13 (Layer→New→Layer).

For the new layer name, I try to use something descriptive that anyone can understand. This will be the only shadow layer in this file, so a simple "Shadow" for the name seems fair, but if I were going to create many shadows for various objects, more descriptive names for each shadow layer would be more appropriate. Layer color can be important; if there are many shadow layers, to color each one the same color may make sense so that the shadows can be easily identified. If one were to have many layers of the same thing, like the shadows, then I would probably group them together in a layer set.

For shadows, I always chose Multiply in the mode drop-down box, because one never really knows where the image may end up. Occasionally, a client inserts a new background, and having the shadow on a multiplied layer will allow anyone to "slip-in" a new background if desired without any fuss with the shadow. This way, whatever background the shadow goes on, the shadow color will be added to that background, as opposed to knocking out any existing color. Set the layer opacity to 100%. If you set the opacity to anything less than 100%, it won't matter what your brush is set to—you'll never be able to brush in the full brush setting with anything less than 100% layer opacity.

Next, you will want to create a new layer below the shadow layer, set its properties to normal, and fill it with white. Adding this layer will show the true look of the work you are creating. If you have no layer under the multiplied shadow layer and simply leave it as is on an alpha channel, the shadow will not show up properly until the image is flattened, and thus you may not arrive at the look you're after.

Deciding on Brush Settings

Once the object is isolated, the next step is to properly set your paintbrush. You'll want to set up your paintbrush tool to match the perspective of the object for which you are creating the shadow. For instance, if the object is a straight-on side view, like the donut in Figure 2-14, you'll want the brush to be very slim and narrow.

NOTE

If your image will be on an image background, don't add the white layer.

If you do add the white layer, and you work on a computer that you share with other people, the last person to use the computer may have had a small dot percentage of color in the color that you thought was white or appears to be white. Needless to say, always check your fill colors with the Color Picker before filling a layer.

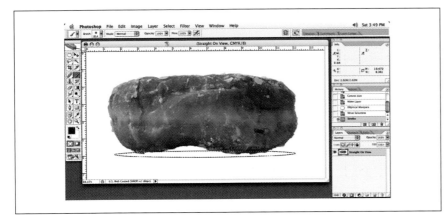

Figure 2-14. The brush set to a straight-on side view perspective

If the object is seen in a bird's eye view, as in Figure 2-15, the brush should be wider.

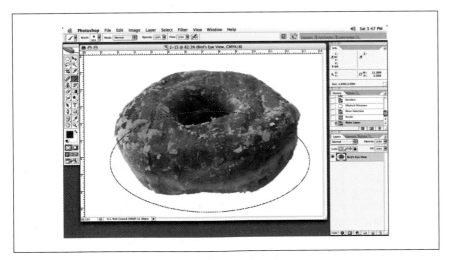

Figure 2-15. The brush set for a bird's eye view

If the object is shot from the top, you'll want the brush to be round, as in Figure 2-16.

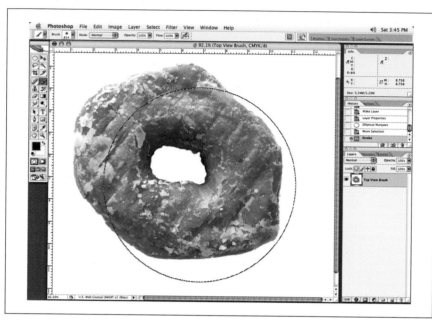

Figure 2-16. The brush set for a top view

Once I choose the brush for the proper perspective, it is very rare that I will change my brush rotation to anything other than perfectly horizontal. I rarely ever rotate my brush when I brush in a shadow. I have found that if you turn the brush at all, the shadow does not work out.

Creating the Simple Black Shadow

Once the brush is set, you can begin clicking on the areas of the image where you want to create the shadow. I usually start in areas where parts of the object in the image are farthest away from the objects closet to the ground or other objects, and work my way in from there.

Here's a tip I stumbled across regarding brushing in a shadow: I usually keep halving the brush size as I get closer to the object, closer to completing my shadow. I like to call this my *halving effect*. By constantly halving my brush size, it seems to gradate the shadow in the proper manner to provide a smooth transition into the rest of the shadow and create the correct size of darker shadow needed for realism.

For example, when I brush a car shadow, I'll start off with a large brush for the underside of the car. As I get closer to the wheels, my brushes seem to be halved with each mouse click until I have reached the tightest spot under the tire of the car.

> **NOTE**
>
> *When I use a mouse for creating shadows, I set the brush attributes to the softest edges and the pressure opacity to about 20%. If you are using a pen and tablet, you have control over the pressure as you go.*

When your shadow is done, you may want to go in and use the eraser to delete small portions of the shadow wherever the shadow gets close to the image (Figure 2-17), since brushing may have caused some overspray.

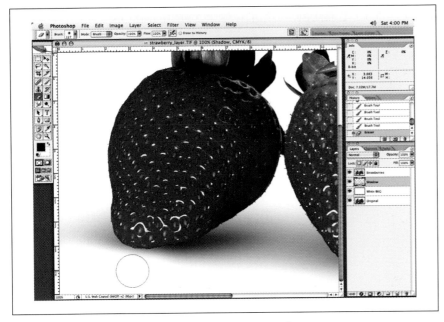

Figure 2-17. Erase parts of the shadow that may have oversprayed

Remember that as the object gets closer to another object, its *fall-off*, or *vignetting*, shortens and the shadow becomes smaller, thinner, and darker, as you can see in Figure 2-18.

Figure 2-18. Shadow getting darker as the shadow gets closer to another object or the ground

NOTE

Keep in mind that a black-only shadow requires noise in the black channel only; if you add noise while viewing all colors, you will add a 1% dot of color in all channels to the shadow, which we don't want for our black-only shadow. If you are creating a four-color shadow, you will want to add a small amount of noise in each channel. Adding noise helps break up the shadow to a small degree, and helps prevent any banding that may occur.

Once the shadow has been created, I will then go to the black channel (assuming it is a black-only shadow I'm creating, and I'm working in CMYK) and add a small amount of noise to the shadow in the black channel only, as shown in Figure 2-19. Typically, I just add a 1 or 2% for noise, depending on the size of the image—just enough that you start to notice the noise, but not so much that the darkest areas of the shadow start to break up. I never go above 8%. Add too much noise, and the image starts to become a colorful array of noise (on a colored image) or too coarse (on a black and white image), as shown in Figure 2-20.

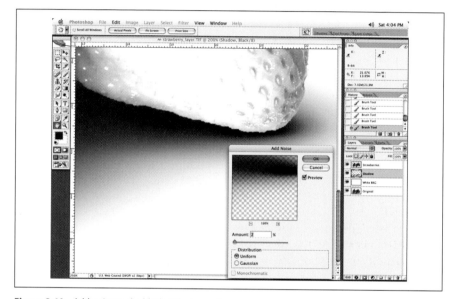

Figure 2-19. Add noise to the black-only channel

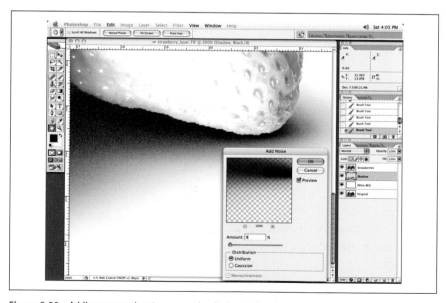

Figure 2-20. Adding too much noise causes the shadow to break up

I add noise to just about anything brushed in because the brush is artificially very smooth when applied. If you look at any image at a very large magnification, you will see a small amount of grain in it. You are trying to replicate this look by adding noise to a newly brushed area. Noise also helps to reduce any banding that may occur when brushing an area in. *Banding* has the look of bands of color, particularly on vignetted or transition areas, like those of brushed areas. Adding noise also tends to break up the faint edges of a brushed area, which helps to diffuse it into a background.

Putting the shadow on a multiplied transparent layer and not on a white or colored background ensures that adding noise doesn't put a 1% dot all over the shadow background, only where there is color that you have brushed in. As you can see in Figure 2-21, the alpha or transparent areas of that layer will contain no dot from adding noise. Creating the shadow on an alpha or *clear* channel means you won't have to go back in and delete the 1% dot that the noise filter puts in.

If I had created this shadow on a layer that was filled with white prior to brushing in my shadow, adding noise to the shadow would have put a 1% black dot in the background of the shadow, as in Figure 2-22. I could remove this with a mild curve adjustment, but putting the shadow on an alpha channel in the first place eliminates the need for any further corrections.

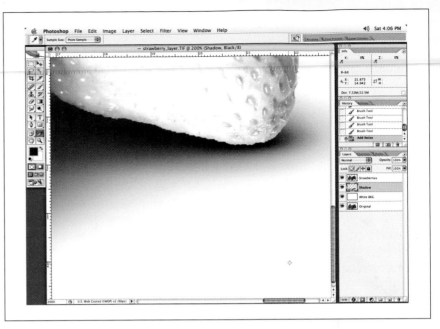

Figure 2-21. A shadow on the alpha channel: there is no dot on the alpha portions of the image

Figure 2-22. A shadow on a white layer when noise is added; note the dot on the white portions of the image

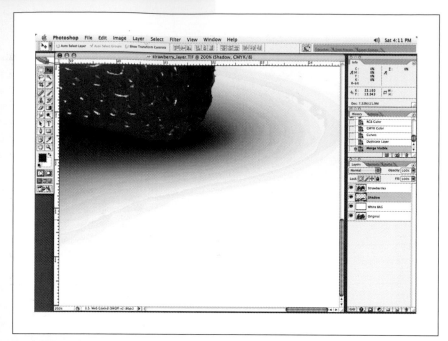

Figure 2-23. Note the shadow banding around the edges

As I mentioned earlier, I like to use black-only shadows when I can, because there is no likelihood of colored banding occurring. Color banding can occur when one of the colors breaks up or pokes out from the other color channels and is more prevalent than another color, causing a rainbow effect, as in Figure 2-23. It isn't always obvious on your monitor either, because it only takes a couple of percent in one color to throw the color off neutral or cause banding. Color banding can also occur if the press happens to gain in one color more than another. Press gain in one or more colors can really cause a problem and throw a perfectly neutral-looking four-color shadow off neutral. This is why I typically stay with a black-only shadow, as I have no control over what happens on a press, and a black-only shadow will stay neutral.

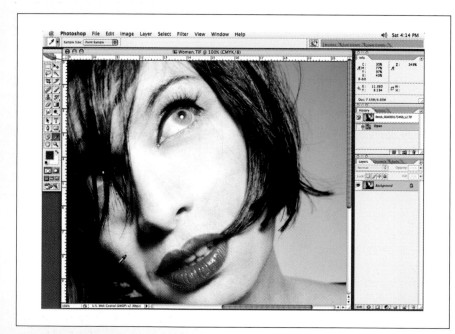

Figure 2-24. Take a color reading of a dark area of a face for a natural shadow

Creating a Four-Color Shadow

You may need to use a four-color shadow when you have natural objects like a human face, for example, where a black-only shadow may look odd, very muddy, or dirty. To create a shadow on a face (or any object made up primarily of cyan, yellow, and magenta), start by taking a reading, as shown in Figure 2-24, of the darkest color in the area you wish to add a shadow to, and use that color as your shadow color.

After choosing this color, brush on a new multiplied layer, again with a very low opacity brush, and build it up until you get the desired look. (I may add a small amount of noise if I feel what I have brushed in looks too smooth and doesn't match the rest of the look of the image.) You can see the before and after images in Figure 2-25 and Figure 2-26, respectively.

Figure 2-25. Before: no blush to the cheek

Figure 2-26. After: using a shadow chosen from a color already in the image makes the blush look natural

Creating Shadows for Complex Objects

Creating a shadow for a complex object is a little more involved than the freehand shading we've done so far. In this section, we'll create a shadow for a more intricate object, the complex tree shown in Figure 2-27. By the time we get to the final image, Figure 2-28, we'll have replanted this tree on a hillside with the proper shadow intact.

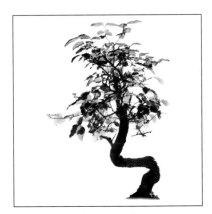

Figure 2-27. Before: a picture of a lonely tree

Figure 2-28. After: tree in its new environment with proper shadow

NOTE

Normally, I would start a project like this by making a mask of the object. Masks will be covered in a later chapter, so for now, we'll assume that the tree has been cropped out.

First, make a selection of the tree and create a new multiplied shadow layer. On the new multiplied layer, fill the selection with a 98% black, as I've done in Figure 2-29.

Next, select Edit→Transform Path→ Skew. Move the transform center pivot point of the transform tool to the bottom of the tree, so that it will be the pivot point of the shadow, as in Figure 2-30. Then, adjust the corner handles and distort the shadow layer until the desired shadow angle is achieved. The desired angle of the tree shadow will of course be determined by the direction from which the light is coming.

Let's say the sun would be coming from the right side of the image. You can see this if you look carefully at the tree trunk, as the right side of the tree has an orange glow to it from the sun and the left side of the tree is dark, or in the shadow area. This would mean that the tree shadow would fall to the left and be placed flat on the ground.

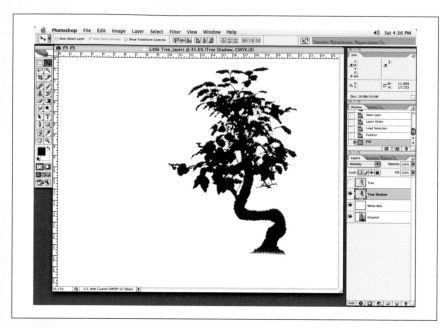

Figure 2-29. The tree selected and filled with 98% black

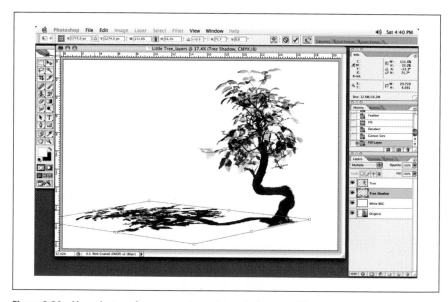

Figure 2-30. Move the transform center pivot point to the bottom of the tree, and then adjust and distort the shadow to the desired angle

If there were an object on the ground to the left of the tree where the shadow falls, the shadow would shape or mold itself around and over that object. For right now, we'll assume that it is landing flat on the ground.

Shadows tend to get blurry the longer they extend out and their intensity starts to fall off, so once the shadow has been distorted to the correct position, I usually go into mask mode and create a fall-off mask, as in Figure 2-31. Then I can perform a tonal correction to the end of the tree shadow, typically lightening the shadow as is it falls off, as in Figure 2-32.

Figure 2-31. Create a vignette mask

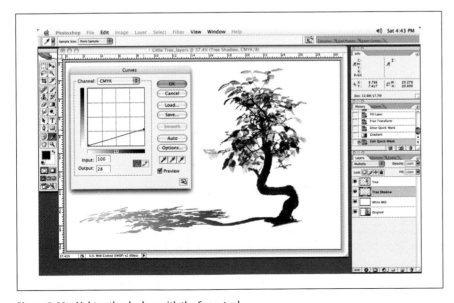

Figure 2-32. Lighten the shadow with the Curve tool

Chapter 2, Shadows and Light

NOTE

Keep in mind as well that, as a shadow gets closer to an object, it gets sharper with less vignetting occurring. The vignetted mask allows you to make these adjustments.

Typically, as shadows extend out father from their original object, they get less sharp and tend to get blurry. You can also use the same vignette mask that you used to lighten the tree shadow fall-off to add a Gaussian blur to the shadow, as shown in Figure 2-33. By using the vignetted mask, it makes it easy to blur the shadow as it falls off from the tree, because the vignetted mask has been created to allow for more correction as it falls off.

Another option would be to brush a fall-off and a varied degree of blur with the Brush tool and or a History brush.

Finally, our tree is ready for its mountainside transplanting. But remember, when a shadow hits an irregular shape, the shape of the shadow will change, too. So when the shadow hits the mountainside, you may have to adjust, as in Figure 2-34.

You can alter your shadow by drawing the new shape with the Pen tool, and then filling it with color on a multiplied layer. You may have to soften it slightly to enhance the realism of it. Or, I occasionally use the Liquify tool if the object the shadow is hitting is an odd shape that has to be massaged into an equally odd shape.

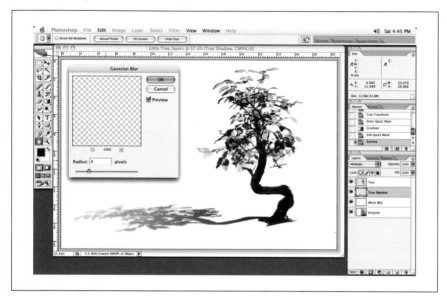

Figure 2-33. Correction made with a Gaussian blur added and a curve adjustment made to lighten the shadow as it falls off; of course, the mask is restricting these corrections

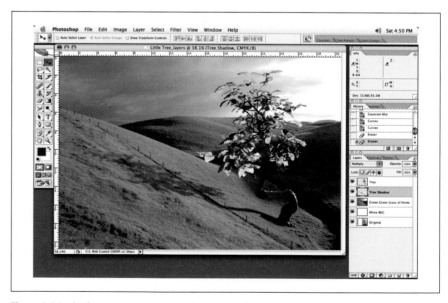

Figure 2-34. As the mountain goes up, so does the shadow

Retaining an Existing Shadow in a New Background

Sometimes your client has an image in which he would like to have the object cropped out of the background but retain the shadow. If the object is on a light background, as in Figure 2-35, this is generally a simple matter of dropping out the background.

I will usually make a selection of the object or the background (whichever is easier) and invert the selection (if necessary) so only the background is selected. Then I use a curve adjustment or a selective color adjustment to drop out the background, as shown in Figure 2-36.

If you have an image in which you want to retain the shadow, but have the shadow in black only, try this technique. First, make a path or selection of your background, and then make a copy of the image and change that copy to grayscale, as shown in Figure 2-37.

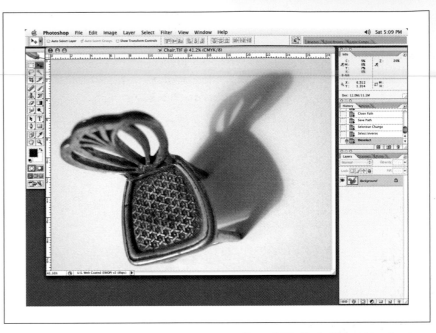

Figure 2-35. The background here has subtle coloring that the client wants removed

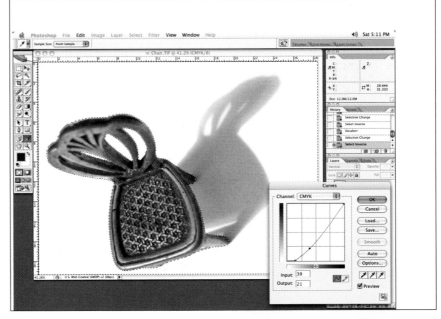

Figure 2-36. Drop out a white background with a curve or selective tool adjustment

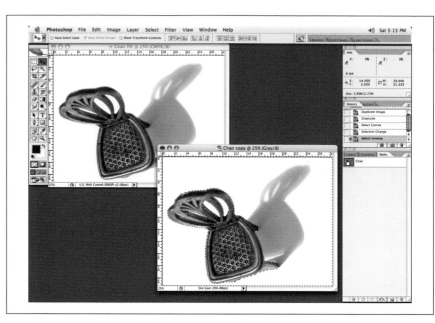

Figure 2-37. Copy a four-color image and create a grayscale

Use the same selection of the background method used above, only this time use your new black and white image. Then copy and paste it into the black channel of the original four-color image (Figure 2-38).

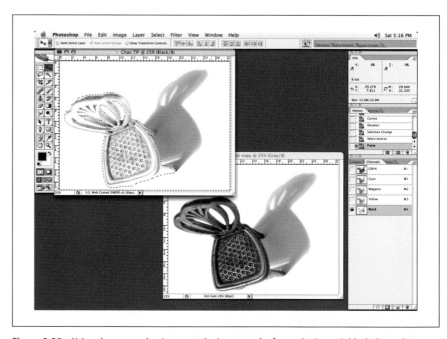

Figure 2-38. Using the same selection, copy the image to the four-color image's black channel

Make sure you delete any color in the shadow in the cyan, magenta, and yellow of the image you are retouching, as shown in Figure 2-39.

NOTE

If the object to be cropped is on—say, a tartan background, for example—you obviously cannot simply drop out the background. In a case like this, you would probably have to recreate the shadow from scratch.

Figure 2-39. Delete the cyan, magenta, and yellow shadow channel information

The final results of your new black-only shadow are shown in Figure 2-40.

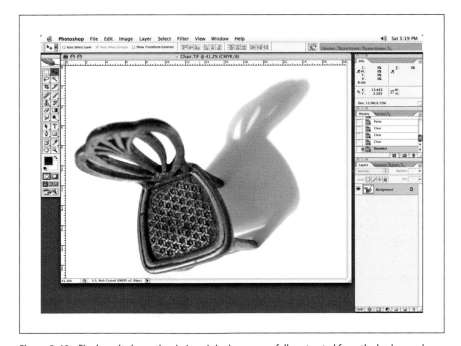

Figure 2-40. Final result shows the chair and shadow successfully extracted from the background

Grounding Objects with Shadows

With every action, there is an opposite and equal reaction. This applies to shadows as well. If you place a shadow underneath an object, some of this shadow should be reflected back onto the object, thus *anchoring* the object to the shadow and the surface on which it sits. Without this anchoring effect, objects will appear as if they are hovering (an effect you wouldn't want unless you were trying to make an object appear as though it were floating), as in Figure 2-41.

To create this anchoring shadow, add a subtle amount of shadow to the object itself on a multiplied layer, particularly where the object gets closer to the ground or to another object. As an object gets closer to the ground or another object, the shadow will become progressively darker. After the application of the anchoring shadow, the object appears properly grounded. Note the anchoring shadow around the underside of the oranges in Figure 2-42.

Figure 2-41. Before: original image without an anchoring shadow

Figure 2-42. After: reflection of shadow onto the oranges anchors them to the ground

Common Shadow Mistakes

There are a variety of common shadow mistakes; in this section, I'll go over a few and give you some tips on how to avoid them.

Incorrect Shadow Angle

Always make sure a shadow stays put on the ground in a horizontal fashion, regardless of how the image angle may change. Notice that in Figure 2-43, there is no mountain or wall to explain the position of the donut's shadow. In Figure 2-44, the donut is hovering at an angle, but the shadow correctly "sits" horizontally on the ground. The only time the angle of a shadow would change is if the shadow hit an object that is on an angle, like a wall or mountain.

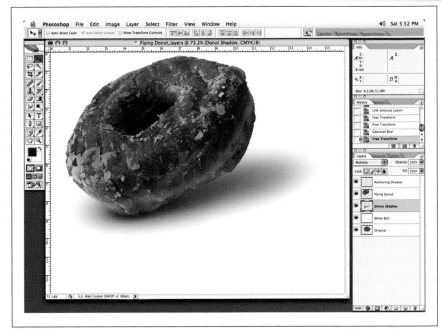

Figure 2-43. Incorrect: there is nothing in the image that explains the angle of the shadow

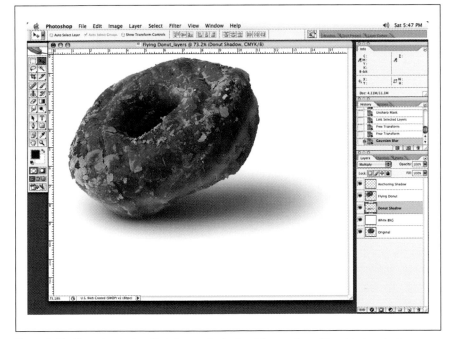

Figure 2-44. Correct: a shadow that stays on the horizontal, regardless of the object angle changes

Not Putting the Shadow on a Multiplied Layer

Creating your shadows on a normal, unmultiplied layer makes the shadow appear to have a "negative" effect because the color of the shadow "knocks out" color beneath it. The shadow ironically ends up having less density than the rest of the image, as in Figure 2-45.

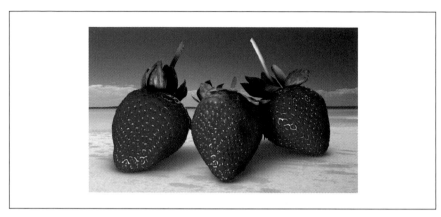

Figure 2-45. Incorrect: negative-looking shadow not on a multiplied layer

Figure 2-46 shows how the same shadow should look when multiplied correctly.

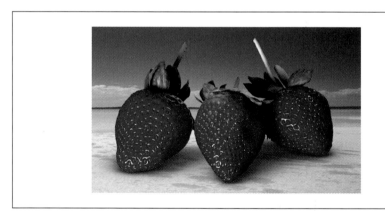

Figure 2-46. Correct: shadow on a multiplied layer

Occasionally when creating shadows on a colored area, it may not make sense to have the shadow on a multiplied layer because too much color will then be added to the background area. In this case, just make sure that the color you brush in for your shadow contains at least as much color information as the background behind the shadow itself, or else it will have a negative look to it as well.

You can see this effect in Figure 2-47. For example, if I have a red strawberry and the red portion of the image is 100 magenta, 85 yellow, 30 cyan, and 10 black, make sure the color information in your shadow has those values, plus whatever extra color you add to create the darker shadow color. (The only things you will have to keep in mind are the ink density specifications, which will be covered in a later chapter.) For now, just make sure the color is there and the shadows look natural. Figure 2-48 shows our corrected example.

Figure 2-47. Incorrect: a shadow added to a colored area with less color than the object being shadowed

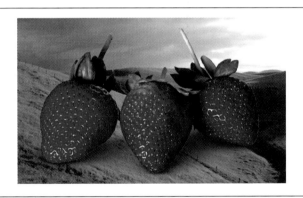

Figure 2-48. Correct: the proper look of the shadow with full color in it

Incorrect Shadow Shapes

Poor shadow shapes are another common mistake. Make sure your shadow shapes properly relate to the shape of your object. If you are not sure what the shadow shape for an object may look like, if feasible, try and locate the object you are trying to create a shadow for in "real life," and have a good look at it. Or find a practical sized replica of the object that you can study. Place the object under a lamp and move it around to see how the shadow falls, or just take a walk outside and have a look at various shadow objects.

The next few figures show the same object, a car, with different types of shadows. Note in Figure 2-49, that the shadows under the car look like they were printed with a squished marshmallow; there is no gradation at all.

In Figure 2-50, the shadow looks like someone just placed a gray bar under the car.

In Figure 2-51, the shadows under the tires look like pads placed under the car.

Finally, Figure 2-52 looks like shadows do in real life.

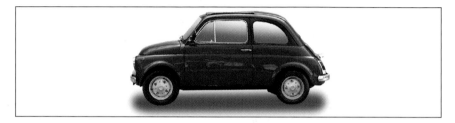

Figure 2-49. Incorrect: this shadow looks like a squished marshmallow with no gradation

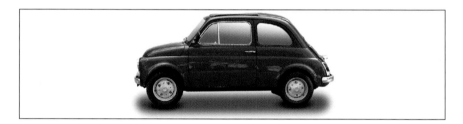

Figure 2-50. Incorrect: this shadow looks like someone painted a gray bar under the car

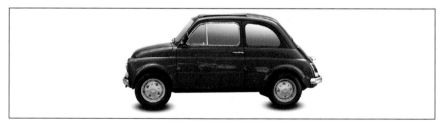

Figure 2-51. Incorrect: these shadows look like pads under the object

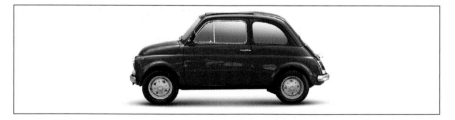

Figure 2-52. Our car with a realistic shadow

Keeping a Shadow Library

One thing I have found quite useful and a real timesaver is to keep a library of shadows. I keep a few basic shadows on file and repurpose them instead of having to recreate them from scratch each time a new image comes in. This is particularly useful for car images, but you may find other uses for them. I usually keep them as a fairly large file, but the nice thing about a shadow is that it can be resized quite considerably, 200% or more, and the image doesn't really degrade all that much. Add a slight Gaussian blur and a little noise to it, and you're back in business.

One big tip for creating shadows is: don't restrict the shadow to the shape of the object. By this, I mean create the shadow as if the object you are making the shadow for isn't even there. Do not create the shadow with an inverse selection of the object.

I say this because if you ever erase or shift the position of the object or shadow, there will be a hole or line where the shift has taken place. You can see the problem in Figure 2-53.

Create your shadow so it is behind your object, and extends itself throughout the image and isn't restricted by any portion of the object, as in Figure 2-54. Also, if you build a library of files and you reuse your shadows, having full shadows as opposed to shadows with previous shapes cropped out will make them more adaptable; a shadow cropped for a specific object will likely be useless.

Figure 2-53. A shadow under an object that has been restricted by a crop mask can't be repurposed easily

Figure 2-54. A shadow under an object that has not been restricted by a crop mask can be altered more easily for a different use

NOTE

If a shadow doesn't fit perfectly with your new image, you can always use the Transform/Distort tool to adjust its perspective slightly to create the desired angle or look you are after.

Creating a library of shadows like the ones in Figure 2-55 doesn't always guarantee a fit, but will save you some production time when one works!

Figure 2-55. Library of shadow files

NOTE

Be sure to give the shadows in your library descriptive names so you can find them when you need them. You can see the ones from my library are titled according to the angle of the view.

Corrections: Improvements on Reality

When I say "correction," I am not talking about your run of the mill correction like when you are asked to make a banana appear more yellow. I am talking about making corrections that can not only make that banana appear more yellow, but add greater shape and pizzazz so it really stands out from the rest of the bunch. The beauty of such corrections is that they can be applied to any image and changed to the point that people can't believe what you started with. Let's dive in and see how to really make those images sing.

> **N O T E**
>
> *The corrections I will discuss here are described in CMYK because anything being printed on paper by a printing press will be of a four-color process, with the occasional special Pantone color. The basic principal of a correction can also be applied in RGB. When I speak of four-color process, to clarify, some ink jet type printers are called RGB devices, but for the most part this means that they like to receive an RGB file. They will then use their internal conversion process to convert the file to CMYK, as the inks used in these printers are CMYK. Some printers use additional ink colors as well to enhance the image.*

Correction Basics

Let's start with a few basic philosophies for making corrections. (Note that many of these techniques apply to much more than color corrections.)

Using Layers to Make Corrections

The first thing I like to do when I make corrections is make a duplicate layer of the original image and assign the date or a descriptive name for the layer, such as "Color Correction." That way, there is no confusion as to when your work was done and what the layer is. This is especially helpful if you have many layers in your file. I find there is nothing worse than calling a layer its default name, like "Layer 0:"; this doesn't tell anyone anything about the layer. Another reason I make a copy of the layer is because if the client wants to go back to the original for any reason, I have it.

One more good reason for duplicating a layer is because it can be very easy to alter a change I have made to the image. If I have made a color change and the client finds that I haven't gone far enough with the change (or I have gone too far with the change), I can simply change the opacity of the corrected layer to get me where I want to go without having to start all over (Figure 3-1). It is very common for client to ask if I can go somewhere halfway in between two changes, if I have a layer with the change I have made, it is a simple matter of adjusting the opacity of the layer. A simple click on the layer opacity to 50%, and I'm halfway there! A very handy way to make quick adjustments.

Figure 3-1. Using layers to make multiple color changes to an image allows for easy adjustments to clients' requests

I may make adjustments to part of an image this way as well. Let's suppose the client loves the color change to one part of the image, but wants to go back to the original in another area of the image. I'd use a mask, a Pen tool–created selection, a Lasso tool selection, or my Erase brush to eliminate what I don't want changed on my color-adjusted layer, as in Figure 3-2. A layer mask would work well in this situation as well.

Correction Changes

Be careful not to overdo corrections. I can't count how many times I've seen corrections that have gone way too far and ended up looking unrealistic. Look at the front covers of

Figure 3-2. Erase part of an image from a layer to let the bottom one show through

magazines at the food store checkout shelves, and you can spot the overly white teeth, whites of eyes over corrected, the color of eyes emphasized beyond anything that exists in nature, and so on. Remember: the idea is to make corrections look as though the image has not been retouched. (I realize that some of these corrections are out of the retouchers' control if the client's wishes have been carried out as directed.)

One good option after a correction is made is to make use of the Fade (Apple/Option+F) command. The Fade command will allow you to adjust the intensity of a correction just after you make it. I have found this to be useful especially if you have a client who can't decide how far to go with a change. At least this way you can move the slider back and forth until you get an OK to the change without having to keep going back into a correction mode. The Fade dialog box is shown in Figure 3-3.

NOTE

One thing to keep in mind, if you are changing many images that require the exact same change, short of running a batch file, is to hold down the Option key while calling up your last color-correction adjustment. The last adjustment will be recalled when you hold down the Option key—pretty handy when doing many images that require the same correction.

Figure 3-3. The Fade command dialog box

It is helpful to reduce the viewing size of the image you're correcting on screen so that you're looking at a size similar to the actual print size (Figure 3-4). Obviously, the size of your screen will dictate how large you can view an image on screen, but this gives a much better idea of how changes affect the image. It's easy enough to see changes at a very large size, but as dramatic as some of these changes may look when blown up on screen, their effect is usually greatly reduced when you see final output from a printer. Having said that, when I make a change at a small size on screen, I will check the image at a larger screen size to make sure the change I have made is as desired, and that nothing unexpected has happened.

Figure 3-4. View the image in actual size to get full effect or lack thereof

Making Corrections with the History Brush

When making corrections, I rely heavily on the History brush, my most often used correction tool. Many people seem puzzled that I use the History brush as often as I do as a correction tool. I try to use masking functions as little as possible because of time and the risk of the mask being the wrong size, shape, etc. With the History brush, I can make subtle changes and corrections easily without masking or selections, so that the corrections will appear far more natural in appearance.

I typically don't like to make a mask to restrict color corrections. There are a couple of reasons for this. For one thing, it takes time to create a mask with the Pen tool and, depending on the image or area being masked, it could be quite complex. Brushing a mask in the mask mode is time consuming as well. What if the mask or shape you create isn't the right size? Or the shape isn't quite right? Or the positioning is off? An "organic" shape such as the blush on a cheek is hard to define with a lasso. There are many variables that could go wrong when creating a mask to restrict a correction.

Admittedly, if the area to be corrected is a sharp, predefined shape, or is a very obvious area that could be masked or selected easily with a Masking tool, it could be worthwhile to make a mask, especially if there is the possibility that the image may come back for further correction in the same area. Care must be taken however when a mask is made that you soften the selection edge to match the general look of the rest of the image so that when the correction is done, it doesn't appear carved out (as in Figure 3-5) or obviously corrected, but rather has a natural effect like the image in Figure 3-6.

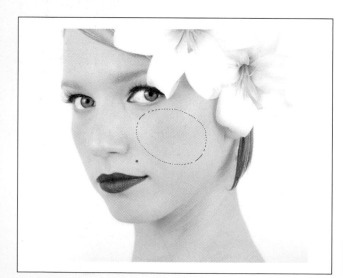

Figure 3-5. Before: using a mask to redden cheeks in a face creates an unnaturally hard edge

Figure 3-6. After: using the History brush can give a natural effect to the blush

Let's suppose you have a person's face and you want to add a red blush to the cheeks. You could mask the area and use the Lasso tool and soften the selection, as in Figure 3-7. Or, you could use the Pen tool to create a shape and make a selection from that, or you could paint in a mask in the mask mode with a soft brush. Again, what if you don't like the position of the mask? Or the shape of the mask? Or maybe it's too hard or too soft? You'll have to spend time correcting the mask or selection when you could be doing the correction.

So let's use the History brush to add the blush to our original figure. First, make sure you do your correction on a duplicated layer of the layer to which you wish to make the correction. Start off by making an overall correction to the image, using the curves adjustment in the magenta channel, as you can see in Figure 3-8. Don't worry that we are making the correction to the whole image, as you will be taking a History snapshot of the correction and will be brushing in the correction only where it is needed. If I have had clients sitting behind me watching a History correction like this, panic usually sets in with them when they see the overall correction! Rest assured, their worries are put to rest when I explain what I am doing. The curve adjustment tool is under the menu item Images→Adjustments→ Curves. Accept the change when you have the blush color you are looking for by clicking OK.

Figure 3-7. Even with a softer edge, the mask still looks unnatural

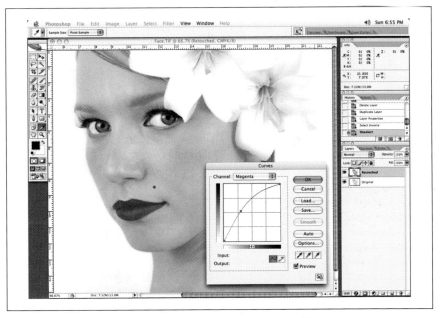

Figure 3-8. A face with a curve adjustment in the magenta without a selection

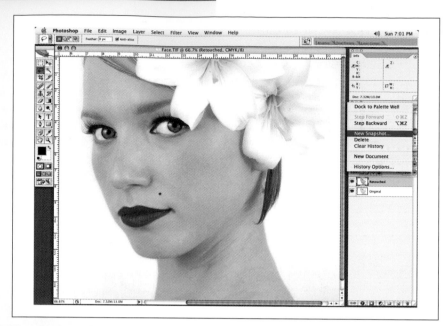

Figure 3-9. Save your snapshot by using the History palette tool

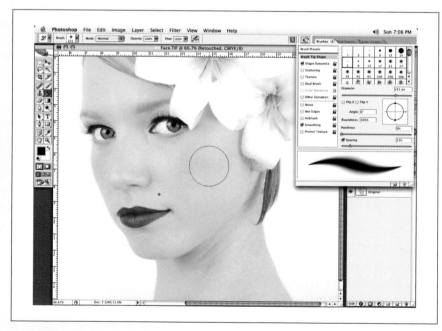

Figure 3-10. History brush attributes

Obviously, the correction is applied to the whole face, which is not what I am looking for yet. Next, take a History snapshot of the correction and name it Red Cheek, as shown in Figure 3-9. A History snapshot is taken by clicking on the little camera icon in the History palette. When you take a History snapshot, a new little image icon appears in the History palette list.

Next, undo your color correction so it reverts back to the original look of the image. Then select the History brush from the Tools palette. Be very sure that you click only the little checkbox to the left of the newly created History snapshot and not on the History snapshot icon itself. If you click on the History snapshot icon, you will change the whole image to the color change you just made, and you don't want that. If you do click on the History snapshot icon, simply go to your list of History palette states and click on the one prior to the correction you just made.

In the History brush attributes (Figure 3-10), select a brush size and softness you think will suit your task; in this case, we'd like to create a soft blush on this person's cheeks, so let's select a large brush that is very soft. I also set my brush opacity to about 20%, a good starting point.

> **NOTE**
>
> *One of the few things you cannot do with the History brush is change color modes and expect to brush in the change. The History brush will not allow you to brush in a change from another color mode. For instance, if you change the image to grayscale, and then back to the original color, you won't be able to brush in the grayscale mode information into the color image.*

Next, click on the History snapshot you took earlier of the correction you had made. Be sure you don't click on the actual image portion of the snapshot or the whole image will change. Just click on the little eye to the left of the History snapshot. Now select the History brush from the Tool palette. Or use the Apple Y key to select it. Once thing to keep in mind with the History brush is that if you ever use the Undo key to revert a change, you will have to reselect the History snapshot from the History palette. If you think you may be making many History snapshot corrections, giving them a descriptive name may prove useful.

Go over to the image and begin to brush in your History snapshot of the color-corrected image onto the cheeks. Keep brushing until you achieve the look you're after. You can see the final effect in Figure 3-11.

Figure 3-11. The final effect

As you can see on the final image, the changes are very natural and very little time was spent on this correction. The beauty of the History brush is that you are not limited to the type of correction you make. You can use any of the filters and color-correction tools available and apply them with the History brush. It wouldn't be uncommon for me to make several corrections to an image using various correction tools and complete the image without ever making a mask.

Adding Texture to an Image

I am often asked to introduce more shape or texture into an image that is lacking it (Figure 3-12). Examples of images lacking shape may be very dark objects that have lost shape due to the amount or density of color in an image. Another example may be a fabric or material that is lacking shape—not that it isn't in the image somewhere, it just hasn't been exaggerated. Imagine a block of chiseled ice. If a client wanted to see all the many textures within that shape, various methods could be used to bring them out. There are a couple of ways I like to do this.

Figure 3-12. Before: an image lacking shape and texture

One basic method for adding shape and the appearance of more texture is to use a simple curve adjustment. Using the curve adjustment with all colors selected, I'll take readings of the darker and lighter areas of the image and come up with a bit of an S curve (Figure 3-13). The S curve is a basic way to introduce more contrast to an image, which usually results in the appearance of more shape, texture, and contrast.

When I say "take a reading," I mean that you want to see what values make up a particular color. This information is displayed in the Information palette window.

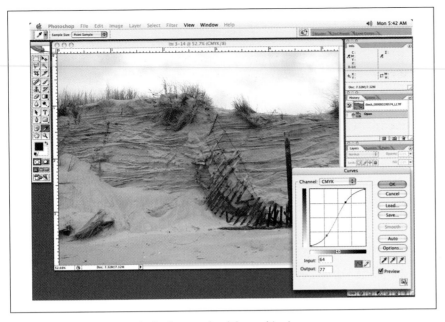

Figure 3-13. After: an S curve in the Curves tool and the resulting image

Changing Texture Using Individual Color Channels

Another way to add texture to an image would be to go into the individual color channels and pinpoint each color on the curve and adjust them individually for maximum shape. For instance, the cyan channel may have more shape than the other color channels, and therefore, you may want to change the cyan channel without changing the other channels, as long as this doesn't affect the overall color balance of the image. The black channel is usually a good starting point because it will not change the overall hue of your image, just its density and shape.

Take Figure 3-14, for example. If you go to an individual color channel in the Curves adjustment tool and click on an area of the image, a little point will show up on the curve adjustment line to show you where the color value is on the particular color curve (Figure 3-15).

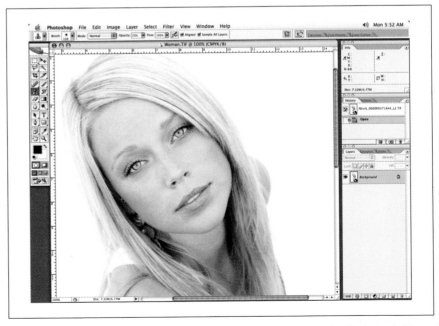

Figure 3-14. Another image lacking shape and texture

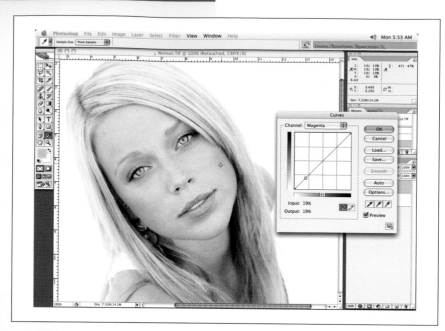

Figure 3-15. Pinpointing points on the magenta curve adjustment line by clicking on the desired image area with the Eyedropper tool to take a reading of the color in that area

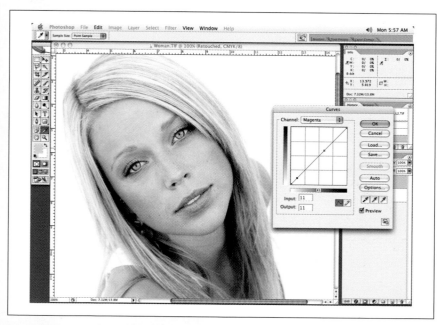

Figure 3-16. Curve adjustment line with point selected on it

Now you can click on the curve adjustment line where the pinpoints showed up and create curve adjustment markers. These curve adjustment markers are the points you move on the curve to make adjustments. First, have a look at your image and decide which areas need help. Start by selecting one of the color channels in the Curve adjustment tool. If there is an area of the image you don't wish to change, move your Eyedropper tool over that area, click and take a reading of the area, and note where that area is on the curve. As you click your mouse or pen button, the exact position of where that color falls will be shown on the curve line.

Pinpoint that spot on the curve line and place a lock or adjustment point there by clicking on it as described above. Then go to the area that needs a boost in color, take a reading of that area, pinpoint it on the curve, and place an adjustment point on that spot. You may want to do this several times until you have points selected on the curve surrounding the problem area. You now have all the points you need to work with (Figure 3-16).

Simply move the pinpoint adjustments around until you achieve the desired look (Figure 3-17). Repeat this process for each color involved. Be sure to keep the colors in balance so that the actual hue of the color doesn't change. If the color is a brown, keep it brown—just make it a lighter or darker shade of the same brown.

Figure 3-17. The result of pinpointing on the cyan channel; repeat this process for each channel

Using the Channel Mixer Tool to Create Shape

Another way you can introduce shape into an image that doesn't have much shape to start with is with the Channel Mixer correction tool (Figure 3-18). Start by determining which of the various color channels has the most shape to it.

Figure 3-18. The Channel Mixer tool with original image

Chapter 3, Corrections: Improvements on Reality

Figure 3-19. Before: the original image with a black change in the Channel Mix

Figure 3-20. After: image with lots of new information in the black channel

Let's suppose the cyan channel has the most shape. Call up the Channel Mixer tool (Tools→Image→ Adjustments→Channel Mixer) and transfer the information from the cyan channel to another channel that will complement or enhance the color of the image.

Depending on the image, a good safe bet would be to transfer the shape into the black channel (Figure 3-19), as black doesn't change the hue or color of the image, it is there to add shape and contrast to an image. If the black dirties the image too much, you'll have to mix the cyan channel into the other color channels in balance so that the hue of the area doesn't change (Figure 3-20). Again, keeping the color in balance means retaining the original color of the image but making it darker or lighter.

When you call up the Channel Mixer tool, at the top of the dialog box, you'll see the Output channel. The Output channel is the color channel that any changes to the slider will affect. The Source channels are where you pick up the information. For instance, if the Output channel is set to black and you drag the Source channel slider of the cyan channel to +100, then 100% of the cyan channel will be added to the black channel.

So as you can see, you can take information from one channel and mix it into another channel very easily.

Using a Grayscale Image to Create Shape

Another great way to add shape is to duplicate the image you wish to correct. From the main menu, select Image→Duplicate (Figure 3-21). Accept the default name, as you will be discarding the image anyway, so the name isn't important.

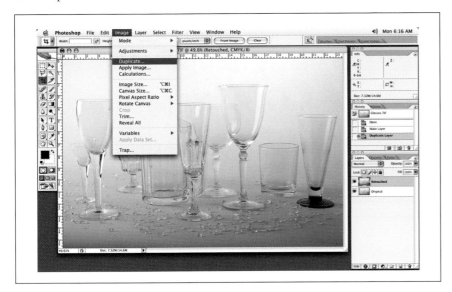

Figure 3-21. Duplicate the original image

Once duplicated, change this new image to a grayscale image (Image→ Mode→Grayscale), as shown in Figure 3-22.

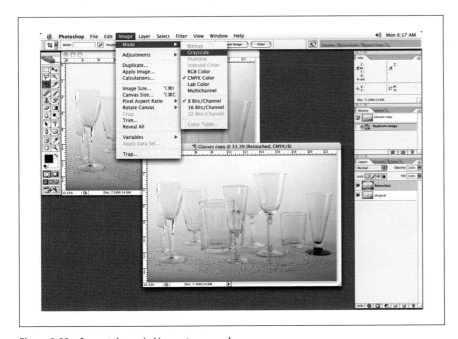

Figure 3-22. Convert the copied image to grayscale

Next, call up your Curve adjustment tool, and make a crazy curve to bring out the most definition and shape that you can muster (Figure 3-23). Once you see something you like, apply the change. Depending on what area of the image you are trying to correct, either Select All and copy the entire grayscale image or a portion of it to the clipboard, or go back to your original four-color image and make the same selection.

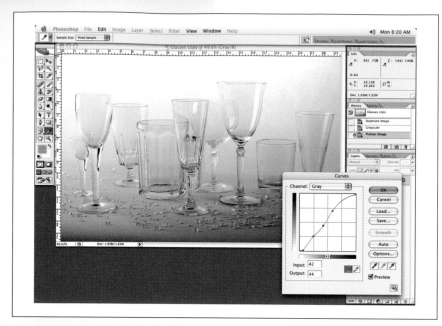

Figure 3-23. Use a Curves adjustment on the grayscale image

Select one of the channels by clicking on it in the Channel palette—typically the black channel, as again, the black is great for shape as long as it doesn't dirty up the image—and paste the grayscale image you created and copied to the black channel. Make sure you make the same selection on your original image as you did on the grayscale image. If you don't make the same selection on the original image, when you go to paste the grayscale image into the original image's channel, the grayscale image will not place in the correct position. I usually make and save a selection or a path with the Pen tool of the area I wish to change prior to making a grayscale copy so that each image has the exact same path or selection available. If I now go to the curve adjustment or any other adjustment tool, there will be a ton of new information to work with in the new enhanced channel (Figure 3-24).

Figure 3-24. Copy the grayscale image

Paste the grayscale image into the original four-color black channel, as shown in Figure 3-25.

Figure 3-25. Paste the grayscale image into the four-color image

You may or may not want to make a color or curve adjustment to the new black channel if you find it too heavy or full. The final result is shown in Figure 3-26.

Figure 3-26. The final result shows much greater shape to the glassware

Figure 3-27. The Photoshop Selective color correction tool

Using Plug-in Filters

I'm not a big user third-party plug-ins or filters because Photoshop alone enables me to do everything I need to. I do like one filter, though, and it reminds me of the Chromacom system. It's the Coco selective color correction tool plug-in. I have written to Adobe to ask them to incorporate this filter years ago, but it appears there have never been any changes to the Selective color correction tool (Figure 3-27).

Photoshop has its version of selective color, shown in Figure 3-27, but it limits your selections to the sample colors they have included with the tool. The Coco plug-in (*http://www.aurelon.com*, Figure 3-28) does not have preset colors, and the selection of color and the range of the adjustment are very liberal—terrific for changing specific colors in an image without affecting any other colors in the image unless you want to. It is a bit pricey though.

Figure 3-28. The Coco selective color correction tool

Using the Clone Tool

The Clone tool (Figure 3-29) basically uses two points: one point reads the image information, and the other point writes that information. Adjusting the Clone tool brush size adjusts the size of the read and write points. The distance between the two points is adjustable, and you must take care to keep from repeating the same information as you brush along.

For cloning straight edges, hold down the Shift key and click along the length of the edge you are trying to fix (Figure 3-30).

Figure 3-29. One Clone tool point reads the information, and the other writes that information; sometimes the information repeats itself: a very undesirable effect

Figure 3-30. Before: cloning an edge of an image with the Shift key

By holding down the Shift key, the Clone brush will follow your every click (Figure 3-31).

Figure 3-31. After: cloning an edge of an image with the Shift key (the second point is clicked while holding down the Shift key)

Cloning Human Faces

I like to use human faces to demonstrate corrections because everyone knows what a face should look like, and if anything is off, people will notice. This forces me to get it right! To smooth out rough skin or some other rough surface, use the Clone brush set to a very low opacity (Try 20% and adjust it from there if necessary). Massage the area constantly by changing the brushes so you don't get any repeat patterns. See Figure 3-32.

Figure 3-32. Smooth out an area with the Clone tool

Keep the brushes moving and change their positions in relation to each other often so that no one area repeats itself. Depending on the rest of the image, add a bit of noise to the area to break up the smoothness of the area retouched (Figure 3-33).

If you zoom in on your image to a large degree, you will notice that there is a texture in the image that isn't perfectly smooth. When painting in color with a brush, or cloning or filling an area with color, these techniques create an unnaturally smooth texture, and can stand out in the image. Adding a small amount of noise helps break up these areas and blend them in with the rest of the image.

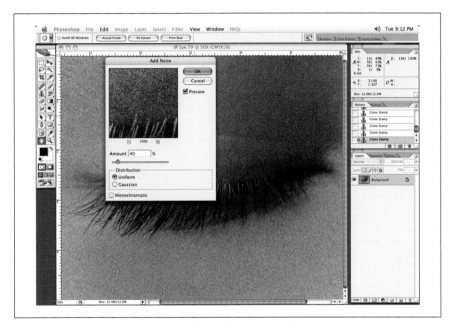

Figure 3-33. Add noise to keep the image from looking too retouched

The Noise dialog box offers a couple of options. You can select a Distribution of Uniform or Gaussian. Gaussian tends to place the noise more randomly, which is preferable. The amount you set is purely a visual thing, and you must experiment with this control to see what best suits the look of the rest of the image. Monochromatic is usually ticked off, and you probably won't need it unless you have a four-color black and white-looking image.

Be careful not to add too much noise, as it will become quite noticeable. Have a good look at your image before you decide on the amount you wish to use.

— **N O T E** —

I rarely use custom brushes, except when cropping hair, which will be covered later in this book.

Figure 3-34. Fabric brushed with a brush that's too soft causes a halo effect around the brush perimeter

Cloning Cloth or Similar Textures

If you are brushing in something with a pattern like that of cloth or a texture, I would increase the brush hardness; otherwise, the edges become diffused and look out of focus. I see many people making the mistake of setting the brush too soft when cloning patterns and material with the Clone tool. Note the diamond-shaped halo around the pointer in Figure 3-34.

Set your brush to a harder setting, as in Figure 3-35.

Figure 3-35. Use a hard-edged brush to avoid the halo effect

Speaking of fabric, a common problem that arises when printing images with patterns, fabric, or something with texture is an effect called a *moiré pattern*. This occurs when the screen angles used for printing interact with the pattern of the material. The effect looks like an oil slick, a wavy line pattern, or some other unintended pattern. Take a look at Figure 3-36 and note the moiré pattern that has developed.

> **NOTE**
>
> *If we are talking about an image that is to be printed and is a CMYK image, then each of the color channels, the CMYK, will be on different angles in relation to one another. Imagine a window screen. If you had four of them representing each color channel, you wouldn't simply lay one on top of the other in the exact same rotation so that they lined up perfectly. As you lay each screen down on top of another, you twist one to the left a little and one to the right a little so that they created a diffused pattern. This is how each color channel is printed.*

Figure 3-36. What the image looks like with a moiré pattern (note the wavy pattern in the image)

There are a couple of things you can do to try and get rid of the moiré effect. If you have any control of the screen angles used in the print process, you can try and change the individual color angles. This technique is a little unpredictable, as this may cause the pattern to show up somewhere else in the image. All you can do is experiment.

You can also try rotating the image slightly, which may get rid of the pattern. Or it may cause it to pop up in another portion of the image!

Another option is to throw the problem area out of focus with a Gaussian blur, enough to get rid of the pattern, and then add a small amount of noise to bring back some of the texture. This is a good option, particularly if it is a small image and the pattern causing the moiré isn't the focal point of the image. You could Clone brush the area at a very low opacity setting and try to massage the pattern out. Increasing the resolution occasionally works, especially if you can do this at the point of scanning. Instead of scanning the image in at 300 dpi (150 dpi line screen), scan it in at 600 dpi. This may help. Unfortunately, there are no hard and fast rules for fixing a moiré; there is a lot of experimentation involved, and you'll just have to try a few things and hope for the best.

> **NOTE**
>
> *Occasionally, you may get hot spots on flesh tones around noses, eyes, and ears. You can use the Selective color correction tool, select the RED and/or the Magenta color chip, and reduce the red with the slider control and increase the yellow and cyan sliders until the color falls in line with the rest of the image in color.*

Neutralizing Images

When I speak of neutralizing images, I mean that I want to make the image true to its natural color. For instance, I want my blacks to be a black, not yellowish black or bluish black, but black black. I want my white areas to be white, not a pink tone or off-white. Neutralizing an image is an attempt to do this.

Figure 3-37. The original shot needs neutralization

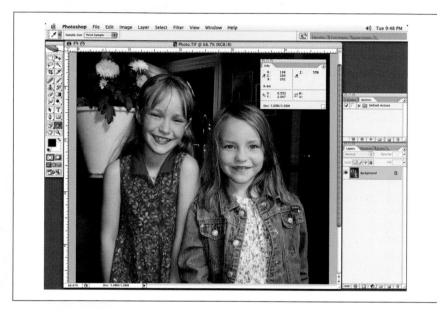

Neutralizing RGB Images

In RGB, it's pretty easy to obtain a neutral look in a full color image. Usually, if you balance the highlight and shadow areas, the rest of the image will fall into place. For instance, if you started with the image in Figure 3-37, look for the whitest area in the image and make of the values in the image the same.

For example, make a white area R5, G5, B5. You can use the Curve adjustment tool or the Selective color correction tool to set the highlight and shadow area neutral points, as shown in Figure 3-38. Use the Color Sampler tool and the Information palette to see what the values are as you make changes with the color correction tools to balance these two areas.

You don't want to blow out an area to the point that there are no values left there. You may get rid of any subtle shape if you do this. Just make sure you leave minimum dot in the very lightest areas.

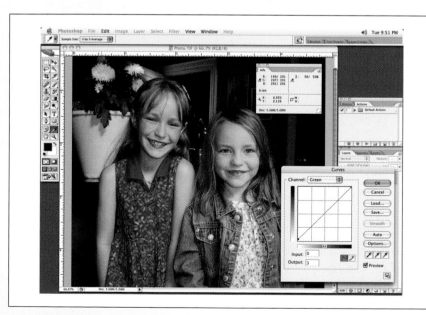

Figure 3-38. Adjust the highlight with the Curve adjustment tool to a perfectly even number in all channels

Next, you want to go to the shadow area of your image and, using your curves, balance all the colors there as well—for example, R250, G250, B250—as in Figure 3-39. Again, just like the highlight area, the opposite holds true here: you do not want to plug up or fill in the shadow areas, for risk of losing subtle shadow detail. Avoid making the shadow areas R255, G255, B255.

NOTE

The exception to blowing out an area to no dot is the creation of a spectral highlight. A spectral highlight is the type of starburst sparkle you may see on a glass.

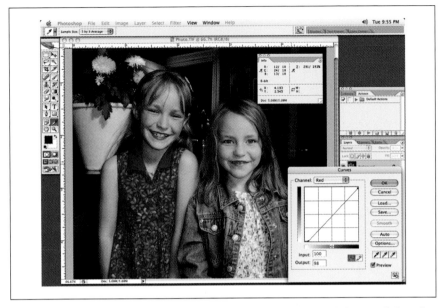

Figure 3-39. The shadow end of the image adjusted; again, look for a perfect balance in all channels

Figure 3-40 shows the final image.

Figure 3-40. The final image

Chapter 3, Corrections: Improvements on Reality

Neutralizing CMYK Images

CMYK neutrals are a little harder to obtain because the cyan values must always be higher than the magenta or yellow to be considered neutral. A good starting balance for neutrals is shown in Table 3-1.

Table 3-1: Starting balance for neutrals in CMYK using the same curve method as with the RGB images

	Cyan	Magenta	Yellow	Black
Highlight	4	2	2	0
Midtones	58	50	50	Depends on image
Shadow	75	65	65	95

This assumes that there is a neutral area in the image to take a reading of, which may be something that exists only in an ideal world. If you have any say in how the image is shot in the first place, it is nice to have a grayscale card included with your image like the one shown in Figure 3-41. It would help you make accurate color corrections. If an image has a grayscale card included, it may be helpful because the card is neutral; adjusting your image until the card is neutral should cause everything else in your image to fall into place. Obviously, if the card appears way off in color, you know there is a problem. However, often there is no grayscale card included, and you'll just have to do the best you can to neutralize the image. Try correcting areas that you feel are off, like a skin tone or a blue sky, and hope that the rest of the image will fall into balance.

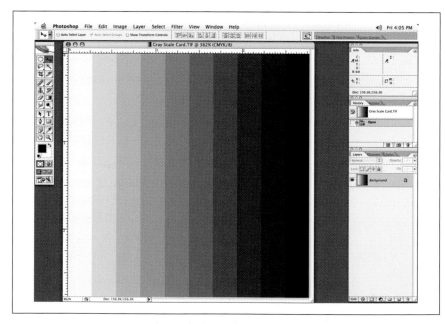

Figure 3-41. A grayscale card

I have left black out, because black is typically used for shape and could be adjusted visually to obtain the desired look. Avoid making the black solid, as, depending on the image, you could fill in shadow detail. Unless it is a flat tint, of course.

Occasionally you'll be asked to put an image onto a black background or solid tint. Of course, the tint may be made up of the four process colors, and the tint values will be spelled out for you. If the tint is to a solid black background, then it is typical to make the black tint 100% black with a support of a 40% cyan (this is very typical for newsprint). This helps to give the black a richer look, as in the "space" behind the lizard in Figure 3-42.

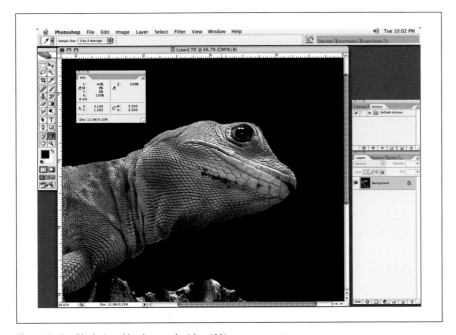

Figure 3-42. Black tinted background with a 40% cyan support

Brightening Images

Another typical request that I get from clients is that they feel the image color looks dull and they'd like to brighten up the image. A couple of easy ways to brighten up images are with the Hue and Saturation tool, and with the Selective color tool. Go in and take out the unwanted colors that dirty up other colors with either of these correction tools. For example, if the following colors look "dirty" or not as bright as you'd like them to, try removing the appropriate color.

- If a red color looks dirty, take out the cyan.

- If a green color looks dirty, take out the magenta.

- If a blue color looks dirty, take out the yellow.

- If a yellow color looks dirty, take out the cyan.

If you use the Saturation slider in the Hue and Saturation tool (Image→ Adjustments→Hue/Saturation), shown in Figure 3-43, and slide it to your right, this tool will take out the unwanted colors for you. The Hue and Saturation tool will do all colors at once, as you can see in Figure 3-44, so it isn't all that selective about what colors will be changed.

Figure 3-43. The Photoshop Hue and Saturation tool

Figure 3-44. After applying the Hue and Saturation tool

Be careful with the Hue and Saturation tool because it can do a fair amount of damage to an image; use it sparingly. It can cause the colors to break up and look posterized or very cartoonish (Figure 3-45), something you will want to avoid.

So, instead of Hue and Saturation, I tend to use the Selective color tool more often, as I have more control over what values I can change. Usually the change I make is a visual one, unless I am trying to dial in an exact color match to a reference color chip or an exact value. Obviously, you will have to experiment with these adjustments, but at least this will get you on the right track. Figure 3-46 shows the effects of using the Selective color correction tool, adjusting just one color—in this case, the green. Other colors can be affected, but to a lesser degree than the wholesale employment of Hue and Saturation.

Figure 3-45. Hue and Saturation tool image taken too far; the image will start to look blotchy or cartoonish

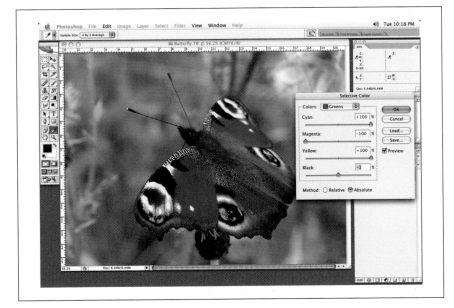

Figure 3-46. Use the Selective color tool for better control

Figure 3-47. In the case of a green lizard, the cyan channel has the most information

Figure 3-48. Desaturating an image is another alternative for isolating an image to change color

Changing Image Colors

Occasionally, you'll be asked to change the color of one single object within an image. If you are changing the color of an image to an entirely different color than the original image color, the first thing you should do is have a look at the individual colors to see which color channel has the most information and shape. If the image is green, the dominant color will be the cyan or yellow. If I were asked to turn the image into a red, the bulk of my correction would use information from the cyan or yellow channels. So let's say we needed to change the color of our lizard. You can see in Figure 3-47 that the cyan channel has a great deal of information.

Another option is to either desaturate the image so that there is a healthy amount of information in all color channels to play with or create a grayscale of the image, and paste it back into the original color image. You could add lots of shape with a "crazy curve" (as described earlier) to your grayscale image, prior to pasting it back into the four-color image. Figure 3-48 shows the effect of desaturation.

Next, mask the area of color to be changed very carefully with the Pen tool; you do not want to either miss some of the color to be changed or crop outside of the area you wish to change. The color change would either spill over into another area of the image, or the old color would poke out from behind the new change.

Figure 3-49. Here are the Channel Mixer settings for making the lizard red

Add a soft feather to the selection as well. Depending on the look of the rest of the image, most of the time that works out to be a .2 to .5 feather. Adding a feather helps the correction look like part of the image. You don't want to have the correction looking like it was cut out and dropped it with a butcher knife!

Once the area has been masked and you've selected it, call up the Channel Mixer adjustment tool) (Image→ Adjustments→Channel Mixer).

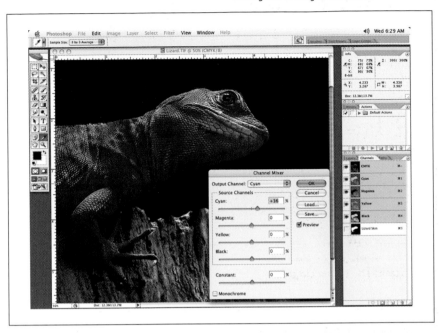

Once you have selected the Channel Mixer tool, the first color to show on the palette is the cyan, which it is displayed at the top of the dialog box as the Output Channel. You'll notice that the cyan, magenta, yellow, and black are also displayed on the dialog box under Source Channels. Basically, when you change the values in the Source Channel sliders, you are adding information from other Source Channels to the Output Channel's information. For example, assuming I have my cyan channel selected in the Output Channel and I slide the magenta slider up to 100%. That would mean that I just added 100% of whatever information is in the magenta channel to the cyan channel (Figure 3-49). There are infinite combinations you can mix up in the Channel Mixer tool, and it can be a very useful tool. Figures 3-50 and 3-51 show a couple of other options for our lizard.

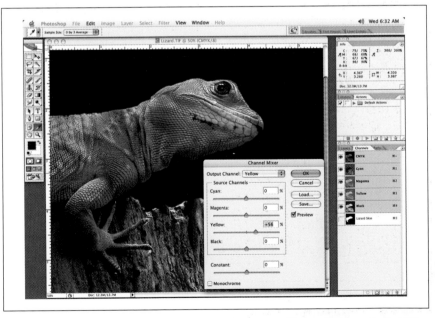

Figure 3-50. These settings turn the lizard blue

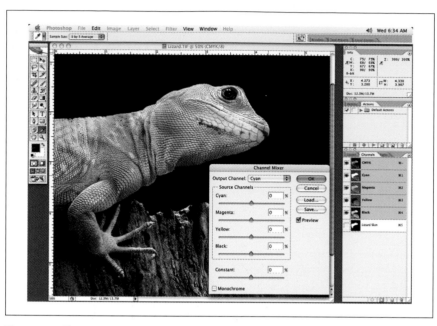

Figure 3-51. These settings turn the lizard yellow

Keep in mind that when changing the color of an object to a completely different color, you don't want to lose any shape, highlights, or shadows that were in the original image. Make your adjustments carefully. You may want to have a duplicate of the original image open while you're making an adjustment to serve as a reference.

Changing Color Drastically

Another challenging request I get on occasion is to make a light-colored object dark or a dark object light. This is one of the most challenging requests for most people, and one of the toughest things you may be asked to do. I've made the following example tough, as I will use two cars, one white and one black, and make the white one black and the black one white.

> **NOTE**
>
> *A white car has very little information to work with, and much of it must be created. A black or dark object has too much information and must be creatively lightened considerably to look like a realistic light car.*

Changing a black object to white

The first step in changing the color of the car in Figure 3-52 is to mask off the color to be changed. You can make a mask of each element of the image with the Pen tool, as shown in Figure 3-53. For instance, in this case, we are changing the color of a car, so make separate masks for the hood, doors, fenders, etc. One trick for changing a black car to white is to leave a small space between the various components, as in Figure 3-53, so that these lines will be dark enough to be apparent when the corrections are done, just like spaces in the real thing!

Figure 3-52. The original black car

Figure 3-53. Create paths for all of the car's paint, including doors, hood, and all shapes within the

Using the path selection you just created, make a copy of the black paint of the car and paste it to a new layer (Figure 3-54). Take care when making the selection, as you don't want the outer edge selection to be too soft. I usually select a .2.

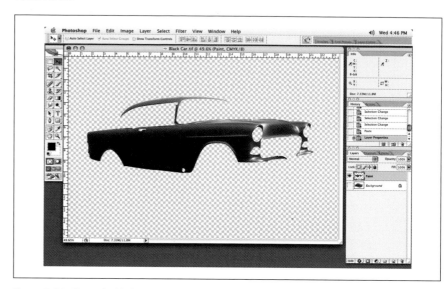

Figure 3-54. Paste the black paint selection into a new layer

Then make a copy of this black car, and change the black car copy to a grayscale image using Image→Mode→Grayscale. Don't merge the layers! Now apply a "crazy curve" to the grayscale image to lighten the color, but try to maintain shape in the body of the car. The dialog box in Figure 3-55 shows the settings for this project.

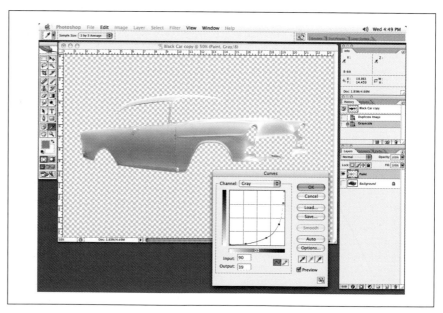

Figure 3-55. Create a grayscale image so the color is neutral

Now make a selection of the new white paint panels of the grayscale image. (A simple Command+click on the layer will do the trick.) Once the selection is made, copy the new white paint color and paste it into the original full color image, as shown in Figure 3-56. Remember to make the same selection on the full color image first so that the paint will paste in the same position.

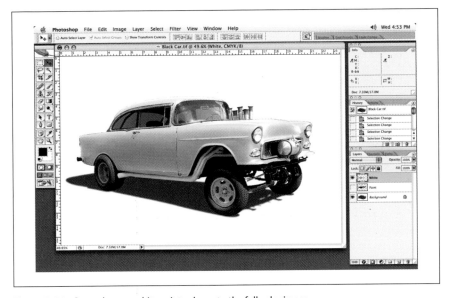

Figure 3-56. Paste the new white paint color onto the full color image

For added realism, add extra shape and shadow. First, create another layer and call it Shape, and set its attributes to multiply. You can use this layer to add additional shape and shadowing. Use the paint selection and, with a black-only color with a low opacity (20% airbrush), brush around areas you feel need some shadowing (Figure 3-57). Use your original un-retouched image for a guide as to where the shadows should be. Depending on the image, you may be able to use a slight curve adjustment to enhance the white car paint you pasted on from the grayscale image and work some detail into it. It isn't always that feasible, though.

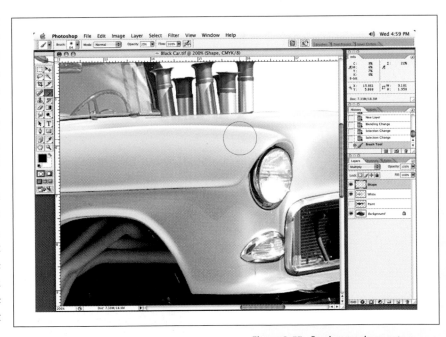

Figure 3-57. Brush extra shape onto a multiplied shape layer

Figure 3-58 shows how my Shape layer looks when I have completed my shadow and shape brushing.

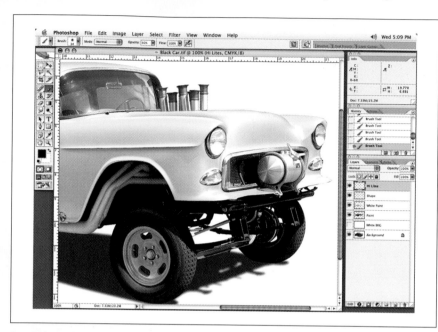

Figure 3-58. The final look of the now-white car

Changing a white object to black

Let's now take a white car and make it black. You really have to use your imagination when making these drastic corrections. Making a white car black when there is so little information available is a challenge. Just as in the previous example, let's start by making a mask or selection of all the colored areas we wish to change and saving that selection. Our new image with the white parts selected is shown in Figure 3-59.

When changing a white car to a darker color, it isn't necessary to mask the individual elements of the car, hood, doors, etc., because the door gaps, jams, and join lines will be enhanced when the correction is made. (Unlike when changing a black car to white, where they would have become lost with the correction to white and become far too light.) Use the Channel Mixer to create information on the black channel, as shown in Figure 3-60.

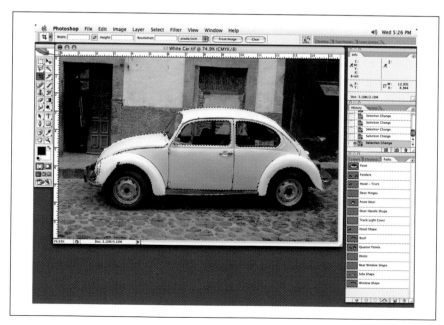

Figure 3-59. Select the white parts of the car to be turned black

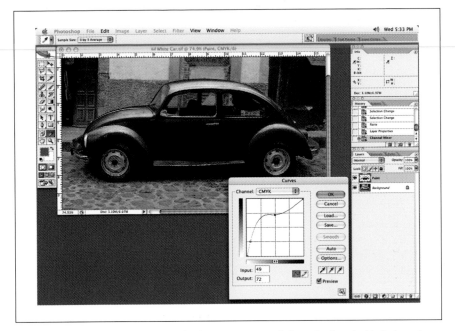

Figure 3-60. Use the Channel Mixer dialog box setup to create information into the black channel

As before, we'll copy the selection of the white body of the car and paste it to a new layer. Now apply a crazy curves designed for the white-to-black conversion. Figure 3-61 shows what the curve looks like.

— **N O T E** —

When I refer to a curve as a crazy curve, it's just my way for describing a curve that may have many points to it that are moved in such a way that the curve looks no longer looks like a curve, but a crazy-looking squiggly line that really can't be called a curve anymore. A rather unorthodox looking curve.

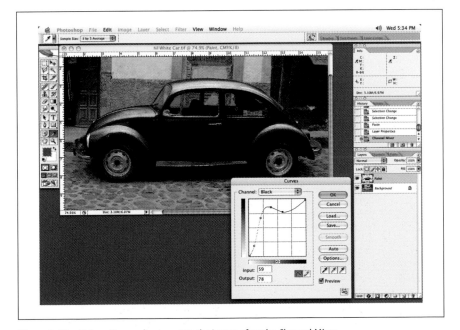

Figure 3-61. Make a Curve adjustment to the image after the Channel Mixer

The car is getting there, but it is a little green looking, so I'll make an addition change with the Channel Mixer to swing the color to a neutral black. Figure 3-62 shows our white car now black. Take a very close look at the final change, and make sure you haven't missed any spots on the car. With a drastic color change like this to an object, it is critical that you don't miss any spots, as they will show up clearly because the color is so different.

Figure 3-62. Neutralize the black color of the car with a Channel Mixer adjustment

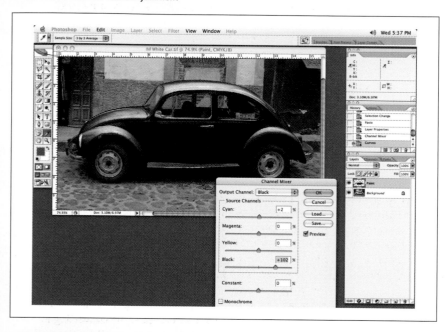

To finish, set a highlight layer (set to Normal) to create highlights on the car as you did to the white car. Figure 3-63 shows our white car is now black.

Turning an object from white to black or vice versa is an extreme case, and typically a correction will fall somewhere in between these two colors. These same techniques can be applied to any color you wish to use. If you wish to change the color of the object to, say, a red or blue, take or create a black car, if it isn't black already, and use the Channel Mixer tool to make up any other color you wish to make the object. Just be sure and watch to make sure that you do not add too much color to the highlights and the various shapes in the object to the point that they fill in. The idea is to keep as much of the original shape and texture as the original, and to make the object look as though it has not been retouched at all.

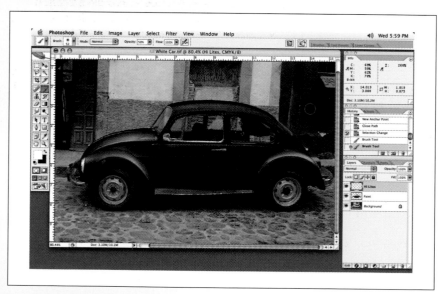

Figure 3-63. The car is now complete

A Note About RGB

I can appreciate that some—or more than some—people work with an RGB workflow, and I think that in a close, tightly controlled environment this is entirely feasible, as ICC profiles can be implemented and everyone knows and understands what is going on. That's assuming everyone's computer monitor has been properly calibrated. Everyone has and uses the same correct ICC profiles and knows the proper procedure for the workflow. Every single film house I have worked in works primarily with CMYK files for a couple of reasons.

The first reason is that files come in from many different sources. Many, if not just about all, of the clients have no idea if the profile attached to a file is correct, should be left on, turned off, or discarded. Most clients don't even know what an ICC profile is. Clients will supply a whole range of images. The client may have converted the images incorrectly, or a profile may be attached to the file because "that's what we always use." There is a mass amount of confusion out there. I think that basically most people simply don't understand the conversion process between color modes, and don't understand the ramifications of what they do.

The use of images is basically for a few different print media applications. Magazines would be at the top of the food chain, as they are typically of the best quality. From the magazine image, various images are generated as needed: newspaper, billboard, or large format.

In any of these cases, it generally appears that the preferred method is to convert the image to CMYK. This is done so that the customer gets no false hopes as to how the final image will look on paper. Let's face it: an RGB file looks great on screen, and on some printer outputs like an Epson, the print looks down right gorgeous. The reality is that the CMYK color space is far smaller than RGB, and many colors are limited in the color range compared with RGB, as I am sure you know. It is preferred for the print medium that the images are proofed in CMYK and shown to a client in that way. I have personally had

problems when a photographer supplied the agency with an RGB image he made from his Epson, and the file came in to be retouched and properly proofed on a high-end device that simulates the look of the actual print medium or printing press only to have the client wonder what happened to the color that was on the photographers proof! Try and match the photographer's proof: it isn't going to happen. It's even tougher to explain why.

Files should be kept RGB if that is requested, or if they are to be printed on an RGB device. Some of the large format printers will print to backlit film-based material, and in a case like that, RGB makes sense. I know that the push has been on for an RGB workflow all controlled with ICC profiles, but I have yet to see it happen in the real world. Maybe you have another view on this; I'd be interested to know. I think there is an argument for either an RGB workflow or a CMYK one, but the reality is that anything put on paper or print will eventually be made up of typically four colors, CMYK, and in the professional film houses I have been in, the workflow has been CMYK. With photographers shooting digital, the images coming from their cameras are RGB, which is great, and by all means supply the images to me or a film house as RGB. However, I would leave the converting to CMYK to someone who really understands the process. If an image is not going to be displayed on an RGB device like a TV or a movie to keep all of the brilliant RGB color, and it is intended for a print medium, and one has done a very good job of converting the original file from RGB to CMYK (or at least as good as it is going to get), then what reason would you want to keep the file as RGB if the intended use is a print medium? This would mean that you would go back to the original RGB file every time to make a change to the file, only to have to reconvert each time to CMYK. In a large shop, this could be a problem, as Joe Blow may convert it differently than someone else another day. This is a reality in a large film house, studio, or agency. Again, if everyone knew what was going on, maybe this would be feasible.

Something from Nothing

4

One of the most difficult challenges of retouching is creating something that doesn't already exist. There may be a portion of an image that is missing and needs to be redrawn or made up. For example, sometimes a person's leg or finger is outside of the original shot and needs to be added in. It might be necessary to add or change a reflection to make an object look more appealing. The techniques described in this chapter will help you create something from nothing!

Creating Smoke or Steam

One common request I receive from clients is to add smoke or steam to an image. Sometimes the desired effect is wispy, floating steam to make a muffin look fresh from the oven; sometimes it's a strong, forceful stream to indicate an iron's wrinkle-fighting power. Knowing how to make steam is a handy tool.

Giving Your Coffee a Warm-up

Adding steam to a food item can immediately make it more appetizing. In this example, we'll add steam to a cold cup of coffee. By the end of this exercise, the coffee should appear hot!

Let's start with the cold, unappetizing cup of coffee in Figure 4-1. Once we add some steam, we'll be serving the much tastier looking cup shown in Figure 4-2!

Figure 4-1. Before: a cold cup of coffee

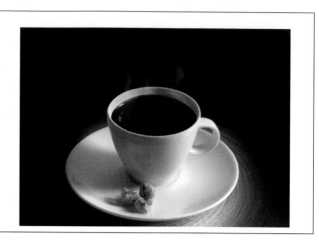

Figure 4-2. After: once we add steam, our java will again be suitable for drinking

First, you'll want to create a new layer. Next, select the Brush tool. Set the brush opacity to a low amount, such as 30 or 40, and set the foreground color to white. Now, brush S-shaped white vertical lines where the top surface of the coffee is, as I've done in Figure 4-3.

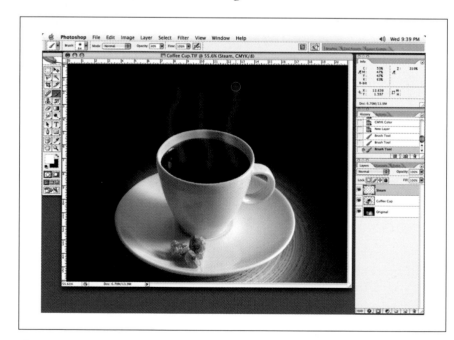

Figure 4-3. Brush S-shaped lines onto the layer

Once you have a few lines drawn in, select your Smudge tool and set the opacity to 50%. Shape and distort the lines with the Smudge tool, massaging the lines and pushing them around like putty until you get the look of wafting steam, as in Figure 4-4.

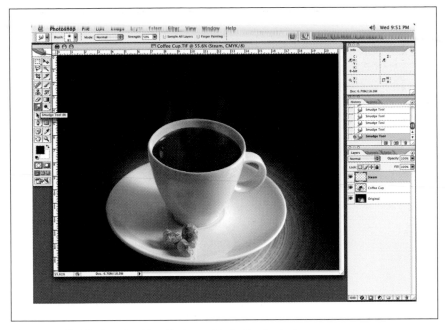

Figure 4-4. Modify the painted in white lines with the Smudge tool

Feel free to create more layers and additional lines of steam, reshaping them differently each time. You do not want any two lines to look the same. You may want to set the opacity levels of the various steam layers at different levels so that the steam will appear more natural and have more of a 3D effect. You can also distort or change the height and width of the various steam layers. Figure 4-5 shows the final effect.

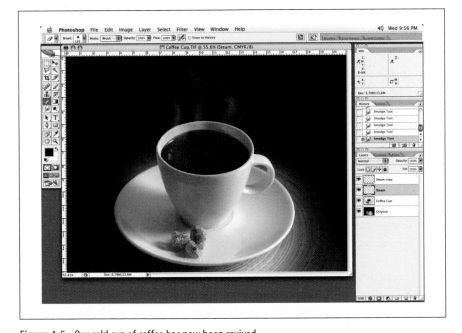

Figure 4-5. Our cold cup of coffee has now been revived

> **NOTE**
>
> *You could keep this steam image on file in case you ever need steam or smoke again for another image. Steam or smoke can easily be sized up to a variety of sizes. Smoke doesn't really show any scaling effects, especially if you throw it out of focus a small amount for larger sizes.*

NOTE

Other situations in which you should add motion to steam include car exhaust, airplane vapor trails, and when making someone or something appear as though it's moving quickly, creating a motion trail behind.

Directional Steam

Sometimes you, or your client, may want to make steam appear as though it is blasting out of something, like a steam kettle, for instance. To achieve this effect, we'll add some motion to a steam layer.

Figure 4-6 shows a picture of a kettle. We'll add steam in such a way that it appears to be shooting out of the kettle, as in Figure 4-7.

Once again, the first thing I would do is add a new layer to my file and set the attributes to normal; let's call this layer "Steam." Start by adding white lines to this steam layer coming from the kettle holes and project them in such a way that they are on the correct angle to the kettle, as in Figure 4-8.

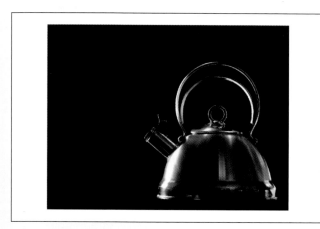

Figure 4-6. Before: kettle without steam

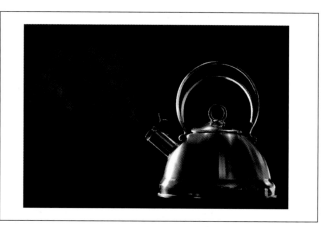

Figure 4-7. After: whistling away

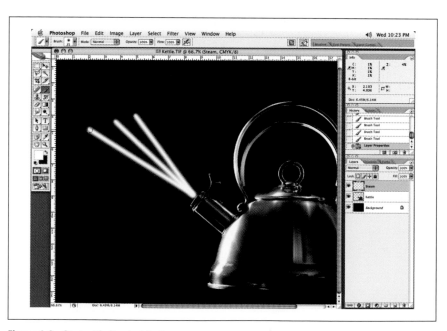

Figure 4-8. Start with direct white lines

NOTE

For the steam to appear natural, the angle of the steam must match the hole angle it's coming out of. For instance, if you were adding steam to a picture of a steam iron, each puff of steam coming from each of the little holes on the face of the iron may vary slightly in angle. You can change the angle of the steam by selecting the appropriate steam layer and transforming it with the Edit→ Transform tool. Remember, though, that when you select the Transform tool, there is a little pivot point that shows up in the middle of your Transform box. Be sure to move this pivot point with your cursor to the point on your steam (or any image, for that matter) that you wish to keep stationary, and any positioning change will pivot from where you have placed the pivot point. Repeat the positioning for each puff of steam.

The next step is to add some white puffs to the straight beams of steam to give the impression of the steam diffusing as it leaves the kettle. Add a new layer and brush in some white puffs. I'll use my Brush tool, set the foreground color to white, and set my brush opacity to about 20% and a maximum brush softness. The size of the brush will change as you brush in the steam, and you'll have to try a few different sizes so it won't be too perfect looking. The idea is to have it appear as though it is billowing out. So, add little blobs of white color in and around the white lines you just created, as in Figure 4-9.

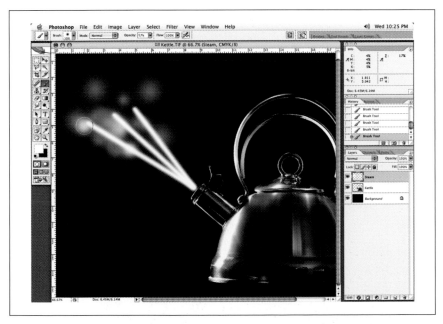

Figure 4-9. Add blobs to the ends of the streams

Reshape the steam puffs with the Smudge tool, like we did with our coffee steam, so that they look like the puffs are diffusing as they dissipate from the kettle, as shown in Figure 4-10. Remember, the farther the steam travels from the source of projection, it loses its velocity and diffuses into puffs or cloud-like formations.

Now use the Erase tool to selectively erase portions of the steam, to create some transparency, as shown in Figure 4-11. I typically set the Erase tool to a low opacity of about 20%. I find this a good starting point for erasing portions of my steam very gradually without any hard edges developing.

If the steam looks too thick, change the layer opacity to make it appear more natural, as in Figure 4-12.

Then, duplicate the steam layer to give some fullness to the steam. Doing this also allows you to change the two steam layers so that they are different than one another, giving a more three-dimensional appearance to the diffused steam, as you can see in Figure 4-13.

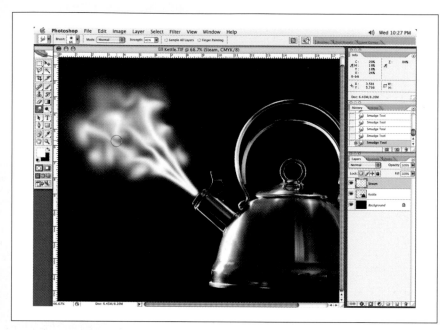

Figure 4-10. Use the Smudge tool to reshape the steam puffs

─ N O T E ─

Have some fun when creating steam or smoke. Use the Smudge tool and the Erase tool to selectively go through the steam and massage it into shape.

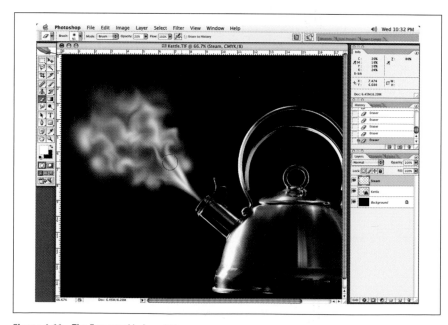

Figure 4-11. The Erase tool helps add transparency

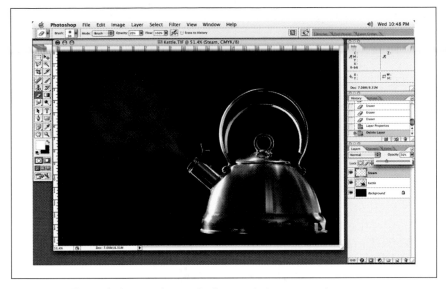

Figure 4-12. Change the layer opacity to make the steam look more natural

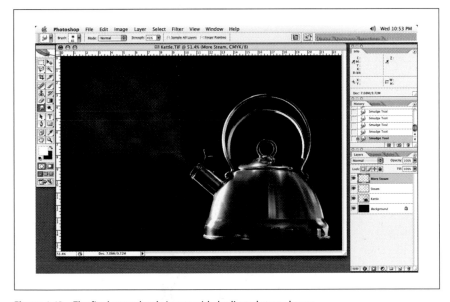

Figure 4-13. The final steam kettle image with duplicated steam layers

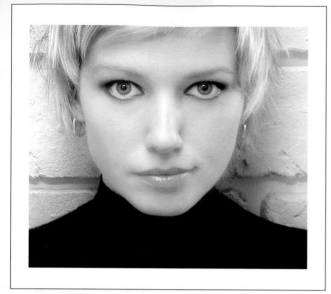

Figure 4-14. Before: Serious model face

Creating a Smile

While using the Liquify tool may be kind of fun for turning people you don't particularly like into aliens with big bulging eyes, I find that it has very practical uses as well. If used sparingly, it can be applied to realistically alter a subject's facial expression. In our example, let's change the demeanor of the model in Figure 4-14 to put a slight smile on her face.

Here, we'll use the Liquify tool to improve her mood. Choose Filter→Liquify. In the Tool options, choose a large brush (a small brush will make it difficult to keep the lines smooth and fluid). Too small a brush will cause small ripples in your change.

Use the Forward Warp tool in the upper-left corner to turn up the corners of her mouth. Do not just pull on the edges of areas where the lines are, as this will cause the area you are distorting to become blurry. Try starting the distortion a little farther away from the actual area, working out toward the edges. If you use the Liquify command in this way you will not stretch the image as much and it won't appear distorted (Figure 4-15).

Remember that when changing the shape of any portion of the image, think of the other effects this may have on the rest of the image. Smiling changes

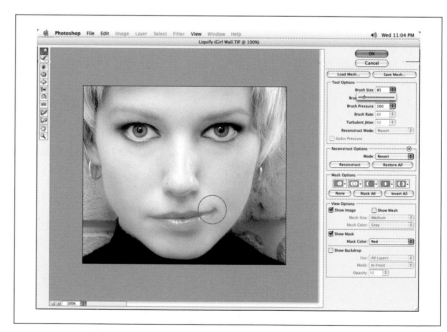

Figure 4-15. Use the Liquify brush to manipulate the shape of the mouth

the shape of your cheeks, eyes, and so on. Make subtle adjustments to these areas with the Liquify tool as well, as shown in the final image, Figure 4-16. Don't be afraid to use your imagination.

Figure 4-16. Changing the shape of the mouth also means imagining what smiling will do to eyes, cheeks, etc.

Creating Motion from Stillness

On occasion I am asked to take a static object and add motion to it so that it appears to be moving. You can add motion to objects in a couple of different ways. For instance, you might be asked to make a lateral motion, like when a car or person goes racing by. Motion could be added to make an object to appear as though it were spinning. Motion could also be added to make an object appear as though it is coming toward or traveling away from us. So how do we create motion where there was none?

Adding Motion to a Car with Motion Blur

Adding motion to cars is a typical request. This is often done because the client or manufacturer does not want to put excess mileage on to the vehicle or run the risk of damaging a new car. In this example, we'll take the car out of its stationary background and add motion to the background and the wheels. Figure 4-17 shows our sample vehicle standing perfectly still.

First, create a selection with the Pen tool. Make sure the selection is accurate by following the object exactly and by using as few points possible on your mask to keep it smooth and fluid. Depending on the how the

Figure 4-17. A stationary vehicle

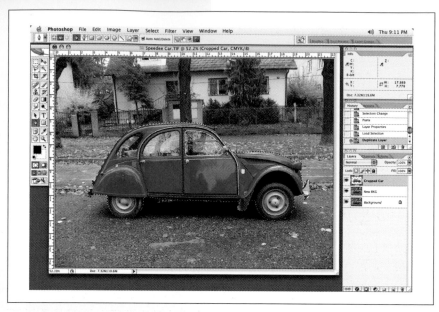

Figure 4-18. Our car is cropped out and pasted on to a new layer and a background layer with much of the car cropped out

rest of the image looks, I'll occasionally add a small degree of softness to the selection by choosing Select Feather prior to isolating the vehicle. Once a selection of your object has been made, go to Layer New Layer via Copy to paste the selection on a new layer. Then give the new layer a descriptive name.

Once the vehicle is cropped and pasted on to a new layer, use the Clone brush to remove the vehicle or a good portion of it out from the original background. You don't have to get too fancy retouching the background, as you are going to blur it anyway, which will hide any brushing you may do. (Unless, of course, you're only going to blur the background to a small degree; then brushing the car out of the background may be a little more critical.)

You should be left with a cropped vehicle on a layer and an image that is the background with much of the car retouched out, particularly around the edges, as shown in Figure 4-18.

Next, clone a portion of the car out of the background, because as you add motion blur to the background, the original car will blur as well and extend well outside of the original static car, if you clone some of it out. If I drop the cropped image of the car back onto a blurred background, the original car, if not airbrushed out, will be poking out around the edges because of the blur. The amount of

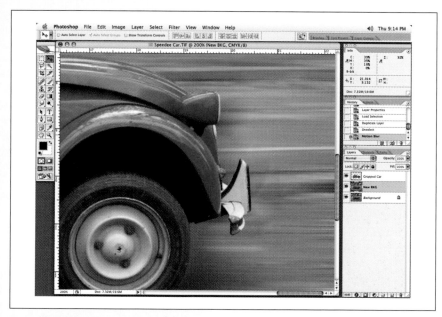

Figure 4-19. Ghosting can occur if the car is not properly selected

image that has to be cloned out depends on how much blur is added. (The faster you want your car to go, the more blur should be added.) If the original car is not retouched out around the edges, when motion is added, ghosting will occur and bring the background car image through, an effect you can see in Figure 4-19. A car speeding forward would not have motion lines coming from the front of the car, unless it was rocking back and forth!

Once the car has been cloned a sufficient amount, you can create the motion blur. Start by selecting Filters→Blur→Motion Blur. Choose the angle of your blur carefully—it is important. The blur angle should match the angle of your object to appear natural. You do not want a blur that shoots off into space when the object is going from left to right, as in Figure 4-20!

To avoid shooting your car off into space, set the motion blur angle to the same angle as the direction in which the car is traveling. You can judge this by setting the blur to match the two points between where the wheels of the car touch the ground. Figure 4-21 shows how the image appears after applying motion blur at the correct angle.

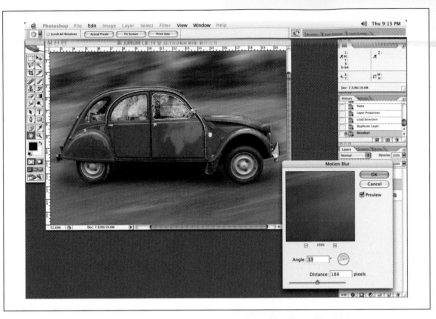

Figure 4-20. Make sure the angle is set correctly so your car doesn't shoot off into space

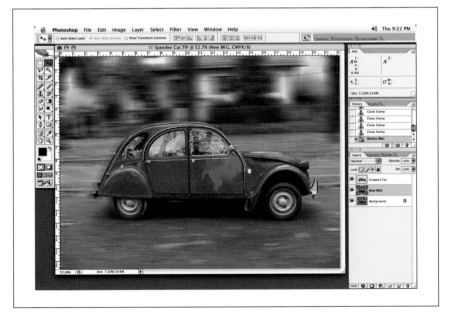

Figure 4-21. Use the wheels of the car to set correct motion blur angle for background

The amount of blur you choose is important, too. Some experimentation will be necessary. The faster you want your object to appear, the more blur you will want to add. Notice how much faster the car appears to be moving in Figure 4-22 than in Figure 4-23. Keep it real, though. Don't add a blur that makes the object appear as though it is traveling at 500 miles per hour when it is actually a person strolling down the street!

Figure 4-22. More blur increases the perception of speed

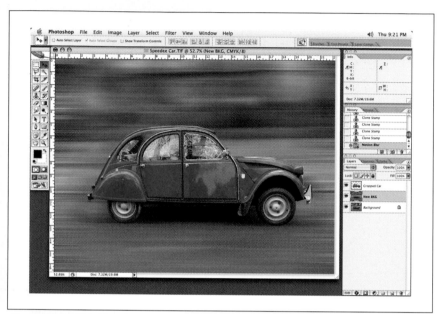

If you have an image with a reasonable amount of foreground and background, you can apply motion blur in two steps or use a vignetted mask. To do the blur in two steps, first add a motion blur you think would be suitable for the background of the image or the portion behind the main object. Then apply this blur to the overall image. Next, add more blur so that the foreground or the part of the image in front of the main object is blurred more than the background behind the main object. To put it in perspective, as a kid, did you ever hang your head out of your parents car window as it traveled down the highway to watch the speeding guardrail whiz by only to look up and see the horizon speed by much more slowly? OK, maybe it was just me, but hopefully you get the idea. What you are trying to create here is a fast moving foreground and a slower moving background or horizon.

Because the foreground is visually closer, the amount of blur will be *more* in the foreground. Add *less* to the background of the image the farther away it is. To accomplish this, make a mask of the background. Either make a very soft mask so the transition is very subtle, or if there is a harder object that is in foreground, like a guard rail, where it is suitable for separating the background and foreground, make the mask a little more defined.

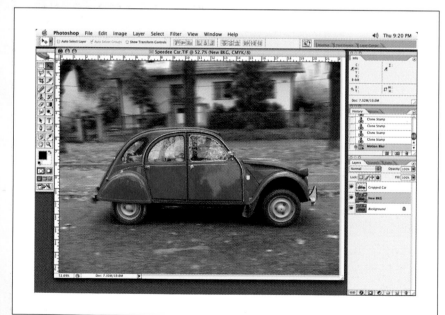

Figure 4-23. Less blur means a more leisurely pace

You can create this type of motion in a couple of ways. One way would be to apply one motion blur overall that is suitable for the background, apply a second blur that is more suited to the foreground, take a History snapshot of the blur, and then paint it into only the foreground of your image. The History brush will be discussed in greater detail later on in this book.

The second way to accomplish this dual blurred effect is to create a selection or mask of the foreground and, by inverting the foreground mask, you'll have a selection for the background, and vice versa. In this way, two different blurs can be added to the background for a much more realistic look.

A third way would be to use the Quick Mask mode (Figure 4-24), select the Vignette tool from the Tool palette, and create a vignette that goes from the top to the bottom of your image. Once out of Quick Mask mode, make a selection through which you can blur the image. If you have made the vignette mask correctly, wherein the bottom part of your vignette mask has more color in it, then the bottom of the image will be affected more by the blur correction.

Next, go back to Picture mode and apply a motion blur to the back through the mask. The result should look like Figure 4-25.

The selection is inverted, and a smaller blur is added to the foreground. The only problem with this image is that no one is driving! I'll guess I'll have to fix up the windows so no one can see through them!

Figure 4-24. Using the Quick Mask function to display the mask selection

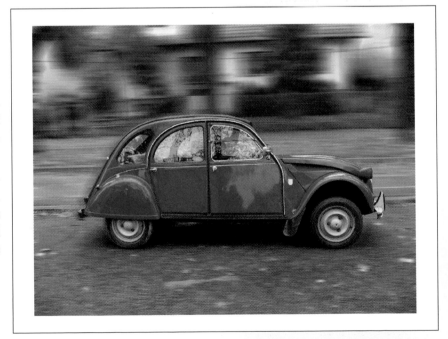

Figure 4-25. The effect of the motion blur applied to the background through the mask

NOTE

Don't forget about the information in the windows of a car! If the car is moving, the background in the windows should reflect that. Select the window(s) with any selection tool, and apply the same amount of blur to them as you did for the background blur.

Typically, the car is what is "caught" with the camera, so the details of the car are sharp, or much sharper than the rest of the image. To finish this image, add a motion blur to the reflections in the windows (see the note) and a radial blur to the wheels and tires, a technique we'll cover in the next section. Applying a motion blur in this fashion will make a blur more realistic.

Off to the Horizon with Radial and Zoom Blur

In this dramatic example, the red car sitting still in Figure 4-26 is going to be made to appear as though it is speeding past us and traveling to the road ahead (Figure 4-27).

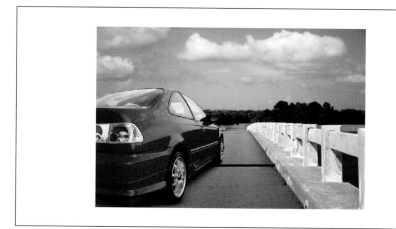

Figure 4-26. Before: the car appears to be standing still

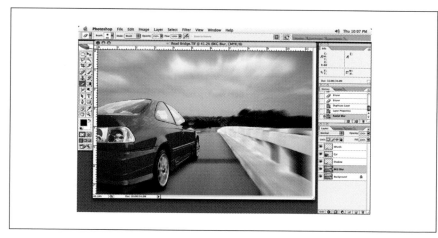

Figure 4-27. After: off into the horizon

We'll begin by putting the wheels in motion with Photoshop's Radial Blur tool. The radial blur is designed to be used with a straight-on, perfect circle. So if the wheels are a straight-on shot, all you'll have to do is mask them, copy them, and paste them onto a new layer, using Layer→New→Layer Via Copy. (Make sure you get the tires as well. I have seen many people spin the wheel or hubcap, but forget the actual tire!) If the wheels are on an angle, like they are in Figure 4-28, you'll have to make sure they are round before adding a radial bur.

To make the wheel and tire round, first make a selection of the two wheels and put them on a separate layer, as shown in Figure 4-28.

Next, select one of the wheels. Choose Edit→Transform→ Scale and scale the wheel on the horizontal plane until you have what you feel is a round-looking wheel. No need to measure it or use a compass on screen! Just make sure that it looks pretty round to you, like the one shown in Figure 4-29. Initially, it will look rather odd, of course, but not to worry—you will distort the wheel back to its original shape once you are done. Do one wheel at a time and repeat this process for each wheel.

An 18-wheel truck would take you quite a while!

Figure 4-28. Tire and wheel selected out from the car and put on their own layer

Figure 4-29. Transformed wheel being turned into a round shape

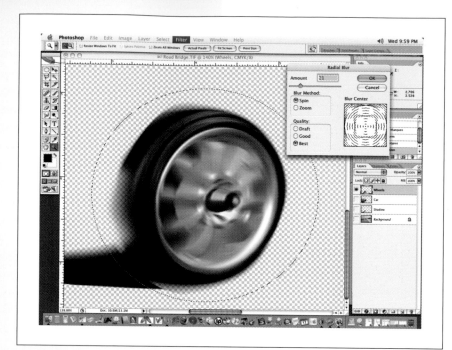

Figure 4-30. Apply the radial blur to your transformed wheel

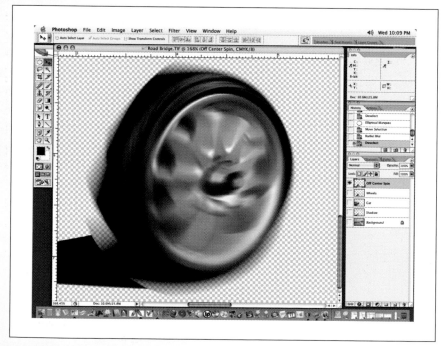

Figure 4-31. If the radial spin center is off, the image doesn't look right

Once you've applied the Transform tool, repeat the transform process for the other wheel. Then make a circular selection around the wheel and apply a radial blur (Filter→Blur→ Radial Blur) to the wheel, as shown in Figure 4-30.

Notice that the center of your wheel should match the center of the spin in the dialog box. You may have to try a couple of times to get the spin just right. If the spin is off center, the wheel spin will look off center, as it does in Figure 4-31.

Choose Spin and Best for your dialog options. You'll have to experiment with the amount of blur or spin to use. It may take a couple of goes before you see the amount of spin that you like. Obviously, the faster the object is traveling, the more spin you will want to choose.

Using the Transform tool Scale mode, bring the wheels back to their original shape on the horizontal plane only, just as you did to originally distort them. Basically, you are just trying to do the opposite of what you had done in the first place to distort the wheels to a round shape, only this time we are changing them back to the way they were originally. Typically, to bring the wheels back into the correct shape, I would set the opacity of the wheel layer to about 50% so that I can see the old wheel through my new spinning one, as in Figure 4-32. Then use the Transform tool in the Scale mode on the horizontal plane to adjust the shape of the wheel back to its original shape. Once done, I set the layer opacity back to 100%. This works for any wheel, regardless of the angle it was shot on.

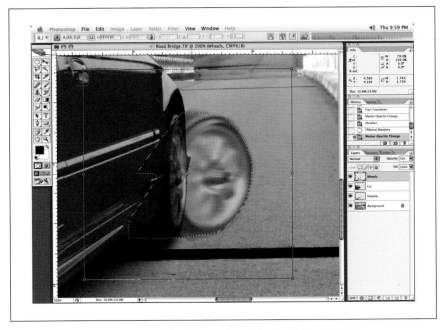

Figure 4-32. The wheels are now ready to be transformed back to their original shape

The radial blur may cause some of the original wheel to overhang onto the body of the car. You will want to erase any of the wheel that may overhang onto the body of the car. Repeat this process for the second wheel. Typically, you can use the selection that you used to crop out the wheels from the original car as your guide to erasing the excess blur overhang of the wheels. The wheels are now complete; you can see the results of this phase in Figure 4-33.

Time to add some motion to the background of the image. Let's call up the zoom blur option (Filter→Blur→Radial Blur→Zoom) to give the impression that we are speeding into the horizon. Adjust the center of the zoom blur to match the vanishing point of the horizon.

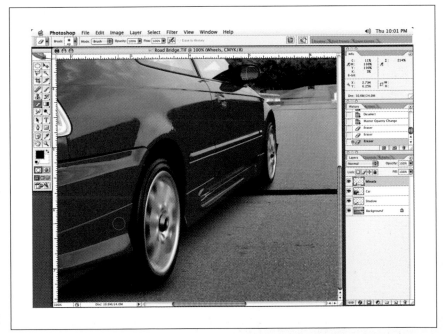

Figure 4-33. Final result of the wheels having been spun

Now that we've got the wheels turning, let's add some motion to the background. A zoom blur option (Figure 4-34) is suitable when we are trying to make an object appear as though it is traveling away from or toward us. This differs from a motion blur, in that a motion blur is for objects traveling horizontally or vertically.

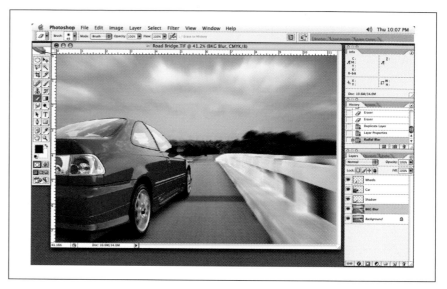

Figure 4-34. Adding zoom blur to the background gives the sense of movement off into the horizon

Select the background using one of the techniques described in the previous section. Within the Radial Blur dialog box, Choose Zoom as your Blur method. Again, make sure that the center or vanishing point, the point or the center where the object is disappearing into or heading toward, matches the center point in the Blur dialog box, as indicated in the Blur Center. Of course the amount of the blur will have to be experimented with. The more blur, the faster the object appears to be traveling.

So there you have it. Our car is on its way to wherever it's going. We've applied motion blur to the background. We've added motion to the wheels. Further motion could be added to the outside edge of the back of the car as if its paint isn't able to keep up with the rest of the vehicle! Adding a range of motion will be discussed in the following section.

Swinging a Hammer

Sometimes clients want to give the impression that an image is moving, but show motion in such a way that it is stepped. The steps may show how many actions are required to use a tool, for instance. In the following example, I'll use the hammer shown in Figure 4-35 and show it moved through a range of motion.

First, isolate the item to which you wish to add motion; in this case, select the hammer so that it is a separate element. Once you have it isolated, paste the hammer on to a new layer, and duplicate this layer depending on how many steps you would like to have. In this case, there will be three steps, so I'll make three duplicate layers.

Next, use the Transform tool to rotate each of the hammers. Make sure that you set the pivot point of the rotation to the correct pivot point of the image. The pivot point is the little crosshair that appears in the center of your image when you select the Transform tool. In this case, the center of the hand or wrist position will be the pivot point from which the hammer rotated. Click on the little pivot point crosshair and move it to the hand position, as shown in Figure 4-36.

Figure 4-35. We'll use this hammer to show a range of motions

Figure 4-36. We will want all hammers to pivot from the same pivot point so they all appear to be the same hammer

Figure 4-37. Space out the duplicates to show the range of motion

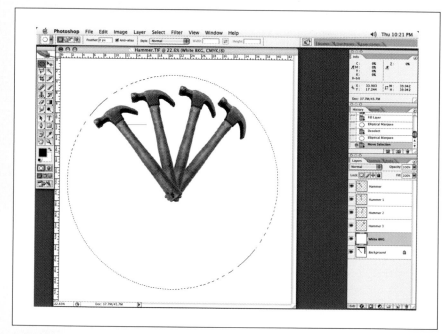

Figure 4-38. Increase your canvas size so that you can create a full circle with the Transform tool

Once the pivot point is established, space out the duplicate images to show a range of motion, as in Figure 4-37.

Next, we will go to each duplicate layer and add motion. Since the hammer is swinging in a circular motion, we'll use a radial blur. Make a large circular selection, trying to make your pivot point the center of your circular selection, as in Figure 4-38. You may need to adjust the canvas size. Just as our wheel images in the earlier example required an accurate center point, the same is true for these hammer images. You want the center of your spin to originate from the pivot point.

Call up the Radial Blur dialog box and apply a blur. You may have to try different settings based on the size of the image and the amount of motion you are looking for. Start with a blur amount of 10 or 20, and work your way on from there. Choose Spin as your blur type and the quality of Good. (You may want to choose draft mode if you are experimenting with a very large image to save some processing time. Then, when you see a setting you like, redo the blur in the Good or Best mode.)

Keep in mind that you will have to repeat the blur for each hammer layer; in this case, you'll have to apply the radial blur to three of the hammers. The hammer to the far left is our final stopped hammer, so a blur isn't required for it. Quite honestly, I usually use the good mode as it is a spin and blurry, and that in itself hides any imperfections and saves you some time over using the

best mode. Ultimately, the amount of the blur effect is determined by the size and resolution of the image. A blur amount of 20 on a postcard-sized image may be too much, but on a movie poster, it may not even be all that noticeable.

Once you are happy with the motion and it has been applied, take a History snapshot of the motion you have applied, and then undo the change so that you are back to the original state of the image. Using the History brush, select the appropriate snapshot, and then brush the motion effect to the one side of the hammer in motion. Since the hammer is swinging to the left from the right, add your motion to the right of the hammer. Motion is always added to the opposite side of the direction the object is traveling to. By adding motion to just one side of the object, as in Figure 4-39, it will appear as though the hammer is traveling in one direction.

> **NOTE**
>
> *You wouldn't add motion to the front of an object, as it hasn't "been there yet." If you did add motion to the front of an image as well, it would appear to be rocking back and forth.*

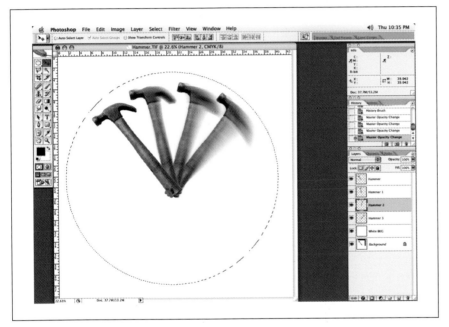

Figure 4-39. Add progressively less blur as the hammer gets closer to the first hammer on the far left to give the impression the hammer is coming to a stop or striking something like a nail

Repeat this process for all duplicate images. Once that is complete, change the opacity of each duplicate layer. You may want to start off with 25% opacity for the first image, the one farthest from the main image of the hammer, and work your way through the layers progressively. The next layer could be 50%, then 75%, and finally the main image at 100%. Of course, these layer opacity values are only a starting point, and some experimentation may be in order. The purpose of the varying opacity percentages is to give the impression that the object is traveling in a set motion range. The lightest layer that is farthest away from the actual hammer is fading away as the hammer travels through its range of motion. You can see the final effect in Figure 4-40.

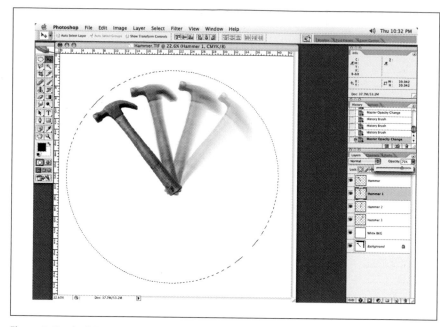

Figure 4-40. Applying incremental levels of opacity helps achieve the final effect of our swinging hammer

Extending Backgrounds

Often images are short on background. Many times, a client will send in an ad with the image placed off to one side so that one portion of the image does not fill the full crop of the ad. I think they do this because they can! Needless to say, it will often be necessary to rework the supplied image to fill the needs of the client's ad. Or, on occasion, the image may fill the ad, but an extra image may be needed to satisfy the printer's needs in the form of *bleed*. In this section, we'll discuss ways to create "more" background.

Extending the Sky: a Simple Background Extension

One of the easiest ways to extend a background is to simply make a selection of as much of the background as possible, and then use the Transform function to stretch out the background until the desired crop is met. Let's say we started with the image Figure 4-41.

Next, add to the canvas size on top so we have room to extend the background, as in Figure 4-42.

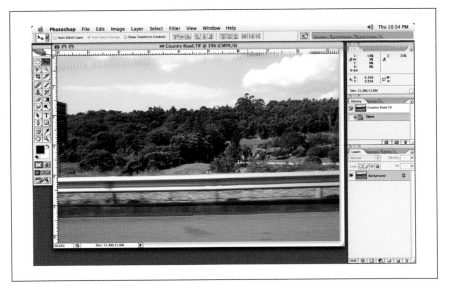

Figure 4-41. Our original country road

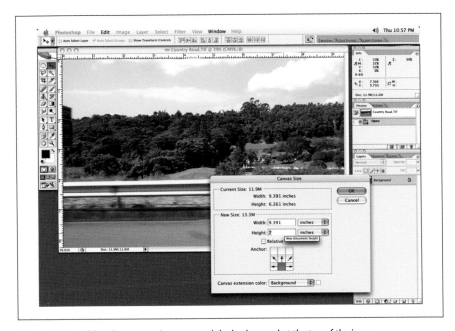

Figure 4-42. Add to the canvas size to extend the background at the top of the image

Then we'll select the sky, as shown in Figure 4-43, and using the Transform tool, extend it to fill the area we've created.

The final look of the image with the background extended can be seen in Figure 4-44.

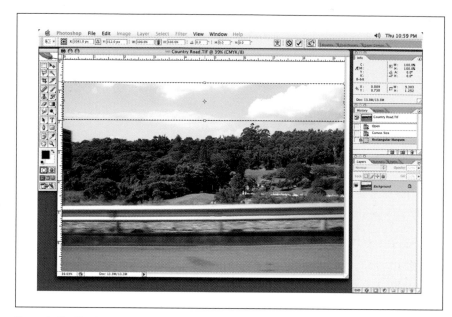

Figure 4-43. The sky is stretched to fill the needed white area

Figure 4-44. The background is easily extended

Slightly More Complicated: Extending a Row of Bricks

Previous example? Simple. But this is assuming, of course, that the background lends itself well to this kind of stretching. If you have a cobblestone road or a row of bricks, then it will look quite odd if you simply stretched the background. One way to extend difficult backgrounds is to do it the old-fashioned way and clone the background, but in the case of our next example, a row of bricks, the perspective makes it very difficult to simply clone.

Let's say we have the image in Figure 4-45 and we want to extend the row of bricks to fill the white space indicated.

The first step is to adjust the bricks so they look like a nice, straight row of bricks. Select the bricks and use the Distort function of the Transform tool to adjust the bricks until they are straight, as in Figure 4-46. You may want to put in some guidelines to help you make sure they are straight.

Figure 4-45. The area indicated by the white space needs to be filled with bricks

Figure 4-46. Select the Transform tool to change the perspective

Then, start cloning the bricks to fill the area, as shown in Figure 4-47.

Figure 4-47. Clone the bricks to fill the area

When you are done cloning, distort the bricks back to the original shape, as shown in Figure 4-48.

Figure 4-48. Distort the bricks back to the original shape

The idea is to continue the flow of the lines as they had started in the original image. You can draw guidelines on a layer if you find that will help you, but I align the perspective visually. As the road gets closer to you, the bricks or stones become larger, and as they get farther away, they appear smaller. You can see the final result in Figure 4-49.

Using Vanishing Point to Extend Background

Photoshop CS2 gives you another option to consider when trying to extend an image with a problematic background, the Vanishing Point filter. The Vanishing Point filter basically allows you to set up a grid on an image that matches the perspective of the image. As you brush or copy part of the image in an attempt to fill the image area, the perspective of your efforts are magically maintained as they follow the perspective of your grid.

Figure 4-50 shows our brick image again. The image has had the necessary image area increased with the canvas size to fill the needs of the crop. The white space represents the amount of area we need to fill up with image.

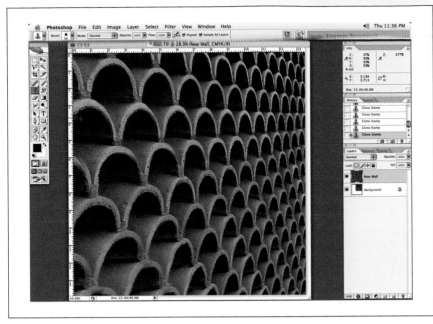

Figure 4-49. Bricks distorted back to their original shape

NOTE

The Vanishing Point filter can be used only on an image in RGB mode. If your image is not in RGB mode, you will have to convert it at this point to call up the Vanishing Point filter. You may also want to use a duplicate of the image or create a duplicate layer of your image in case things don't work out the way you have planned!

Figure 4-50. Our brick wall with extended canvas

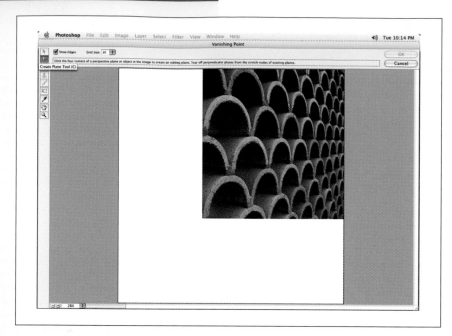

Figure 4-51. Vanishing Point filter window

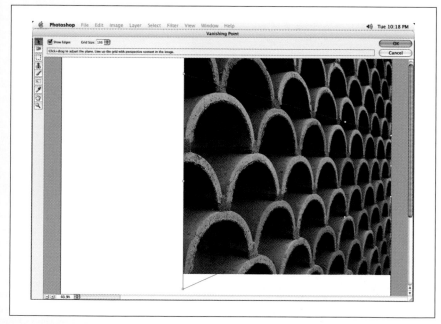

Figure 4-52. Draw grid to match perspective of existing brick

Once you have your RGB image with appropriate canvas size set, access the Vanishing Point filter, Filter→ Vanishing Point. You are now presented with the Vanishing Point filter window, as shown in Figure 4-51.

Select the Create Plane tool button, the second button from top left tool set. The first thing we have to do is create a grid over our image that matches the existing perspective of the bricks in our image. Obviously, the bricks are smaller to the right of our image and, as they get closer to us, they become larger. The grid button is the second button from the top of the tool set on the left side of the interface, as indicated in Figure 4-52.

You get four points to draw with. Click on the image, and a new point is made for a total of four points. You can manipulate these points once your grid has been drawn with the Arrow tool button at the top of the tool set and move the points in such a way that they match the perspective of the image. This is a very important step to get the grid matching the perspective as accurately as possible. If the grid is off, you have less chance of getting an accurate look to your image, so spend some time getting it right. It won't be necessary to make the grid the full size of your image yet, as you will resize it later. You make the grid smaller than the full image so that you can make sure all four points are visible as points of reference on the image.

Once your grid has been made, you will want to resize the grid so it covers the entire image. The resizing of the grid is done by using the Arrow tool, grabbing the midway points on the grid lines, and clicking and dragging them to the desired size. As you can see in Figure 4-53, don't grab the corner points, as you will change the shape of the grid! Figure 4-54 shows the grid adequately resized.

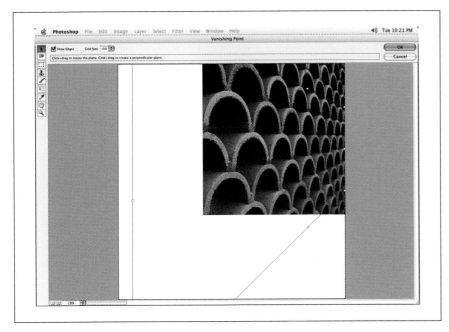

Figure 4-53. Using corner nodes will undesirably distort the grid you made

Figure 4-54. The final look of our grid once it has been completed and resized to fill out the image

There are a couple of ways to extend the image. The first way is to use the Stamp tool. The second way is to use a selection and duplicate large chunks of the image to fill the needs of the image. We'll start with the Stamp tool (Figure 4-55).

Figure 4-55. Select the Stamp tool

Take note of the green Xs that indicate the alignment in Figure 4-56. This is very important, as you will clone and repeat the wrong portion of the image if the alignment is off.

Figure 4-56. Carefully align the two brush points on the same perspective as the brick

Once your alignment is set and you have selected your brush size, opacity, and hardness as you would for any other brushing you would do in Photoshop, you can begin brushing. Kinda cool, eh? As you can see in Figure 4-57, as you brush, the perspective of the Stamp tool changes to match the perspective of the image!

Figure 4-57. Brush in the image with the stamp tool while Vanishing Point keeps your perspective

Figure 4-58 shows the final brushed image extended with the Stamp tool.

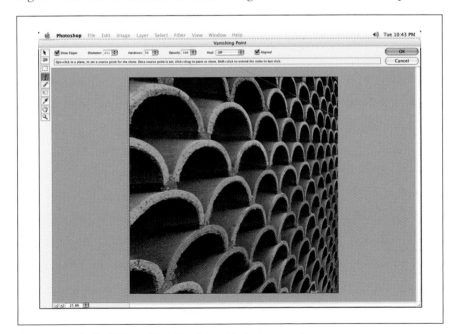

Figure 4-58. The final effect of Vanishing Point with the Stamp tool

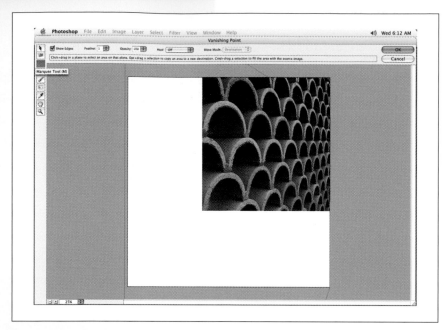

Figure 4-59. Select the Marquee tool and grab a section of brick image

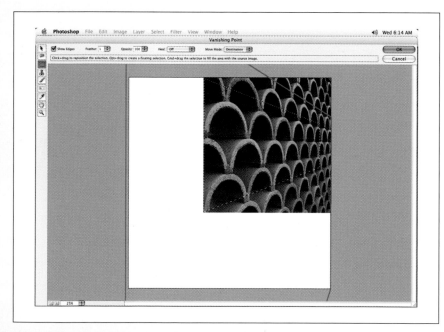

Figure 4-60. Hold the Option key and drag the selection to extend the bricks

The other method for extending an image is to use the Marquee tool. Once you have your grid, start by making a Marquee selection containing the largest possible image area (Figure 4-59). (You don't want to grab the white area, as it will be included only when you paste in this new selection section.) The Marquee tool will follow the perspective based on the grid you made.

While holding down the Option key, drag the selection area to an area of the image that needs extension (Figure 4-60). Placement is important. Notice how the selection changes quite dramatically as you move it around. As soon as you let go of a point, the adjustment takes effect. You do have an undo (Command+Z) if you have to undo your adjustment.

If necessary, use the Transform tool to fine tune the placement of the selection. (The Transform tool is the sixth button down on the Vanishing Point tool set.) Nodes will appear on the selection, and you can make adjustments from these points. Again, as soon as you let go of a point, the adjustment will take effect. Not bad, but you can see in Figure 4-61 that the black lines inside the bricks are a little off the correct perspective.

I have found that adding selections can be difficult, especially in the case of the bottom portion of this image. If you go back in and make a Marquee selection of an area and try to fill another area of the image, you may run into difficulty. I won't lie to you and say it works like magic; there is a lot of fiddling around to do. You may want to visit each method I have discussed for extending a difficult image like this and see which one work best for you.

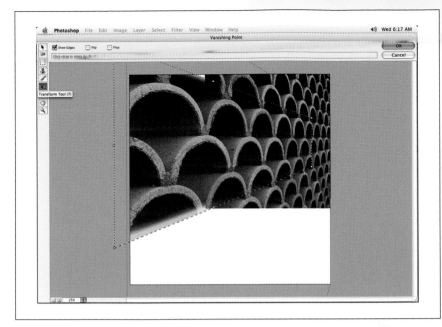

Figure 4-61. The black lines inside the bricks are slightly off perspective

Thoughts on Vanishing Point

Vanishing Point is cool, but here are some reservations I have and tips for its most effective usage.

- The effect is not always perfect. There can be a lot of fine-tuning and fiddling to get the image to look right.

- I have found that the Vanishing Point tool can be a little slow, especially if you are not on the fastest computer around; seems a little unfair, eh?

- When using the Stamp tool, it appears to be blotchy in the way it laid down the color. I find single clicks work best.

- Some alignment problems occur if you have to change your brush alignment like I had to do to fill a corner.

- The image must be RGB. This may or may not be a big deal for you.

- When using the Vanishing Point tool, I found that some of the perspective was off, in spite of the fact that some areas looked bang on.

- Adding areas to an image once you deviate or start a new selection from the original Stamp selection or Marquee selection makes it difficult to get the right alignment.

- Using the Marquee tool to add to the image area is a faster way to add image than the Stamp tool.

Try different methods, and keep an open mind as to what serves you best. I suspect that the Vanishing Point tool is best suited to objects where alignment with other elements in the image is not critical. For instance, if you were to place an image on the side of a building or vinyl siding on a building, I could see it working well. Again, there are many ways to do the same thing when retouching, and you have to decide what is best for you.

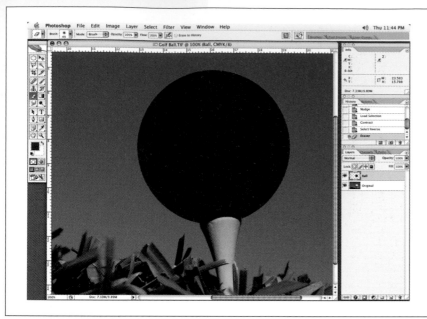

Figure 4-62. Before: adding a basic circle of color in Photoshop

Shining Things Up

Another request I often get is to create highlights and add shape to an object. There can be many reasons for this. The client loves the shot, but it requires some fixing up to make it more dramatic. There may be wine glasses that require a sparkly sheen to them or a piece of metal or paint requires a shiny look. Care must be taken though, as there are different types of sheen to objects. A very shiny, smooth surface will have a hard, bright shine to it, but an object with a flat, dull finish, like a brushed metal surface, should have a flatter sheen to it.

Let's take a round circle of color, as in Figure 4-62 (I just created the circle part of the image in Photoshop by filling a circle selection with color).

Once you have the object identified, create a new layer in your file, call it Highlights, and set the layer to normal (default). Create another new layer, set the attributes to multiply and call it Shadows. There are a couple of different highlights and shadows we could draw on this ball to achieve two completely different looks. One could be flat looking, as if the ball were sprayed with a flat paint. Another look could be that of a very shiny ball where the highlights and shadows appear very hard with little diffusion. In Figure 4-63, I've created a ball with a flat look to it, and in Figure 4-64, I've created a very shiny ball. Let's go through the steps to see how each was made.

Figure 4-63. After: the flat spray paint technique

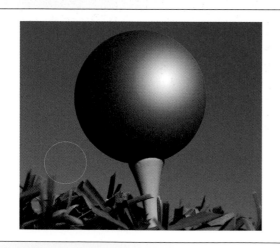

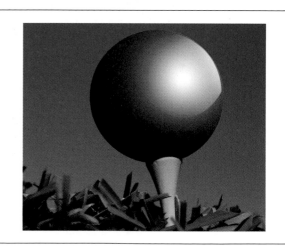

Figure 4-64. After: the high-gloss technique

Creating a Flat Finish

If we want the ball to look like it's been painted with a flat purple spray paint, we'd use soft highlights without any hard edges to them. Using the Paintbrush tool with a very soft hardness setting, like 0%, again set to a very low opacity of 20%, spray on highlights in an area you think would need them, as Figure 4-65. Where you brush in highlights will be based on where the light is coming from. Let's assume the light is coming from the right side of this page, then the highlights on the ball will land on the right side of the ball. Imagining that this is the only light source, the shadows will fall to the left of the ball. I've added a shadow on the left side, and the result is Figure 4-66.

Creating a Very Shiny Finish

Now let's see if we can shine our object up a bit. Using the Pen tool, draw in a shape in an area that I think will need highlights based on where I think the light is coming from. I'll usually make the bottom portion of the highlight shape larger than I need to because I like to go wide on the bottoms of the highlights, as it is typical for a highlight to fall off softly without a hard edge. I can also go back in with the Erase brush, if I have to, and adjust the extra highlight. When I finish making my shapes with the Pen tool, I have shapes that look like Figure 4-67.

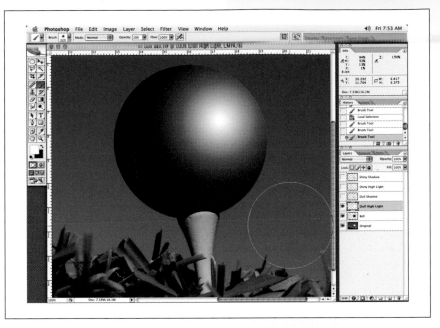

Figure 4-65. A selection of the ball is made and a white highlight is brushed in

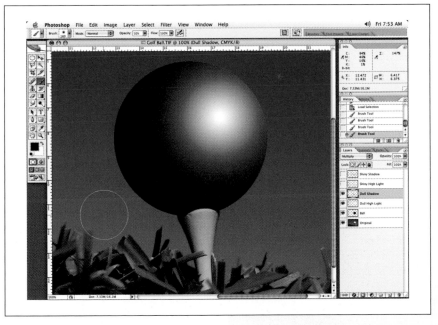

Figure 4-66. After adding a shadow for our dull ball, it is complete

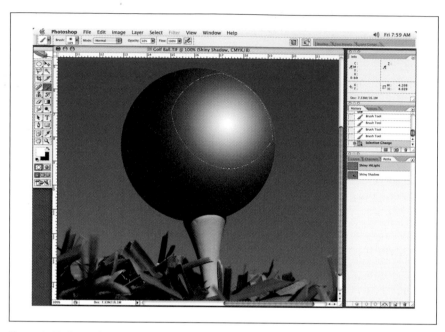

Figure 4-67. Leave the original highlight layer on, but add a shape with the Pen tool that you will use for the shine

Next, I'll make a selection of the shape with a slight softness to it to match the look of any other hard edges on the ball. While on your highlight layer, use a low opacity, 20%, Airbrush. Now brush through the shape until you get the desired effect, as in Figure 4-68.

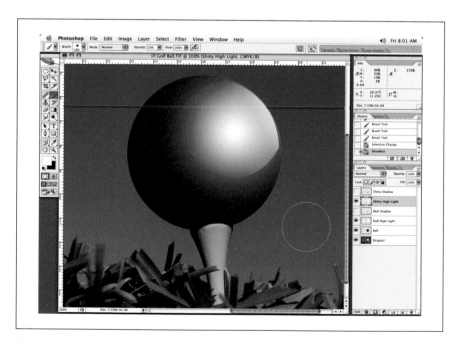

Figure 4-68. The look of the ball with the shiny highlight painted in

Highlights typically come from the top, so I usually make the tops of the highlights the brightest points and feather them off as they move down the ball. I usually do only one shape at a time if I have more than one shape—what I brush in for one shape may not be suitable for the other shapes if they are too close together.

Then, let's do the same thing for the shadow. I'll create a shape for it as well that will give it a harder edge, as shown in Figure 4-69.

For a finishing touch, I added a reflection of the grass onto the bottom of the ball to appear as a very shiny ball. This was done with a low opacity Clone tool and a large brush size. I put the source of the Clone tool brush on the grass and cloned that information onto the ball. The final results are in Figure 4-70.

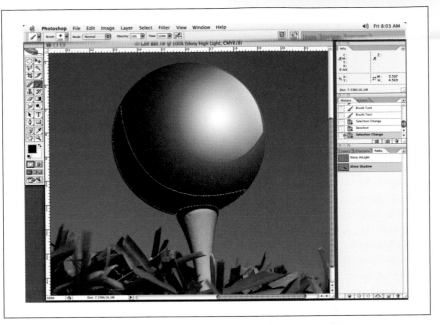

Figure 4-69. Give the shadow a hard edge as well

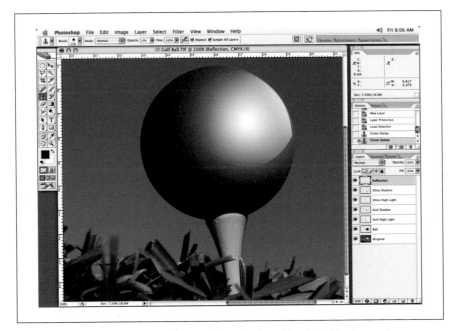

Figure 4-70. A touch of highlight on the grass shows just how shiny the ball has become!

Reducing Windshield Shine

As a professional retoucher, you won't always be asked to create that which doesn't exist; sometimes you'll be asked to remove something undesirable. One of these types of requests I get often is to eliminate reflections from windows (of cars, or any window for that matter), or at least tone down the reflection so that it just contains basic light rather than a bunch of distracting objects. Figure 4-71 shows the before image with a very distinct reflection, whereas in Figure 4-72 the reflection is realistic but no longer distracts from the image of the car.

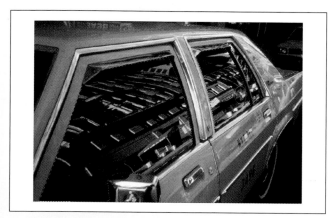

Figure 4-71. Before: reflections in the car window are distracting

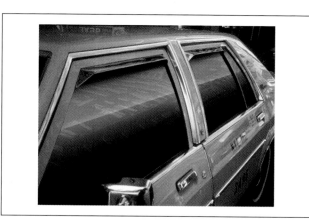

Figure 4-72. A sleek, subtle reflection

Let's start by selecting the area we wish to change with the Pen tool. Create a new layer for your selection. Use the Brush tool to paint in a darker color, as shown in Figure 4-73. Next, take readings of the existing color in the window (by clicking on it and noting the color information in the Info palette), and then paint with that color. If there are variations in the color of the window, take a few color readings and paint in with those colors. Choose tones for the darker and lighter colors based on what you see in the image. If there seems to be a large variation between the two colors, pick up some in-between colors to smooth the transition from dark to light. Paint in the highlight as shown in Figure 4-74.

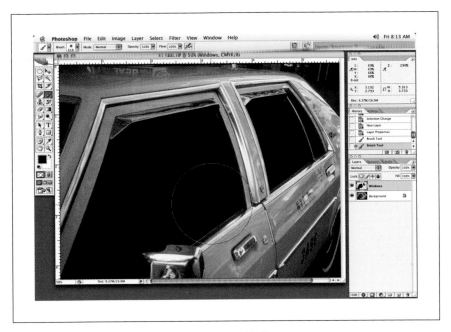

Figure 4-73. The darker shade of the window is painted in first

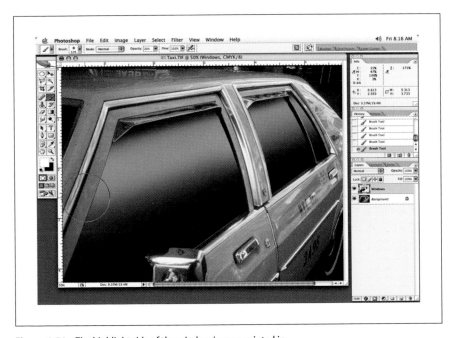

Figure 4-74. The highlight side of the window is now painted in

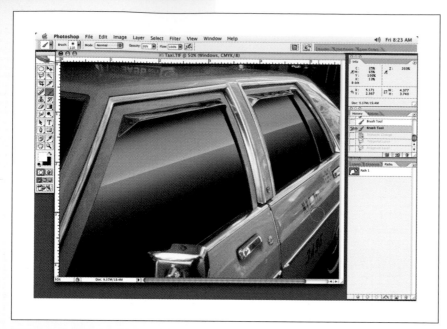

Figure 4-75. Subtract some of the original window selection to create a shine line, and then brush highlight into the selection area to create a hard shiny edge

At this point, the window looks flat, so let's modify the window mask so we can add a hard highlight edge. Using the Polygonal Lasso tool, divide the window where you think a shine could exist—you'll have to use your imagination! Next, use the Lasso tool to subtract some of the selection. Add a small feather to the mask (Select→Feather) because the Lasso tool tends to make too hard an edge. A feather of .5 should do it. With a low opacity brush, paint in a white edge along the edge of the new selection, as in Figure 4-75.

Next, modify the mask for the dark shadows under the top of the windows by the rain guards for the shadow area. Then, paint a hard shadow line in there, as you can see in Figure 4-76.

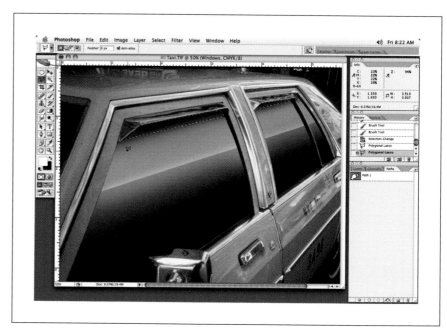

Figure 4-76. Paint in a hard shadow under the rain gutter

Next, add a tiny bit of noise to the window layer. I added a two-pixel amount to the example (Figure 4-77). This is done to help smooth out the transitions in the vignetted windows.

The window layer opacity can be changed to suit the client needs. It is typical for a client to play with the opacity of this layer. At least you have a lot to show them! In Figure 4-78, I've chosen 90% opacity to let a little of the building reflection shine through. This helps add a sense of realism. By all means, experiment with the layer opacity.

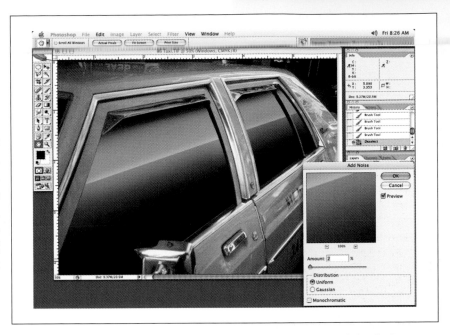

Figure 4-77. Add a little bit of noise to smooth out transitions

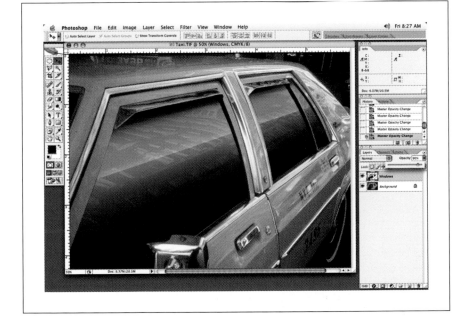

Figure 4-78. The final look with a little bit of the original reflections showing to make a realistic reflection

TIP

Learning a 3D Program?

One option a retoucher may want to consider is learning a 3D program. On one of those occasions when you may be asked to create something that really doesn't exist, it could come in handy. Take for instance the car ad in Figure 4-79, which I did for a fishing related magazine. I created the road entirely in a 3D program called Lightwave (*www.newtek.com*). It is fairly easy to learn as far as 3D programs go, and it works on both the Mac and PC platforms. It would have been pretty difficult, if not impossible, in Photoshop. The road was created as a wire frame image—the texture, in this case, was asphalt—and then wrapped around the wire frame shape. I added some shadowing and the road lines in Photoshop. The truck was then brought in and modified with the Liquify tool. Additional shadows were added beneath the truck as well.

Figure 4-79. A 3D image created in Lightwave

Special Color Requests

5

In the day-to-day world of commercial retouching, you'll often be asked to work with special colors. For instance, you might be asked to create an image with a company logo that uses a special color that is unavailable in the CMYK color spectrum. Or you may be asked to make a four-color image usable in a three-color output scenario. In this chapter, we'll cover working with special color scenarios outside the typical CMYK color space.

Pantone Matching System (PMS) or *special colors* are basically special ink colors that the CMYK color palette cannot generate. For instance, have you ever seen an image or a printed sample that contains a gold or silver? Or, say, a car in an ad appears to be unusually red? Ever seen a bright pink or green object in a fashion magazine? An image in which one item appears to be shellacked? All of these unusual colors and finishes require special ink.

Adding these special inks will require another printing plate, so in addition to the four standard CMYK plates on the printing press, a separate printing plate will be required for each special color or finish used. As you can imagine, it can get quite expensive to print additional special colors. Not only is there extra work needed to produce files with special colors in them, but the printing press will require extra time to wash and change the printing plates, particularly since you may be their only client using a particular special color. Press time can be very expensive. However, it is not unusual to have multiple special colors for some images, particularly for carton work and food packaging.

Creating Touch Plates

A *touch plate* adds a special color to existing CMYK color to enhance the color of a particular item in an image, making it appear richer in color. There are a couple of ways to add a touch plate; you may wish to experiment with both methods to see which gives you the best result. Let's start with the image in Figure 5-1.

Figure 5-1. A touch plate added to this lizard will really make it stand out

You first make a mask of the color areas you're going to enhance. Take care in making your mask, as any areas where the mask spills over onto another area will be very obvious when the final touch plate is complete. I'll usually mask the color areas with the Pen tool and add a small amount of softness to the selection generated from the Pen tool mask based on how the rest of the image looks, as in Figure 5-2.

For instance, zoom into the image and have a look at lines or object edges within the image. This will give you an idea of how much softness to add to the mask. Once you've made a selection, go to Menu→Select→ Feather and put in a pixel amount. The amount of softness usually falls into the .2 to 1 pixel range, but you will have to experiment. Once the mask is made, save the selection of the Pen tool path and make your selection.

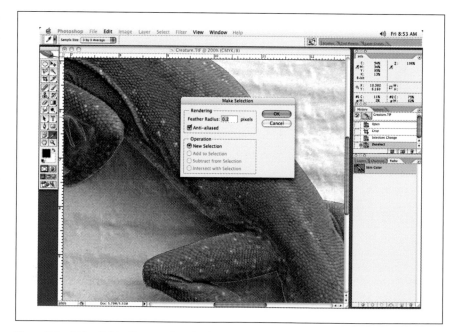

Figure 5-2. Add a slight softness to the selection

As we did in Chapter 3, determine which color channel has the most shape and color. For instance, if the lizard is green, there will be a lot of information in the cyan and yellow channels. Look through the various channels either by clicking on each color channel in the Channels palette or by holding down the Command/Control key and clicking through the 1 (cyan), 2 (magenta), 3 (yellow), and 4 (black) numeric keys to skip through the various channels to find the best channel. As you can see in Figure 5-3, in this case, the magenta happens to have some of the best shape information. The cyan and yellow channels appear too full and lack detailed shape.

Figure 5-3. The magenta looks good for shape

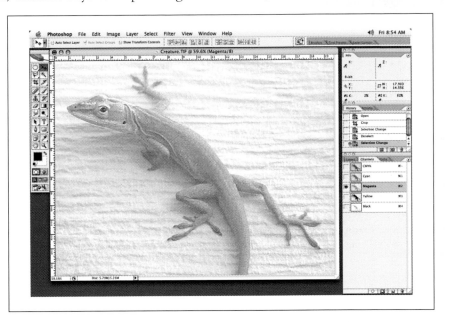

Once you choose a particular channel, in this case, the magenta, make a selection of the object from the mask you created earlier. While viewing the magenta channel only, make a copy of the color information of the lizard, using Command/Control+C or Edit→Copy. Then go to the Channels palette, and under the little arrow at the top right of the menu bar, select New Spot Channel, as in Figure 5-4.

When the dialog box comes up, select the special color you (or the client) wish to use by clicking on the little colored square marked Color. You will then be presented with the Color Picker dialog box. Click on the Color Libraries button to the right of the box, and that will bring you to the Color Libraries dialog box, shown in Figure 5-5.

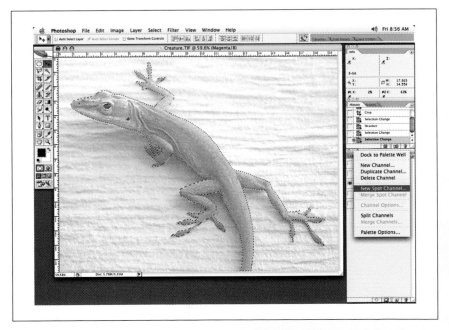

Figure 5-4. Add a new spot channel

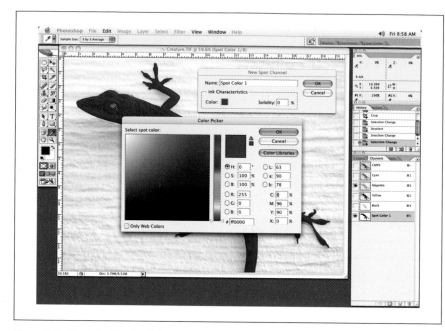

Figure 5-5. The Color Libraries dialog box

From this dialog box, in the Book drop-down menu, choose the type of Pantone color you would like to use, shown in Figure 5-6. Pantone has many PMS color books for various print media applications. For instance, if you wish to print a metallic color like a gold or silver, select the Metallic Coated option.

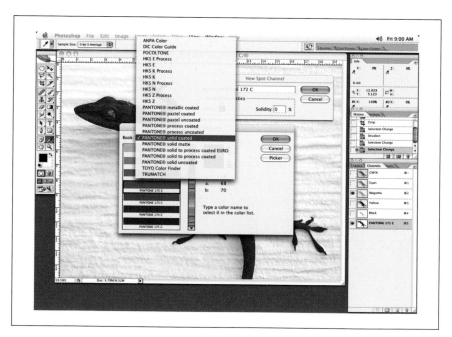

Figure 5-6. Select the correct book for your project

Typically, you'll use special color only in high-quality print work like magazines, and Pantone Metallic Coated is a typical choice, but do check with your client—or better yet, check with the printer that will be printing the job!

Once you have selected the right book, you can select the actual special color you would like to use. You can scroll through the list or quickly type in the PMS number from your keyboard (if you have an exact number), to find the PMS color in the list. In Figure 5-7, I've chosen a green.

Always make sure the PMS number you select displays the correct name in the New Spot Channel dialog box (Figure 5-8); it is important, as you'll see later.

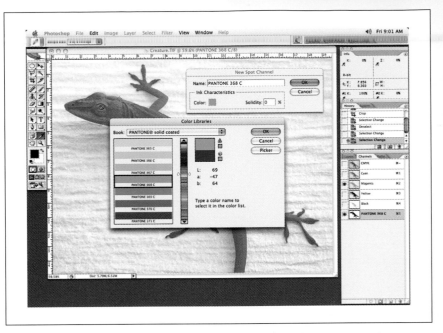

Figure 5-7. Choose the correct Pantone number

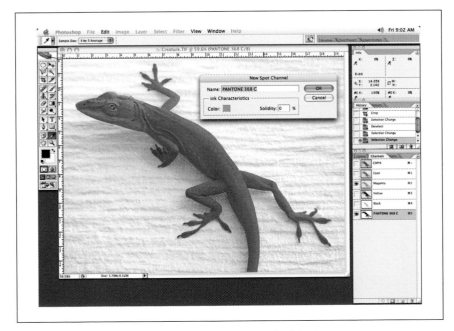

Figure 5-8. Make sure the correct Pantone name appears in the dialog box

Figure 5-9. With the solidity set at 100%, it's hard to visualize the final outcome

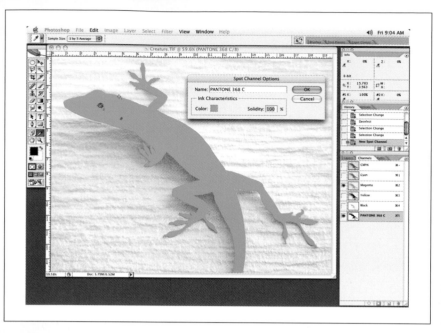

Before you click OK to accept the new spot channel, you will notice that there is also a solidity option in the New Spot Channel dialog box. The solidity option is purely a visual aid—if you set it to 0 or 100%, it doesn't make a difference to the final output of the file. Visually, though, your Photoshop file will differ and, as you can see in Figure 5-9, it's not a very helpful way to view the file. Setting a value of 100% will make the PMS color look like a solid opaque tint, which is typical of a metallic special color, but it will be impossible to see what the final look of the image will be. Instead, try setting it to 0% to get an idea of the final look of the PMS color, as it adds the color to the existing four-color separation, as in Figure 5-10.

> **NOTE**
>
> *Keep in mind that gold and silver special colors are opaque, which means they will cover up anything underneath them. For that reason, these special colors are often printed first, and then other colors are printed on top of them. This is true for most special colors, but metallic colors are particularly unforgiving. The solidity option, when set to 100%, will give you a good indication of what will happen with an opaque special color. Keep in mind, though, that it tends to hide the rest of the image and may not be a true representation of the final file because your printer will print the metallic special color first and the other colors on top of that. This is unclear when the solidity is set to 100%. This is assuming that the other colors or images in your file are not knocking out of the special color.*

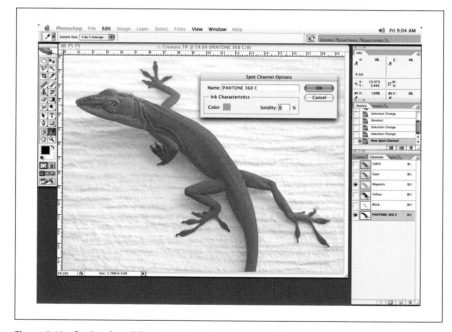

Figure 5-10. Setting the solidity to 0% gives a better sense of the image

With the color selection still active, paste the magenta channel into the new special color channel (Figure 5-11).

Typically, a touch plate is a meant to be a subtle change in color, and the special color is applied at a percentage. In this case, let's knock back the newly created special color to 50%. Click on the special color channel and call up the curves color adjustment, as in Figure 5-12.

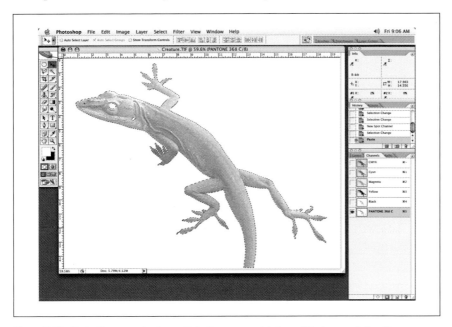

Figure 5-11. Paste the magenta channel into the new special channel that we copied earlier

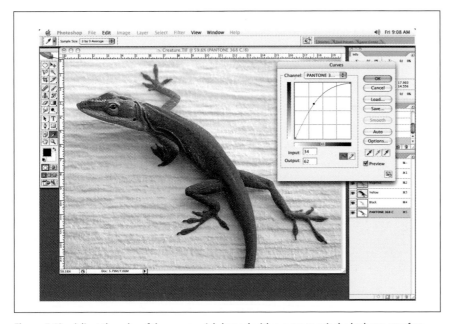

Figure 5-12. Adjust the color of the new special channel with a curve to suit the look you are after; here, we've made it a little darker

Chapter 5, Special Color Requests

Next, take the 100% mark and drag it down to the 50% mark. You can also type 100 into the "input" box in the curve adjustment box and 50 into the "output" box. Figure 5-13 shows another option obtained by making a lighter curve adjustment.

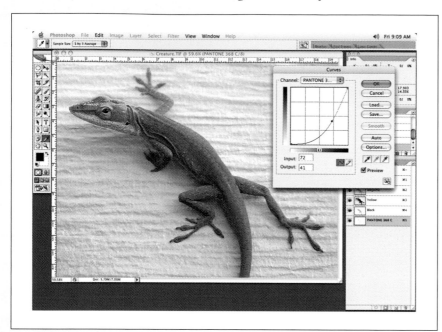

Figure 5-13. You could also make a lighter curve adjustment

Whenever you create a file with a special color, remember to save the file as a DCS2 file (not a DCS1 file), as in Figure 5-14. DCS1 files are related to scanner files. I will add the extension *.dcs2* to my filename so that anyone picking up the file will realize that there are special colors involved.

Another way to create a touch plate is to duplicate the original image and turn it into a grayscale image. In this case, use Image→Mode→ Grayscale to convert your image. Then copy the grayscale portion of the grayscale image that you need— in this case, the lizard body—and

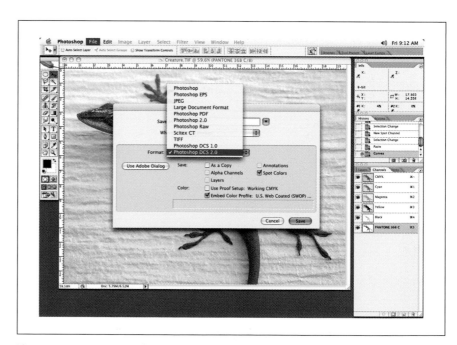

Figure 5-14. Save the special color file with DCS2 extension

paste it into the special color channel of the original file, just as we did when we pasted the magenta channel earlier (Figure 5-15).

For a touch plate, you will have to cut back on its density, which can be done to the grayscale image prior to pasting or on the special color channel, as described earlier. A simple way to do this with the grayscale image is to double-click on the Background layer so it becomes active, set its opacity to 50%, and then flatten the image before you copy it over. Creating a grayscale image makes for a quick and easy way to create a special color or touch plate.

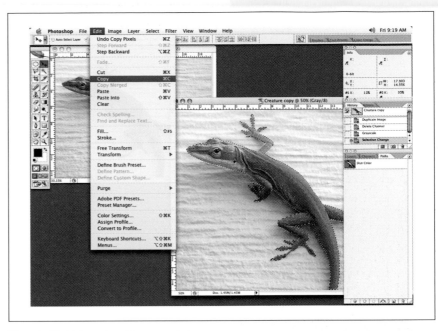

Figure 5-15. Make a copy of the grayscale image

Often touch plates or special colors end up looking flat, as in Figure 5-16. This comes as a result of making a selection of the object color, for example, and simply filling the selection with a solid PMS tint that contains no shape. Don't fall into this trap. This is very amateurish. Make the extra effort to create the special color channel, as described above. Figures 5-16 and 5-17 show the undesirable results.

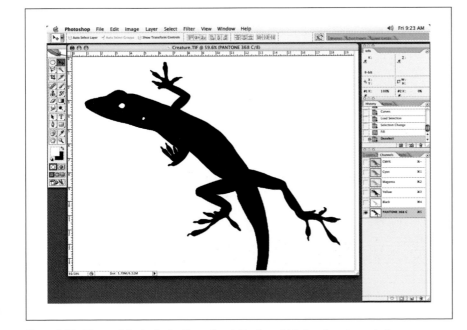

Figure 5-16. The special color in the Channels palette of a solid tint, and no shape at all

> **NOTE**
>
> *One thing to keep in mind is to make sure that the name of the spot color you use is correct. If the name is incorrect or not recognized, applications and printers may not print the file correctly, may substitute another color for your color, or may fail to print altogether.*

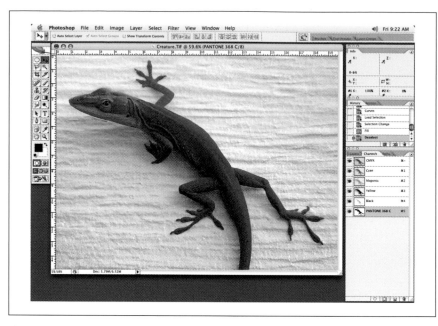

Figure 5-17. The Channels palette applying a simple flat tint for the touch plate

Merging Spot Colors into CMYK

Sometimes files come in that contain spot channels, and the client wants to omit them but keep the color look as close as possible with the four process colors. It can be quite expensive to print extra spot channels, and this is usually the rationale behind using fewer or no spot channels.

Adjusting this is a pretty simple process. First, click on the Channels palette and click on the special spot color channel you wish to merge into the CMYK image. If you have more than one special color that you wish to merge with the rest of the image, hold the Shift key and click all the special colors you wish to merge. Go to the channel File menu and select Merge Spot Channels (Figure 5-18).

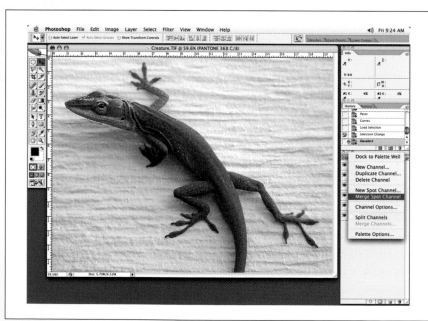

Figure 5-18. Merge multiple spot channels

The only downside to merging channels is that Photoshop will force you to flatten any layers you may have in the file. In fact, Photoshop asks if you are sure this is OK (Figure 5-19). Just make sure it is OK before merging your channels. I typically merge any spot channels as my last operation and save the file with another name in case I have to go back and modify any of the layer elements.

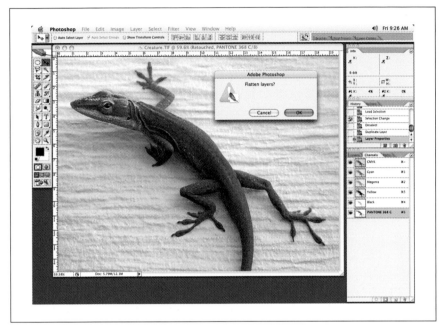

Figure 5-19. Force flattening of the file

Keep in mind—and inform your client—that when you merge spot channels into your four-color file, the file will not look like it did with the special color. Photoshop will do its best to simulate the look of the PMS color, but it just won't be available in the CMYK palette. Hey, that's the point of a special color in the first place! If the image looked just as good without it, why would anyone ever use a special color?

Converting CMYK to Special Colors

On occasion, I'll be asked to convert a four-color image containing CMYK channels into four special colors or some combination thereof. Some clients feel that a special red or blue instead of the standard magenta or cyan will help to make the image stand out or give the image a difference color cast. Typically, the client will want to use a Pantone Process Blue, Pantone Process Magenta, Pantone Process Yellow, and a Pantone Process Black as replacement colors, but it could be any special color for that matter.

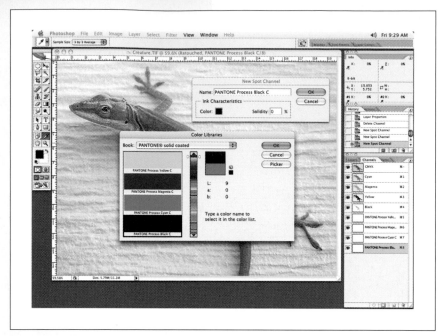

Figure 5-20. Create four spot channels

Let's change the four CMYK channels to four specials. Start by going into the Channels palette and creating four new spot channels. Follow the same process described earlier for creating a new spot channel, only do it four times! When you have added your new channels, your Channels palette should look like Figure 5-20.

Click on each of the CMYK channels until they are all highlighted. Then do Select All, copy each CMYK channel, and paste it into a new spot channel, as illustrated in Figure 5-21. In this case, I started with my cyan channel and worked my way through the process channels, repeating this process for each CMYK channel.

> **NOTE**
>
> *Delete the CMYK channels by clicking on them and dragging them to the trash can on the bottom-right side of the Channels palette.*

Figure 5-21. Create four spot channels, clicking on the black channel to copy it

Once you have completed this process, you will have four new spot channels and four CMYK channels. In Figure 5-22, I've gone through the process of deleting the information left in the four process colors, as it is no longer needed.

Figure 5-22. Clear all the current information in the CMYK channels

When you're done, you have an image converted completely into special colors (Figure 5-23). This process is typically used for packaging or special carton work.

When you're done, save the file as a *.dcs2* file with the Binary option. Some workflows may not support the ASCII option (Figure 5-24).

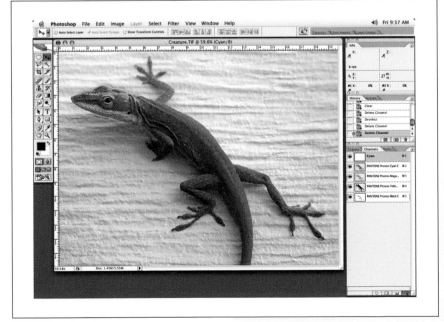

Figure 5-23. The final look of new spots

Figure 5-24. Save the image as a .dcs2 file with the binary option

Changing a Four-Color Image to Three Colors

Another common issue for certain packing work or carton work is making food shots or brightly colored images look as good as they can. With some types of printing presses, having black channel information in a file can make an image look dirty and unappealing.

Eliminating the black channel of a four-color CMYK file, in order to satisfy the requirements of the printing process, can result in a superior looking image. Printing the job with three colors instead of four also saves some money, as it's one less printing plate and one less ink color to worry about. Having said that, a discussion with your client (again, he may not know or care!), or better yet, the printer involved with the job, may be a good idea if you are considering eliminating the black.

If you were to go in and simply delete the black channel, you could lose a lot of shape and contrast, and depending on where the black is in the image, the whole image could look terrible. So rather than remove the black channel altogether, we will blend the black channel information into the C, M, and Y channels to the best of our abilities so we do not lose the information, we just redistribute it!

For example, imagine that our client gives us the four-color image shown Figure 5-25 and wants a file that can be printed without using black.

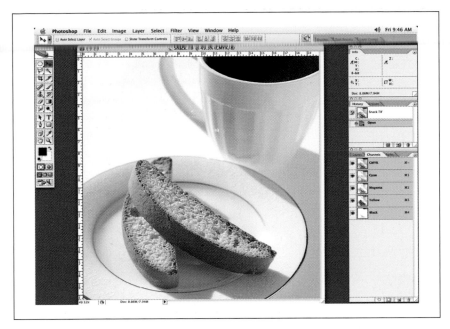

Figure 5-25. Imagine that a client wants this image to be printable without black

If we simply remove the black channel information, we get the image in Figure 5-26, which is colorful but lacks texture.

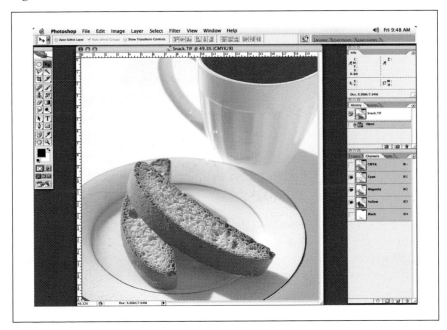

Figure 5-26. Simply removing black information flattens the image too much

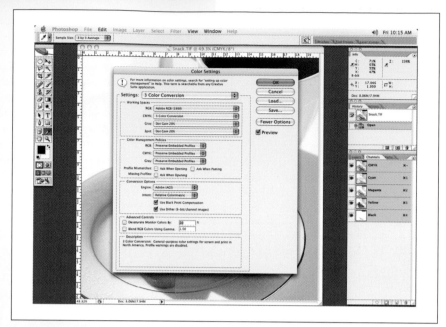

Figure 5-27. The Color Settings dialog box

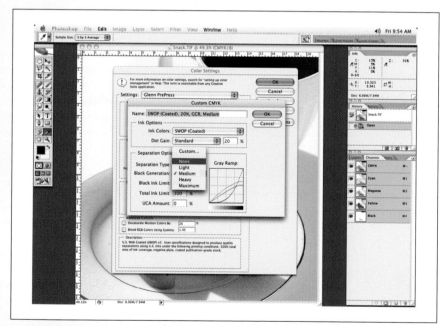

Figure 5-28. The Custom CMYK dialog box, setting Black Generation to None

This first step is to change the image to an RGB file so that when we convert it back to a CMYK file later, our special color setting will be read and our conversion to a three-color CMY(K) file will be done. (I use Adobe 1998 as my RGB color setting.) We'll then use a special color setting that converts a four-color CMYK image to a CMY image with no black information.

Call up your color settings by choosing Edit→Color Settings. You'll see the Color Settings dialog box that's shown in Figure 5-27. Under Working Spaces, choose CMYK and then Custom CMYK.

In the Custom CMYK dialog box, shown in Figure 5-28, put in a descriptive name like: Three Color Conversion. Under ink colors, choose SWOP (coated). Leave dot gain at Standard and 20%. Under Separation Options, choose GCR, and then set the Black Generation to None. Set the black ink limit to 0% and the total ink limit to 300%.

Click OK (twice), and all your new settings are ready to go. Now convert your image to RGB, as in Figure 5-29. When you convert your image from its current RGB state to CMYK (Image→Mode→CMYK Color), Photoshop will read the settings you have put in and convert the image without a black channel back into CMYK, and you'll end up with a three color image (Figure 5-30). Notice how there is only a slight change to your image (as opposed to Figure 5-26). The black channel is now empty of color information, but the texture is still there.

Figure 5-29. Convert your image to RGB

Figure 5-30. Now back to CMYK, at which time the Photoshop will read the new color setting and apply it to your image

You can then make further changes with a curve adjustment or a hue and saturation, if you feel you need more contrast or brightness. In Figure 5-31, I've used a slight curve adjustment to add contrast and depth. This file is now ready for output.

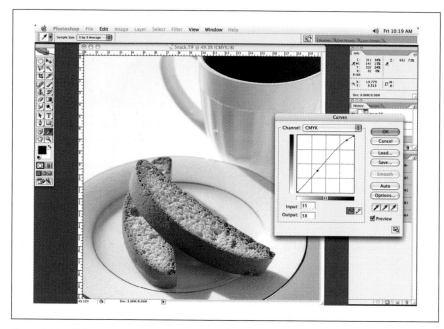

Figure 5-31. Make a slight curve adjustment to add contrast and depth to the image

Adding Trap

When working with special colors, you have to make sure they will trap properly with one another or with the existing color channels. *Trap* refers to overlapping areas of color in such a way that if a color becomes misaligned during the printing process, there is sufficient color information between the different colors to prevent a gap through which the white of the paper or another color in the image might poke out where it isn't suppose to. Your eye can really be drawn to an area that has a poor trap.

Let's say we were printing the image with the special color text shown in Figure 5-32. Take a look at the difference in the area around the letter S in Figures 5-33 through 5-36.

Figure 5-32. We'll work on adding trap for the special color (text) in this image

Figure 5-33. Colors are butted together without trap

Figure 5-34. Colors are butted together without trap and have shifted during printing

I have worked on many packaging projects in which a special color is used for a text heading or shape with little or no CMYK values. When a spot channel area containing little or no CMYK values butts up to another area of an image that uses no special color but contains CMYK values, you have to somehow create an overlap where the CMYK of the image and the special colors meet. That way, if the special color plate shifts during the printing

Figure 5-35. Colors butted together with trap

Figure 5-36. Colors butted together with trap, after having shifted

process (which can happen often), there is some elbow room for the CMYK values, and the spot channel colors still print on top of each other without causing a gap to occur. Although Photoshop does not have the elaborate trap functions that some specialized programs designed for trapping do, there are a couple of things you can do to create a trap in situations where you may need it.

Figure 5-37. Copy text in the special color channel

To create a trap, make a selection of the special color shape or heading (which may be a layer you have in your Layer palette or a special color that is already in your Channels palette) by holding down the Command/Control key and clicking on your special channel in the Channels palette. This then makes a selection of your special color (Figure 5-37). Then paste the text into a new special color channel, as in Figure 5-38.

Figure 5-38. Paste the text into a new special color channel

As you can see in Figure 5-39, the text pasted into the special color appears transparent, and you can see the CMYK image beneath it. Special color always overprints an image and does not knock out the image below it. If you wish to overprint your special color, you can skip the next few steps. However, if you wish to have the special color knock out the image beneath it, read on.

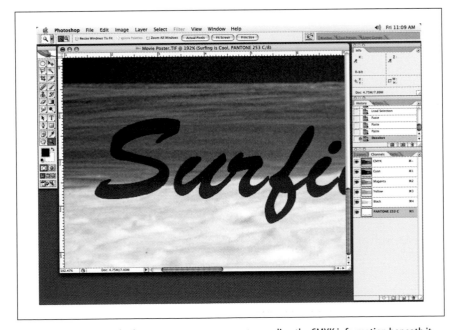

Figure 5-39. The special color text appears transparent, revealing the CMYK information beneath it

Figure 5-40. Contract the white layer slightly to create trap between the CMYK and the special color channel

So, keeping in mind is that spot colors basically will overprint, let's knock that CMYK information out to let the full strength of the special color to show through. Start by creating a new layer and calling it Knock-Out. Make a selection of your text and fill it with white.

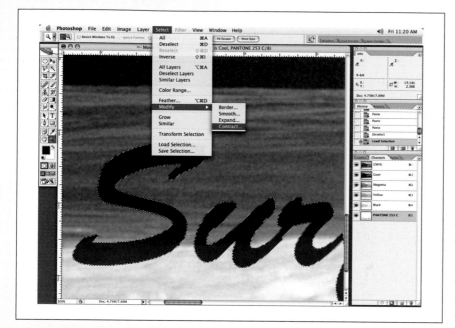

Spot colors cannot be put on a layer; they can only be created as a channel. You won't have the flexibility that you have with a layer. That's why I typically add this white knock-out layer so I can knock out the CMYK information. This way, if the position of the special color changes for some reason, I can just make my change and know that I haven't permanently knocked out the CMYK information.

When you fill this white layer, it will be the exact same size as the special color text. This means that there will be no trap between the CMYK file and the special text channel. To fix this, contract your type selection by a pixel or two. After selecting the text, use the Select→Modify→Contract command (Figure 5-40), as shown in Figure 5-41.

> **NOTE**
>
> *Keep in mind that unless you are given an exact value by the printer, you can typically use one pixel as a starting point. However, this is not correct all the time—it's just that Photoshop requires a minimum of one pixel in the expand or contract command.*

Figure 5-41. Now the selection is contracted to act as a trap for the special color

Next, fill the white layer selection, as in Figure 5-42, by using Edit→Fill and choosing the appropriate color. The results are shown in Figure 5-43. You now have a poster with a heading that is colored white. The white text heading is on a layer so that if the poster ever comes back for a text change, all you have to do is change or update your white layer file.

NOTE

A spot channel will print only in the spot color chosen, regardless of what it is filled with. I choose 100% of a color, typically black. If you choose any percentage less than 100% for filling the spot color selection, the new special color will not be a solid color, but the percentage of color indicated from the Color Picker on the toolbar.

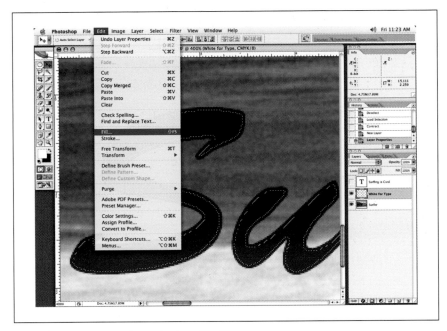

Figure 5-42. Fill the white layer selection with white

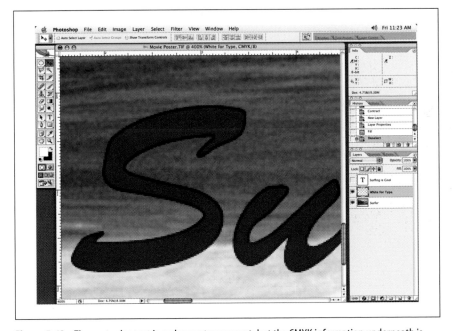

Figure 5-43. The spot color text is no longer transparent, but the CMYK information underneath is preserved in case there is a text change later

Now the image, shown in Figure 5-44, is ready to print properly.

Figure 5-44. Final image ready to print

TIP

Adding Trap with Photoshop's Trap Function

Photoshop has a Trap feature that allows you to add a blanket trap over an entire image (or isolated part thereof). Start by opening the image to which you wish to add trap in Photoshop. Select Image→Trap. Photoshop will ask if you want to flatten the file, say OK. Select the trap size in pixels, points, or millimeters, and click OK.

The Photoshop Trap function traps the entire image. If you wish to limit a trap to a certain portion of your image, make a selection of the area you wish to trap, or take a History snapshot and brush it into the area you wish to trap.

With a trapped image, if the special color happens to shift during the printing process, there should be enough extra to prevent the shift from causing gaps or white spaces to appear around the text.

This method is obviously shorter than the one described above, but it doesn't allow you to adjust the edges for smoother transitions. Photoshop Trap also chops off corners of the trapped area, leaving a notched effect.

Changing the Overall Color

I'm sometimes asked to create an image that has a particular mood. I might be asked to create a sepia-toned image that has an old-time feel, or a cold, gothic looking image made of blues and blacks. Whatever the overall look, images like this are called *duotones*, which means you are using one color

and a black, for instance. You may actually create an image that has only one, two, three (*tritone*), or four (*quadtone*) colors; in fact, you are actually creating a CMYK image to *appear* as though you are using only one to four special colors. CMYK is typically used for this process, since people don't want to go to the expense of using special colors. Of course, you may not get the same color hue as with special colors, but you can probably get close enough to make your client happy.

Creating Duotones

Let's imagine we've been asked to take the farmhouse in Figure 5-45 and make a sepia duotone out of it. For this technique, we'll basically apply a spot channel over a black and white image.

Start by converting the full-color image to grayscale (Image→Mode→ Grayscale), as shown in Figure 5-46.

Figure 5-45. Our original farmhouse

Figure 5-46. Change the image to grayscale

Next, select Image→Mode→Duotone, as shown in Figure 5-47.

Figure 5-47. Choose the Duotone function from the menu bar

In the Duotone Options dialog box (Figure 5-48), select Duotone in the Type field. (Despite the name of the dialog box, this is where you'd choose tritones and quadtones, too.)

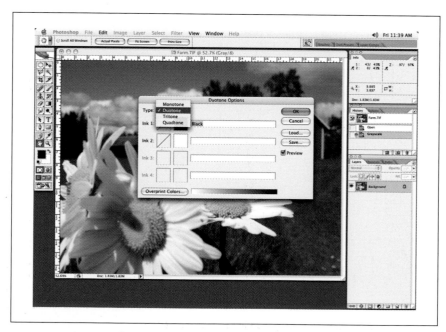

Figure 5-48. Choose the Duotone option in the Type field

The Ink 1 field should be set to black, as in Figure 5-49. Set the Ink 2 field to your desired color. In the case of Figure 5-50, we'll choose a yellow tone. Again, remember to be careful with the spot color name, as incorrect names may not print properly.

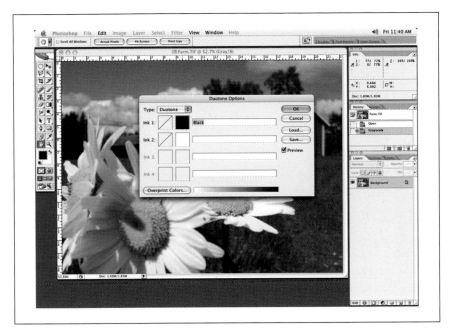

Figure 5-49. The Ink 1 field is set to black

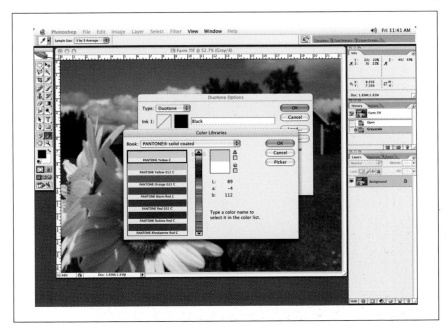

Figure 5-50. Select the special color you wish to use, then click OK

In the Duotone Options box, click on the Curve adjustment icon next to the left of the color box you just chose. This brings up a Duotone Curve dialog box, shown in Figure 5-51. Here, you can make a curve adjustment on the new color.

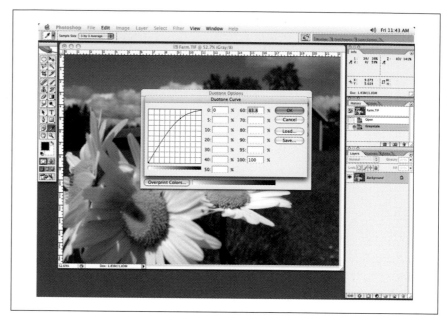

Figure 5-51. Click on the curve adjustment next to the special color you just chose if you wish to make any adjustments to the special color

Save the final image as a *.dcs2* file. The results of our farmhouse are shown in Figure 5-52.

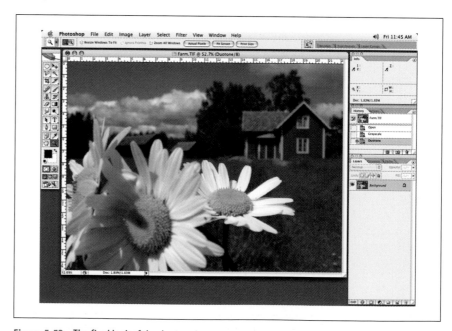

Figure 5-52. The final look of the duotone image

If you need to make further adjustments to your duotone file, you will have to go back to duotone mode to get the adjustment curves back. It's a little bit of a hassle, as you will notice that the only channel in your Channels palette is the duotone one.

If your want to see the two channels that make up your duotone, go to the menu bar and select Image→Mode→Multichannel. This will break up the duotone into two channels. Makes corrections a little easier!

There are a couple of things to keep in mind with the duotone mode. Some workflows do not support images supplied in the duotone mode. Check with your service provider or printer if you wish to supply your files as such. Also, with the duotone method, you will be limited to four spot colors, not that it is typical to have more than that!

Creating Fake Duotones

You can also change overall color to create a "fake" duotone look in CMYK with the Image→Adjustments→Hue and Saturation command.

First, create a copy of your image and grayscale it. You don't have to change the image to a grayscale image to colorize it with the Hue and Saturation, but it seems to produce a better result. I have noticed that the image can lose detail in some areas when using a full-color image.

Make a selection of the grayscale image and paste it into the black channel of your CMYK image (Figure 5-53), and then delete all the other colors: cyan, magenta, and yellow.

> **TIP**
>
> ## Changing Duotone to CMYK
>
> Occasionally, I'll be supplied with a duotone/tritone and the client would like to change it to a CMYK file, usually to save on printing costs. No magic here, a simple Image→Mode→CMYK will do it. You should get into the habit of checking your color settings though prior to any conversion to another color mode. I typically use the US swop coated, but you may have another setting you prefer; just make sure it is loaded prior to changing your file.

> **NOTE**
>
> *By all means, try a full-color image first, if you're looking to save time.*

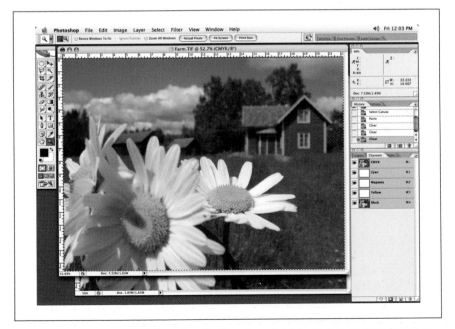

Figure 5-53. Paste the grayscale image into the black channel; delete all other channel information

Next, select Image→Adjustments→Hue and Saturation. In the Hue and Saturation dialog box, starting with all sliders in the center positions, move the Hue slider around until you get the color you want, as in Figure 5-54.

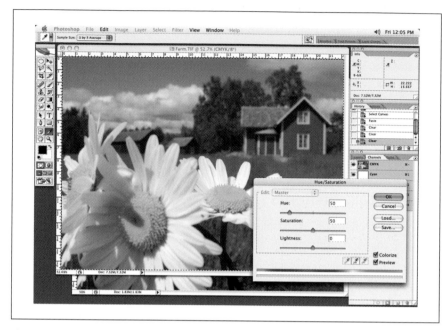

Figure 5-54. Move the Hue slider and adjust until the desired color is achieved

In this case, I've chosen a cold blue look for our farmhouse (Figure 5-55).

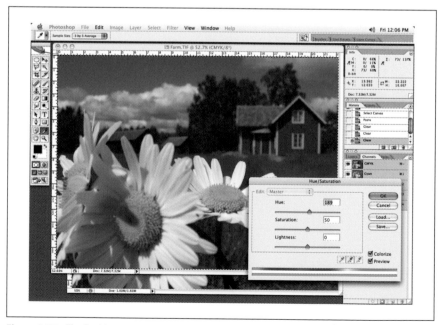

Figure 5-55. The final image

With this method of creating colored images, changing the image to different colors may knock out some of the channels to nothing, depending on the color you make it. Losing information in one particular channel may not be an issue for you, but just make sure you are aware of it.

If you desire information in all channels, you may have to go into another correction mode, like channel mix, to add information back into the file after a Hue and Saturation color change. Or change your image from its current CMYK mode to RGB, and then back to CMYK. This process will put information back into all channels, but at the possible expense of a slight color shift.

TIP

Printing Images with Spot Colors in Them

If you own a desktop inkjet printer, unfortunately you will not be able to see the results of your spot colors correctly. Most ink jets cannot simulate spot colors accurately and are limited to the inks in the printer. To recreate the spot colors correctly, you'll have to have your files output on a high-end proofing device or get a film-based proof made to create a final proof with the spot colors in it.

One other thing to keep in mind is that printing an image with a spot color channel to a composite color printer will print the spot color at an opacity indicated by the solidity setting. So be careful of this.

Merging Images

As a working retoucher, on any given day, you'll most certainly be asked to merge images. The images may have been taken with intent to have them merged in post-production or it may have been a decision to merge images after the fact. Whatever the case may be, it will be your job to make the merged images look seamlessly put together. Some of my more unusual requests have been to take facial features from one person and place them on another shot of the same person because the body position might be better in one shot than another. Other requests have been to take objects shot in an indoor photo studio and make them appear as if they have been shot outdoors in a different scene altogether. You must make sure any images brought into another image take on the characteristics of that image.

At some point in the process of composition, you'll have to create a crop mask for an image. Masking is typically done by creating a selection with the Pen tool, the Lasso tool, or by using the mask mode to paint in a mask. Any of these methods will allow you to make a selection of a particular part of an image. Cropping or making a selection of part of an image allows you to select a picture element to be placed on a different background, restrict a correction or an effect, or select many images for a montage or composition of many images. Selections must be done accurately and correctly to be effective. Again, the idea in retouching is to make images appear as though they have not been retouched at all.

Preparing the Pieces: Options for Selecting the Components

The first thing you'll need to do before merging images together is to correctly isolate the individual elements of the image(s) you need so that they merge together seamlessly. I typically use the Path tool for selecting my images. When creating a clipping path with the Pen tool, make sure you use as few points as you can get away with to select your shape or image. For

instance, as you can see in Figure 6-1, accurately selecting a perfect circle should require no more than four points to complete.

I have seen clipping paths, like the one in Figure 6-2, where it appears as though the person created the entire path just by clicking and creating new points, resulting in an inaccurate selection. When you use too many points, you run the risk of creating bumps and irregular shapes that are not part of the original shape. The final selection may also appear more obviously cropped out when you use too many points because of the poor selection path. It also makes it rather confusing if you or someone else has to go back and edit the path for any reason because there are so many points to deal with and edit.

Figure 6-1. Perfect circle selected with four points

Figure 6-2. Incorrect: a circle created with many points simply by clicking around the circumference of the circle

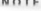

This is a case in which less is more; using shape handles, as in Figure 6-3, allows you to follow the contour of the shape you are trying to cut out precisely.

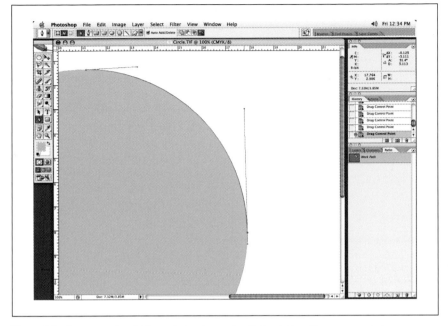

Figure 6-3. Correct: each point is created and moved so that point handles are generated

Another way of generating a clipping path would be to generate one from a previously made selection. (Selections will be discussed soon.) This might seem attractive on the onset because you can then go in and tweak the points for a perfect path, but it is far from problem free. If you use this method, make a selection, and then go into the Path palette and select Make Work Path. This brings up the dialog box shown in Figure 6-4. It gives you a path that traces the edge of your selection.

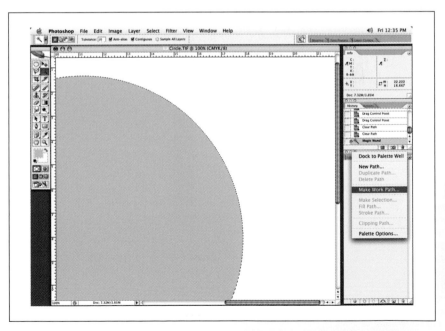

Figure 6-4. The Make Work Path function

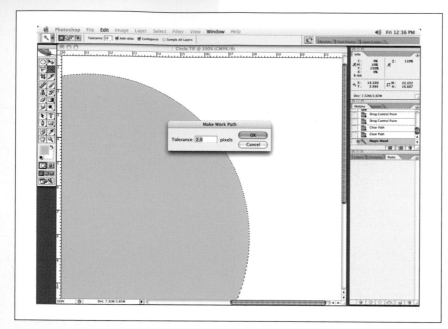

Figure 6-5. Auto paths from a selection yield poor results, with many unnecessary points

However, I do not recommend this method for making a path either, as again, it typically generates far too many points and isn't all that accurate, as you can see from Figure 6-5. You'll spend more time fixing up this path than starting it from scratch.

Selecting Circular Shapes with the Pen Tool

I primarily use the Pen tool when I select an image, as I feel this gives me the most accurate results. I configure my Pen tool settings, as shown in Figure 6-6.

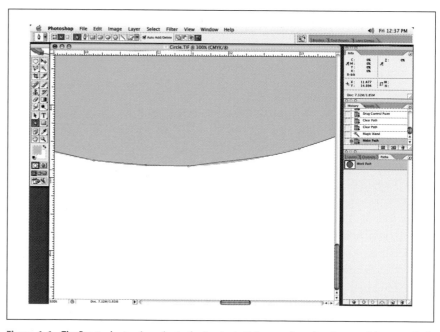

Figure 6-6. The Pen tool setup I use (note the Pen tool attributes selected at the top of the menu bar)

This configuration works for me and, in fact, I don't think I have ever used any other Pen tool setup. This will allow you to create a hole or cutouts in an object. For example, you could effectively select out a donut out of Swiss cheese with this configuration, as shown in Figure 6-7.

NOTE

Just make sure you check your setup prior to starting a clipping path. If you forget to check your Pen tool attributes, or someone else has used your computer and you don't notice that someone else changed the setup, and you go ahead and create a path, you may have to horse around with the clipping path to get the selection you want. I'll explain the different clipping path setups shortly and how they affect your selection. You can work around a different configuration, but it can be a big waste of time, so why make it harder on yourself?

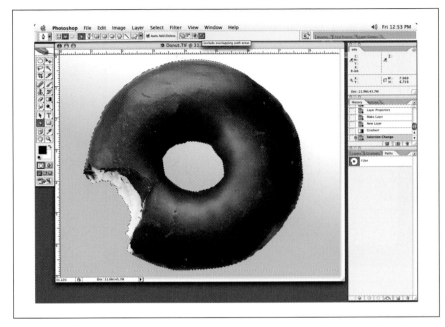

Figure 6-7. Add to Path Area option and the results cropping a donut (exclude overlapping path areas)

Selecting other Pen attributes will yield different results, as you can see in the following examples. Take note of the different Pen tool attribute buttons selected along the top menu bar, and their effects on the selection efficiency. For instance, in Figure 6-8, the center of the donut did not crop out. Here, the Pen attributes were set to Subtract from Path Area.

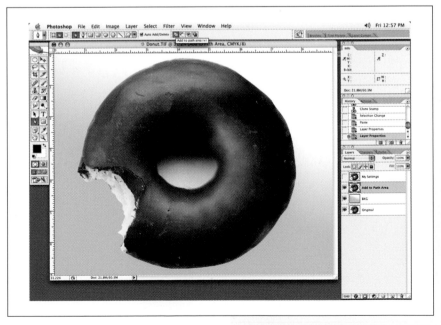

Figure 6-8. Subtract from Path Area option and the results cropping a donut

In Figure 6-9, the outside or background of the donut was the only portion to get cropped out.

Figure 6-9. Pen tool set to Subtract from Path Area option and the results cropping a donut

With the Pen attributes set to Intersect Path Areas, as in Figure 6-10, only the hole portion of the background is selected out and retained.

Figure 6-10. Pen tool set to Intersect Path Areas option and the results cropping a donut

Using the Lasso Tool

I will occasionally use the Lasso tool to select an object. It depends on how complex the object is and if it lends itself well to this method of selection. There are three options for the Lasso tool: the standard Lasso, the Polygonal Lasso, and the Magnetic Lasso.

The basic Lasso option is for drawing a selection freehand. This is a good option if the object you want to make a selection for is small and can be drawn in one go without having to stop and continue drawing, as it could create join marks where you start and stop your selection.

The second option is the Polygonal option. This option is good for creating a selection of an object that has straight edges. Again, if you have to start and stop the selection because you can't finish the selection in one go, you may get join imperfections as you go along.

There is also the Magnetic Lasso tool option. I find that I really don't use it often at all. I find the edges can get quite jaggy with this tool, and it is time consuming. I'm much quicker with the Pen tool.

Use the Lasso tool if you can fit the whole element you want to select on the screen without having to scroll through the image to complete the selection. Of course, if you don't have a steady hand, the Lasso tool might not be for you. A selection made with the Lasso tool should be made in one smooth, fluid motion. When you stop and start a Lasso selection, it can have a jerky, uneven look to it. Large, smooth areas that are to be cropped are better done with the Pen Tool.

Using the Mask Mode to Isolate an Image

Another method of selection I use often is the Quick Mask mode. Masking works particularly well for choosing objects that are soft or fast moving where it is difficult to define an edge in the object. A fast-moving car or cropping someone with hair out of a background can be tricky, but made easier with the Quick Mask mode. The nice thing about this way of isolating an image is that you have control over how the mask is made.

When you double-click the Quick Mask Mode button toward the bottom of the Tools palette (shown in Figure 6-11), you get the dialog box shown in Figure 6-12.

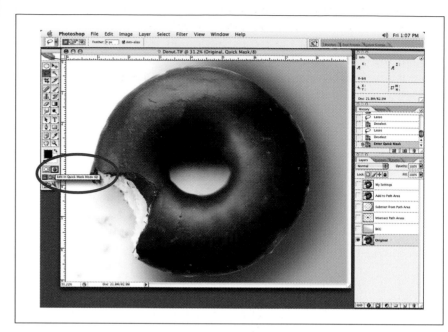

Figure 6-11. The Quick Mask Mode button

Figure 6-12. When you start Quick Mask Mode, you see this dialog box

Commercial Photoshop Retouching: In the Studio

You have two options. You can choose to have the mask color indicate the selected areas, which means your selection will fill with color, as in Figure 6-13. Or, you can choose to have color indicate the masked areas, which means the background will be filled with the mask color, as shown in Figure 6-14. You can choose whichever works best for the needs of your particular project.

Figure 6-13. If you choose Selected Areas, the selection will be filled with the mask color

Figure 6-14. If you choose Masked Areas, the unselected areas will be filled with the mask color

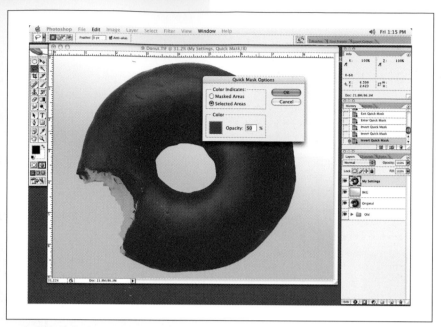

Figure 6-15. Opacity setting allows you to see your image through the mask so you know where you are brushing

The opacity setting allows you to set the transparency of the mask so that you can still see a certain percentage of the image through the mask, and know where you are brushing. Note in Figure 6-15 that the opacity is set to 50%, and you can still see some details of the donut behind the purple mask. The color of the mask can be set by double-clicking on the color swatch, which launches the Color Picker. You might want to change the mask color to something that cannot be confused with any other element in your image.

You use the Brush tool to brush in the mask, and all brush attributes can be used just as they would for any brush. Using a combination of the Opacity setting and the Hardness setting, feathering off a mask gradually is a perfect way to create crop masks for blending images together seamlessly. For instance, as mentioned earlier, hair is very troublesome for people to crop out and, if not done properly, it will look just plain fake and carved out.

> ### TIP
>
> ## Save Your Selections
>
> Once you have made a selection or clipping path of your object, save the selection or path for future use. Save the path or selection with a descriptive name so that next time you need the file, or if someone else works on the file, it is clear what the path or selection is for. This is particularly helpful if several channel masks or clipping paths are made. I like to use names anyone could figure out to make it easy for everyone.
>
> Once you have created a path, double-click on the work path and enter a descriptive name for the clipping path. If the selection is made in the Quick Mask mode or as a hand-drawn selection, save the selection as a channel mask. Typically, once I have created a mask in the Quick Mask mode, I go back into my Standard mode and choose Select→Save Selection to save the selection as a mask or channel.
>
> If you have created many paths, you can turn one of then into a clipping path. Programs like Quark will recognize the clipping path created in Photoshop and crop the image out as determined by the clipping path shape. Any path you make can be turned into a clipping path, and you will be given a drop-down list of paths to choose from.

Selecting with the Magic Wand

On occasion, you can get away with using the Magic Wand tool for selection. The Magic Wand tool is designed to make a quick, automatic selection of a color area with a simple click. The tolerance setting adjusts how far away or how close to the sample color you clicked on the selection will deviate. For instance, if I set a value of 10 as my tolerance, the selection will limit itself very closely to the color I click on. If I set my tolerance to 100, my selection will not only pick up the color in the area of the image I click on, but will also select many other colors within the image.

For the image in Figure 6-16, I was able to select the entire background easily in one go with the Magic Wand tool. Additional areas of the background between the legs and arms of the creature can be selected by adding to the selection with the Shift key. You may want to soften the selection or expand or contract the selection when you are done to adjust the softness, or to crop in tighter to the object, depending on how well the selection worked out. In this case, the background was selected first (because it's solid), and then I used Shift+Command+I to invert the selection.

The Magic Wand tool can be good for very simple or very complex objects,

Figure 6-16. I chose the background with the Magic Wand, then reversed to select the creature and his perch

especially if there is good contrast between the object you would like to make a selection of and the other objects in the image. It also works well if the part of the image you wish to make a selection of is a solid, continuous tone without breaks. However, making a mask or selection with the Pen tool for the same complex object could take a very long time. The downside to the Magic Wand tool is that even though the image may contain the same color throughout, if there are any breaks in the color or big deviations in color from one part of the image to another, you will have to keep clicking throughout the image to make a complete selection.

For instance, if I have a screen full of raindrops I can't just click on one raindrop and have the Magic Wand make a selection of all of the raindrops at once just because they are the same color or tone. If I were to make a selection of a spider web where the entire web is connected together without any breaks, though, the Magic Wand tool may work well.

Channel Masks and Clipping Paths

If your image is to be placed in a layout program like Quark, it is typical for Quark to recognize a clipping path that you have created in Photoshop, assuming you have saved a path that you created in Photoshop as a clipping path. Quark will recognize the clipping path in the image and crop the image to the shape of the clipping path you created when the image is placed in Quark. The downside to this is that you cannot create a clipping path that will carry any kind of softness, so any image that is placed in Quark with a clipping path will always have a very hard edge to it like a knife cut. This may or may not be desirable.

It the clipping path option is not suitable, the newest version of Quark now recognizes a channel mask. This is terrific because nice, soft masks can be made with a channel mask, and it will come into Quark nice and soft!

I find that many clicks are often necessary with the Magic Wand tool, and it can be quite time consuming. Additional selections can be added by holding down the Shift key until all desired areas are selected. You can also click on other colors and include them in your selection. If you use the Magic Wand tool, you will have to click in every nook and cranny before getting all the areas you are after.

> **NOTE**
>
> *In all cases of selection regardless of the tool or function you use, make sure you adjust the feathering or softness of the selection so that it matches the image you are working on. There is no bigger giveaway than an object that has been cropped out and the edge of the object does not match the rest of the image. Zoom in on the image you are working on, have a good look at the edges of other objects in your image, and notice the edge softness. Never set edges that look like knife cuts. There is usually some pixel softness. Once you are staring at the selection you created, choose Select→Feather and add a small amount of softness to your selection. It may be as little as a .2, or as much as 2 or 3 pixels or more. Use settings that match the rest of the image.*

Bring Out the Whole Toolbox: Isolating Hair

Let's follow the selection of a particularly difficult type of image: hair. Ideally, every image with hair to be cropped would be photographed on a white, lime green, or blue screen background, similar to what is done on movie sets. If you have any say prior to the photography being done, opt for the blue screen. Having an image with a flat background that is colored with a color that is different from any portion of the image you are trying to crop out makes life a lot easier, as it allows you to select the background color to isolate the portion of the image you wish to crop out. Unfortunately in the real world, images are usually supplied from a number of sources, none of which lends itself well to cropping, unless you get an image from someone who is really on the ball.

Anyway, we are not going to make it easy on ourselves, so I'll select a typical image that you might get from a client. In this case, the client would like to crop the girl in Figure 6-17 from the background. We will make a selection of the person and the hair and place them on a layer so that any background can be dropped in behind them.

Start with the Color Range tool

I have found that a good way to create a mask or selection for something like hair is to first go into the Color Range tool and either select the hair or the background. If the background is fairly flat looking, it may be easier to select the background, and then invert the selection once all the background is selected, leaving the person/hair selected. If the background is very busy and the hair is more or less the same color, it may be easier to select the hair first with the Color Range tool to get your selection.

When using the Color Range tool, start by taking readings of the desired area to be masked or selected. I leave the settings just as you see them in the dialog box shown in Figure 6-18. With the Eyedropper tool, take readings on your image of the areas you would like to mask. Holding down the Shift key will allow you to keep adding to your selection. Continue to add selections of the hair or background, whichever area you decide to isolate, until you feel you have selected as much of the area as you can. When the selection starts to spill over into other undesired areas, you know you have reached you maximum selection.

Once you have a good selection of either the background or the hair itself, adjust the slider in the Color Range tool until you get the maximum selection you can without the mask spilling over outside the desired area.

In Figure 6-18, the little slider control is above the black and white image in the dialog box; the number reads 96. I start my Color Range selection with the slider at the halfway point so that I have a wide adjustment range either + or −. If you start with the slider all the way at either end, you may find that you run out of range!

Figure 6-17. The task: remove this girl from her complicated background

Figure 6-18. Use the Eyedropper tool to select areas you wish to mask

In Figure 6-19, I've positioned the slider to capture the last bit of the hair possible.

Once you're happy with your selection, click OK. You will now see your selection (Figure 6-20).

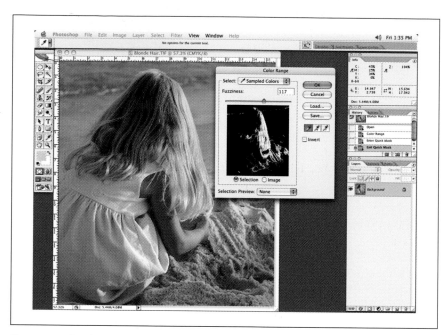

Figure 6-19. Use the Fuzziness slider to squeeze the last bit of selection out of the image; I've adjusted it to +117

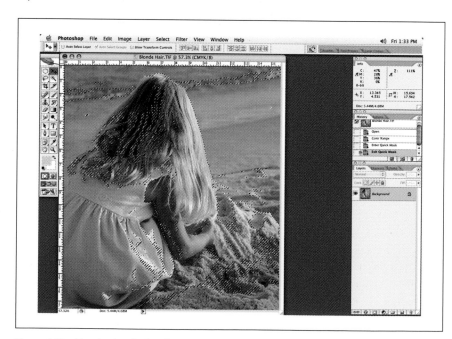

Figure 6-20. My selection displayed

Commercial Photoshop Retouching: In the Studio

Use Quick Mask mode and a curves adjustment to maximize selection by color

With the selection made, I will switch to the Quick Mask mode and have a look at my selection in the form of a color. Seeing my selection in the form a solid color helps me see what my selection will look like. To me, the little marching ants don't really tell me what I am going to get; I could have little holes all over the place, and it's tough to see with a selection made. The Quick Mask mode allows me to see the selection I have made very clearly. And, as you can see in Figure 6-21, it needs some work.

Figure 6-21. Seeing the selection as a color really helps

> **NOTE**
>
> *The Quick Mask mode can be used a couple of different ways. You can use it to check a selection you have made as a visual aid, or you can go in and manipulate the mask in the Mask mode.*

One way to manipulate the mask or selection you have made is to do a correction to it just like you would the image itself. If your mask looks weak in some area (one good reason to use a solid opacity in the Mask mode), instead of painting or reselecting, open the Curve adjustment tool (Image→Adjustments→Curves) and adjust the curve so that it fills in the mask. Or you can adjust the curve to expand on what you have done to fill in any areas that need work. In this case, I'll adjust my curve to fill in and improve my mask, as I've done in Figure 6-22.

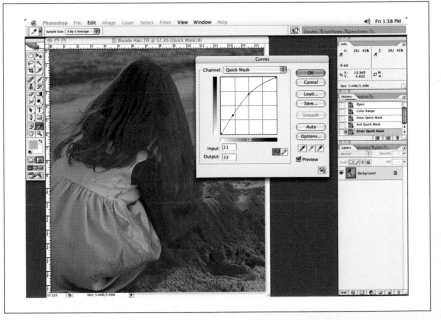

Figure 6-22. Using the curve adjustment to fill in the mask and add to it (this can help you fill in little holes or rough edges of your selection)

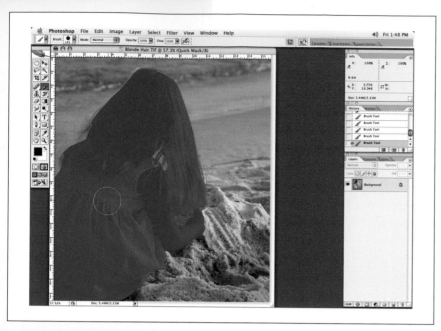

Figure 6-23. Use the Brush tool to paint in mask

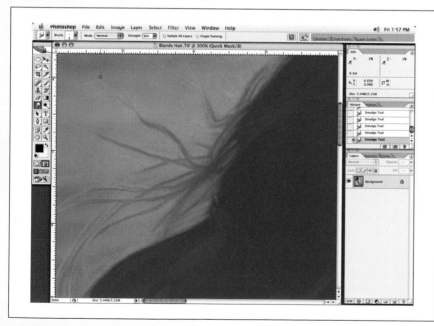

Figure 6-24. Use the Smudge tool to feather off the edges of hair

Paint in areas that need to be added to the selection

Another option is to use the Brush tool from the toolbar to paint in any areas you wish to add to your selection. The great thing about using the Brush tool is that you can set all the usual Brush attributes to the Brush tool in the Quick Mask mode as you would for normal brush work in the Standard working mode. Fill in any spots or edges on the mask that need to be filled in, as in Figure 6-23.

Use the brush as you would on any color image. The opacity, size, and softness adjustments can be adjusted. Use the X key to switch from brushing mode to erasing mode. Just make sure that the Color Picker on your toolbar is displaying a black and a white square. If your Color Picker is displaying a light shade of color, say a 50% black or any other light color, when you paint with the paint brush, you will not get 100% coverage with your brush. You will get a brush density set by the Color Picker color density.

Feather off the ends with the Smudge tool

Another tool you can use to alter a mask selection in Quick Mask mode is the Smudge tool. This is a great way to feather off hair. Set the opacity of the tool to about 50%, then make quick swiping motions to feather off the edges of the mask. This works well, but can be time consuming. You can see the results in Figure 6-24.

Remove hard edges with Gaussian blur

When the mask is nearly complete, add a small amount of a Gaussian blur to the mask to remove any hard edges or any small pixel-sized holes. Typically, a blur of 1 is fine, but larger images may require more.

Prepare for a change of scenery

Once the Quick Mask mode alterations are complete, switch back to Standard working mode, where the selection will be made. Now copy and paste the image to a new layer; it's ready for a new background to be placed. In Figure 6-25, I've pasted our girl onto the new background.

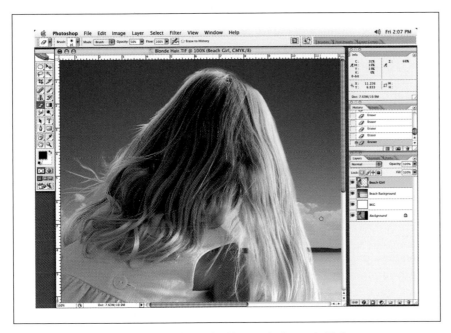

Figure 6-25. Cropped image copied and pasted, with a new background added

Figure 6-26. Dialog box you'll see when dragging a Quark EPS file into Photoshop

> **NOTE**
>
> *Sometimes, when a Quark or InDesign file is supplied, I delete any unnecessary elements in the page that may cause clutter or cover up a portion of the image I can't see. For instance, if there is a lot of text or there are banners splashed across the Quark file, then I will delete them from my Quark file prior to creating an EPS file so that the image FPO (position file) looks cleaner when brought into Photoshop.*

Preparing the Canvas: Your Position File

Unless you are assembling the file from scratch, you will typically be following a client file to assemble to; I call this my position file. A client can supply you with a position file in a couple of ways. They may supply a low-resolution layered or flat file that you will have to mimic in high resolution (see Chapter 7), or a PDF file that you can rasterize when opening in Photoshop. If the file is a PDF or EPS file, simply drag the file icon onto the Photoshop icon, and Photoshop will process the file.

- If a file is supplied in Quark or InDesign, you can save out an EPS file of the entire page for use as a position file. Simply call up the client's file in either program and save the file as an EPS (Menu→File→Save As, at which time you'll have the option of saving the file as an EPS file). When you go to open this file in Photoshop, the dialog box shown in Figure 6-26 will come up and ask you what resolution and color mode you wish to open the file in. The file begins to process, and you'll get a progress dialog box to let you know things are underway.

- If you open PDF files in Photoshop, the dialog box in Figure 6-27 comes up and asks you which page to process and open, if there are multiple pages within the PDF file.

- Of course, if you are the creator of the file, your image composition has endless possibilities and you will start with a blank canvas or a background image.

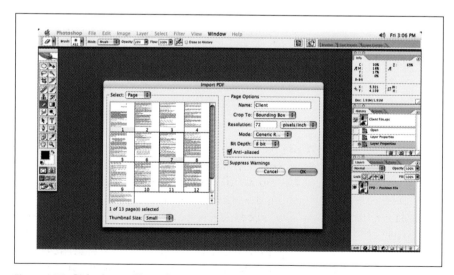

Figure 6-27. Dialog box you'll see when opening a PDF file in Photoshop

The final application will determine input information, but I usually accept the default 72 dpi and may even choose grayscale just to speed things up. You can always change the file later, to 300 dpi and CMYK for magazine specs, for instance. I'll OK that and wait for the file to process. Once the information is input, it will continue to process. It may take some time, depending on the size of the file. Be patient! (Although this image isn't all that big, some files of this type opened in Photoshop this way can take a very long time. So don't panic if nothing seems to be happening; eventually something will!)

NOTE

Make sure you save your file when it opens—you don't want to have to reprocess it!

Adjusting the Canvas

When the file finishes processing, you are ready to go. It should be the right resolution and the right physical dimension. You may want to go into the Canvas size dialog box (Image→Canvas size) and add a small amount of bleed or image background just in case the client decides to shift the image slightly. By doing this, you'll save yourself redoing an image more than a few times! I typically add a half inch or less of bleed, depending on the size of the image (Figure 6-28).

Let's assume that the client supplied the file. The client wants us to place the high-resolution images we have on file in position as she has laid them out on her supplied position file.

Figure 6-28. Use the Canvas size dialog box to add some bleed to the position file

Once the canvas size is set, double-click on the FPO image layer and rename it "FPO" so you know this is the position file.

NOTE

Again, I am a big fan of keeping layers to a minimum and with names that anyone can recognize. As I have mentioned before, you just never know who might pick up your file.

Putting the Pieces Together

Now that we have figured out how to isolate the parts of our composition, let's look at the process of putting those images together. Once I have my recipient file prepared, I call up all the other images I'll use in my composition. Assuming we'll be using the selection techniques we discussed earlier to isolate the pieces, we now need only to make those selections and copy and paste or drag the elements over to the new image. You have a couple of options to bring an image in to the new composition: you can Select All, and then copy and paste it into the new composition, or you can drag and drop the image layer over to the new composition. Either way will get the job done.

Making a Simple Composition

I will start with the image of my guy on the beach and my lizard, shown in Figure 6-29.

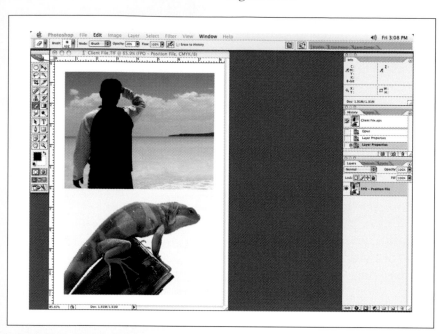

Figure 6-29. All the pieces ready to place in a composition

Once I have all the pieces, I change the image element's opacity to 50% so I can see the FPO through my image for correct positioning. This a much better way of positioning a file than using guidelines. I have seen images rotated slightly and distorted; guides would not work effectively in a case like this. Notice how, since I am able to see both pieces of my composition at once, I can put the lizard right where I want to, as shown in Figure 6-30.

I usually resize the image elements that make up my composition as I go along, using the Transform tool (Edit→Transform→Scale) to resize (Figure 6-31).

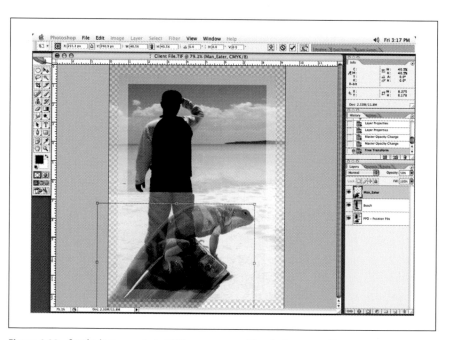

Figure 6-30. Set the layer opacity to 50% so you can position the images easily

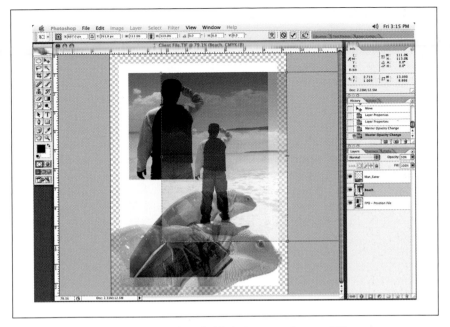

Figure 6-31. Using the Transform→Scale tool with the image opacity set to 50%

Once the correct positioning is achieved, I change the elements opacity back to 100%, assuming that 100% is what it is supposed to be!

Figure 6-32 shows the final image assembled to the client file. Save this as an EPS or TIF file; now it is ready for an application like Quark or InDesign.

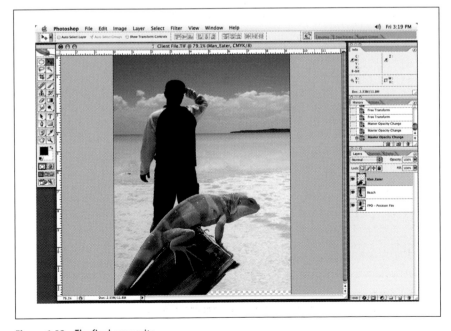

Figure 6-32. The final composite

N O T E

When adjusting the size of the picture element with one of the corner adjustment handles, be sure to hold down your Shift key while scaling to keep the picture element aspect ratio the same; if you don't, you could distort the image. On occasion, if you can't seem to fit your picture element to a client position file, the client may have distorted the image. It is typical for them not to say anything—I guess it's assumed you'll figure it out!

One note about edges: once you have an assembled composition with all the elements in place, turn off the FPO layer in the Layer palette and check all the element edges to make sure they don't look cut or carved out, and that their focus or edge softness matches the look of the rest of the image, as discussed earlier.

If you find that the edges of the images you have placed look too hard, here is a quick fix if the image has already been cropped and placed. Make a selection of the picture element in question by clicking on the layer while holding down the Command key. Go to Menu item Select→Modify→Contract. Type in a value of one pixel and accept this. Go to the Menu item Select→Feather, type in a softness value as determined by our discussion earlier, and accept this. Invert your selection so that the background is now selected (with Shift/Command+I). Now hit your Delete key and watch the edge soften up. You can continue to hit the Delete key, and it will continue to nibble away at the edge of you picture element until the desired softness or look is attained.

I continue this procedure for each element for the entire composition. I may have to turn layers on or off as I go to see my image placements clearly if any picture elements overlap each other and the view of an image where it may make it difficult to see.

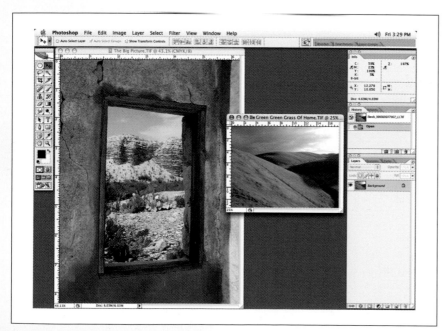

Figure 6-33. A picture frame and a new image that will be going into the center of it

Changing Outlooks: Putting in a New View

Let's say we wanted to replace the image seen within a frame or window, like putting the green valley in place of the desert view in Figure 6-33.

There are a couple of different ways you can isolate images for a situation like this. The easiest way is to first create a selection or mask of the inside of the picture frame where the new image is to be placed with one of the selection methods discussed.

Once the selection is made, you can use this selection as a layer mask, which will not physically crop the picture frame element, but apply a mask that will allow the center of the picture frame to become transparent so you can see an image through the center of the frame where the selection was made. Think of it as becoming transparent or hollow.

A layer mask is applied by choosing the Layer→Layer Mask→Hide selection from the menu bar. However, assuming a selection is made of the window area in this case, if you simply copy the image that will be used as your window image and choose Edit→Paste Into, Photoshop will create a layer mask for you automatically. In Figure 6-34, the grass layer has been pasted with the Paste Into command. A layer mask is created automatically. I've renamed my new layer.

NOTE

One nice thing about a layer mask is that it can be discarded or deleted at any time without affecting the original picture element, or it can be modified and reapplied.

Figure 6-34. Use the Paste Into command to insert the grass image

Figure 6-35. If the lock icon is on, the layer mask and the picture move together

There is one option for your layer mask. Note the little lock or chain icon between the picture icon and the layer mask in your Layer palette, shown in Figure 6-35. If there is a lock between these two items, they will move together. If the link is clicked off, the image can move within the layer mask.

Just as a matter of interest, if you find that your cropping of the picture frame could use some fixing up in spots, you have a couple of options. You could delete your layer mask, remake your selection, and then reapply the layer mask.

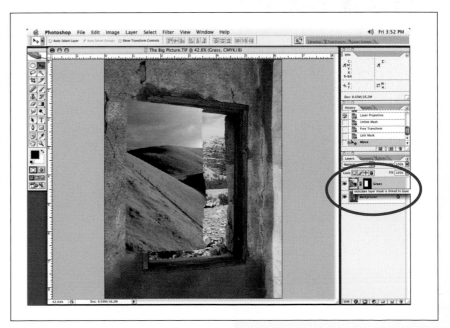

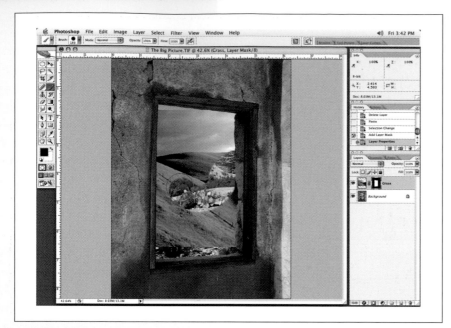

Figure 6-36. Painting on the layer mask to reveal the original image of the window frame

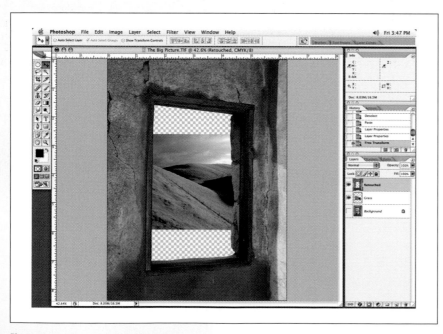

Figure 6-37. The center of the frame has been deleted

If you find the edge of your mask needs to be softened or the shape could be improved, you could click on the layer mask associated with your picture frame so that it is highlighted in the Layer palette, and use your paint brush to paint more or less layer mask material (see Figure 6-36). Use the X key to add or remove your layer mask material with the Brush tool, assuming of course your Color Picker is set to black and white. Remember this affects only the mask and not the image, so you are not harming the image.

Another option is to take your picture frame element with the selection of the inside of the picture frame and to simply hit your Delete key to delete the information in the center of your picture frame element, as in Figure 6-37. Of course, the information you delete will be gone forever, but the center of the picture frame will be cropped out!

In either case, once the center of the picture frame element has been cropped out, you can create another layer of the image you wish to paste into the center of the picture frame. This image would be placed on a layer below or behind your picture frame layer and can be resized, rotated, and distorted within your picture frame selection regardless of which method is used. Figure 6-38 shows the final composition.

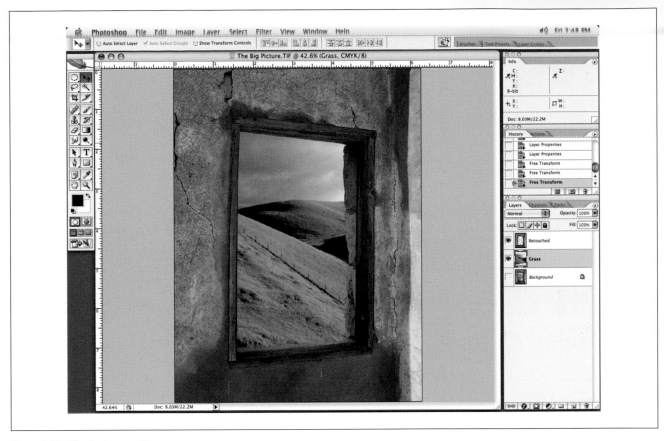

Figure 6-38. The final composition

Low Resolution on a Grand Scale: Making Low Res Look High Res

7

Many times, I have worked on an image only to find out later, once my work was completed, that the image ended up being used at a much larger size—say, a 200% enlargement. Perhaps the image ends up being used for a billboard or a poster. The client doesn't always know that the image will be used for other purposes, so you can't be too quick to lay blame, and sometimes decisions are made on the fly, so it's out of the client's control. Nonetheless, when an image needs to be used at a size for which it was never intended, something has to be done to make it usable.

The first reaction is always scanning or reshooting the image at a larger size. If this option exists and can be done, it's ideal—but this isn't always the case. Some images may have been purchased or shot in some exotic location where a reshoot is financially unfeasible. And sometimes, even if a reshoot or a new scan is an option, the retouching may still need to be repeated. If the retouching was very complex, it can be rather frustrating to redo the work or quite difficult to replicate what you have done the first time around, especially if you have a memory like mine: it's very good, but short.

So in a situation when you have an image that looks terrific but has to be enlarged to a great degree, you can increase the size of the image and help it along with some retouching so it looks a lot better at the larger size.

Let's say we have the image found in Figure 7-1.

There are a couple of approaches we can try before doing any extensive retouching. Basically, we will take the image to be used on our client's billboard, blow it up in Photoshop to meet the specifications outlined by the billboard people, then retouch it in such a way that it appears to be of a higher resolution than it really is. I say this because when an image is blown up to a large degree, it is typical for the image to have problems that are undesirable. Hopefully the retouching outlined in the following chapters will help you to provide your client with a more pleasing result.

> **NOTE**
>
> *In terms of scale here, I have seen images used for posters or billboards that are blown up 300 to 1,000% from the original supplied image size.*

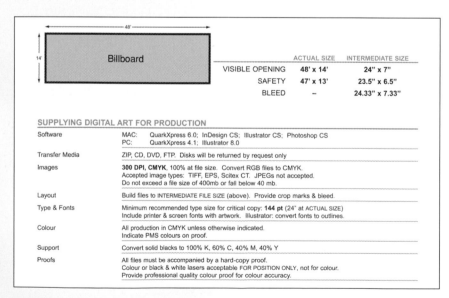

Figure 7-1. Let's say this image has to be enlarged to a great degree to meet the requirements of a new creative concept

Figure 7-2. Typical example of a spec sheet from a billboard company

Understanding the Spec Sheet

Before working on an image that's going to be blown up to a large degree, make sure you have all the information you need. This usually means getting a specification sheet from the company that will be doing the final output of the billboard. Don't rely on verbal instructions, as this may lead to finger-pointing down the road if something goes wrong. Once you have a spec sheet, you know the exact requirements and can then tackle the image. A typical spec sheet is shown in Figure 7-2.

Take note of the physical size the final image should be, both in dimensions and megabyte size. Also note the resolution and color mode desired.

Let's break down some of the information on this billboard specification sheet so you have a clear understanding of it.

Software

This is the software that the billboard company supports, and your files should be compatible with this software.

Transfer media

This is the media that the billboard company supports.

Images

This is the area you should be concerned with. Build your image so that one inch equals one foot. In the case of this billboard, the Photoshop file will be 48" wide and 14" high. To produce a file that is *no* more than 400 megabytes, that would mean a resolution of about 395 dpi. If you build a file to the maximum limits, you get the best file possible. JPEGs are not acceptable, and saving a file as an uncompressed TIF file will save you about 25% of the size over an EPS file, so you may want to save the file as a TIF.

Layout

As I mentioned before, building the file so that one inch equals one foot keeps things simple!

Type and fonts

Fonts and text are usually placed in the ad with a program like Quark or InDesign, as this is the best way to assure that the type looks sharp and clean. The exception to this is if the text is to be placed in the Photoshop file because it is to be manipulated in Photoshop.

Color

Files are to be supplied as CMYK files. You are best off supplying them as CMYK. That way, you know how you converted the files and what color profile you assigned to the file. The billboard company may accept an RGB file, but then you leave the conversion process to them. They may or may not convert the file the way you want it, and a color shift may occur depending on the color profile they select. Why leave it to chance?

Support

Some people who are inexperienced may simply supply a file with a black area as black only, with no other color in it. When you use the other three colors in a black area, it makes it appear much richer and more solid. The optimum color breakdown is 100% black, 60% cyan, 40% magenta, and 40% yellow. This color combination gives you a nice neutral black as well. Those ink values add up to 240, which may or may not be the maximum amount of ink in a dark area regardless of the color. I'd put a call in here to make sure of my maximum ink density in a shadow or dark area.

> **NOTE**
>
> *It is important to follow any specifications given to you by a supplier, not only for the billboard discussed here, but any time your work will be outsourced, because you can be charged fees if your supplier has to go into the image and rework it in some way. Pretty tough to turn around and charge the client for these charges, especially when you are expected to know this in the first place.*

Proofs

The reason why the billboard company (or whoever you're processing the file for) will want a quality accurate proof is that they want some kind of a reference as to how you want the final output to look. It's no good to spit out a great looking proof from your uncalibrated inkjet printer, which has no relevance to what the color will really look like upon output on a printing press. Typical film houses are good sources for accurate proofs, as they have specialized proof outputs that simulate real world press outputs. (This is discussed in greater detail in Chapter 1.) You and your clients are typically expected to sign off on these proofs as your acceptance to the look of the proof output. If the output from the press matches the proof you have signed off on, they have done their job. No complaining at that point!

One additional spec you should keep in mind is the *minimum required dot*. To determine the minimum, take a highlight area of your image and consider what would be the smallest dot you can have in an area that will hold on press? You may have a 3% dot in a highlight area, but the press may only be able to hold and print a 5% dot.

Assessing the Situation

Let's assume that the client wants to increase the size of an image to meet the billboard specifications. To start things off, calculate the final size of the printed creative and convert it into inches, since the specifications are typically supplied in feet, and Photoshop needs at the very least inches when typing in variables.

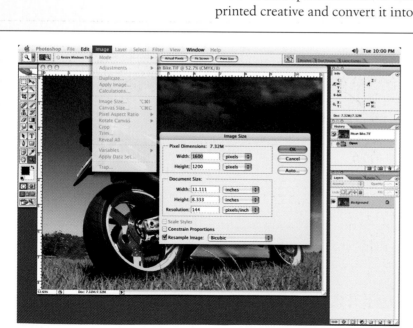

Figure 7-3. The Photoshop Image Size dialog box

Now open the image to be scaled in Photoshop. Let's assume that the file is a typical CMYK file that is 8.5 x 11 inches at 300 dpi, which works out to be about 32 megabytes. Go into the Image Size dialog box in Photoshop (Image Image Size), shown in Figure 7-3, and click off the Resample Image checkbox, change the resolution to 50 pixels per inch (assuming that the requirements are for a 50 dpi resolution at final size), and then let the document width and height adjust themselves to see what the size works out to be. In this case, the file will have a new height and width of 51 x 66 inches. This

may still be a far cry from the 20 feet wide we'll need, but it will give us some indication of where we currently stand with the image.

Of course, the image's megabyte size doesn't change when you make these resolution changes in the Image Size dialog box—only the physical dimensions do. Once the image is sized in this manner, inform the client the status of the image and let them know just how short the image will be or how low the resolution will be at the size required.

Options for Enlarging on a Grand Scale

Once the client is aware of the shortfall of the image and they decide to go ahead with the image anyway, increase the image to the full size required (if possible), or to a size you are comfortable working with. I say "if possible" because sometimes it may not be possible to increase the image to the full final size required because of the limits in Photoshop. If Photoshop imposes or limits the physical size of the image, try changing the image to half the size, but at the highest resolution acceptable that will meet the requirements of the final output. Of course, you can only do what you can do. Some versions of Photoshop limit your file size to about two gigabytes, although this limit has been lifted on the later versions. One option might be to change the file to an RGB file to knock about 25% off the image size. Make sure you crop only what you need out of the image. Of course our billboard specifications are asking for a 400 MB maximum file size, so we will work to this, but some applications may require other larger file sizes.

NOTE

This actually reminds me of some unusual requests. On occasion, a client will ask me for a huge file. Further investigation (contacting the printer or output people) reveals that they do not require the huge file the client is asking for. Often, clients just assume that they need these incredibly sized files when in fact they don't. If something seems a little off, don't be afraid to follow up on some requests and get the correct information firsthand.

Another option is to build the image in two or more sections if the background will allow for this, and then assemble the various pieces in a program like Quark or InDesign. Building files in sections works if the background can be broken down into sections—if there is a tint or a white background and you are not cutting through the middle of an image where a join will not show up during the final assembly process.

When it comes time to scale the image, make sure you are using the highest quality scaling when sizing up an image. In the case of Photoshop, that would be Bicubic Smoother. You can choose this setting each time or set your default preference in the Photoshop Preferences menu (Preferences→General), shown in Figure 7-4.

Figure 7-4. The Bicubic setting for scaling images (Bicubic Smoother in Photoshop CS2) for the best quality

Set up your new image. In Figure 7-5, one inch equals one foot. We are keeping the size of the image to the maximum 400 megabytes asked for. These dimensions do include bleed.

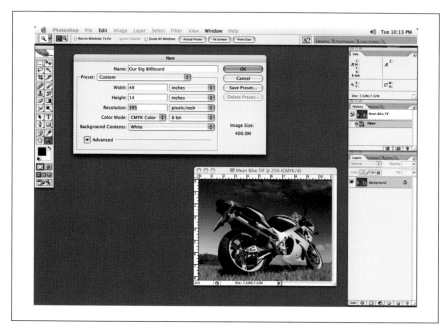

Figure 7-5. Our new image

The only saving grace in some cases is that the resolution requirements for billboards are around 30 to 50 dots per inch (dpi), which means that if you have a 300 dpi image, there is obviously some decent resolution to start with. Of course, this diminishes rather quickly as the size goes up.

Reality Check: Spot Test

Once the image has been sized up, take any small sections of the image that look like they might be particularly troublesome and output them at the full size on a proof just to see how good or bad they may be. Check for graininess or jaggedness, which you might get when an image is blown up. Sometimes the graininess of the enlarged image is acceptable and you can get away with it. Remember, billboards and posters are typically viewed from a very far distance; what may look like golf balls on the image will not be all that noticeable at a far distance. No point in checking the proof with a magnifying glass from an inch away, although clients may still do this!

Next, discuss the results of the output with the client to see if the image should be processed further or left as it is.

— N O T E —

To clarify, when I say "get away with," I am not implying that I am trying to fool anyone into accepting an image. Let's face it—retouching is my livelihood. But unnecessarily retouching an image isn't the objective here. Clients will usually appreciate an honest evaluation, especially if it can save them some money in the process.

Improving the Existing File to Survive Magnification

If the image is unacceptable once resized and no retouching has been done, drop the image into the new canvas you created; in the case of Figure 7-6, use the billboard image created earlier. Again, if you have problems making the image full size, try to create the biggest size you can within your limitations.

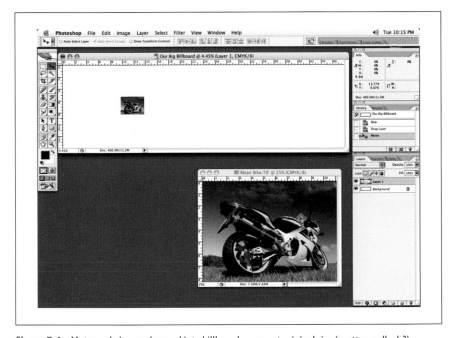

Figure 7-6. Motorcycle image dropped into billboard canvas at original size (pretty small, eh?)

Remember to add an extra amount of canvas for bleed. *Bleed* on an image is basically the extra portion of the image that extends around the perimeter of an image or ad. When an image or ad is printed and the image prints to the edge of the paper or page, an extra amount of image is needed so that when the paper is trimmed to the printed size, there is image or bleed there in case the trim process is slightly off. If the image were supplied with no bleed and the trimmer cut the paper outside of your image, a small amount of the white paper will be seen on the edge of the advertisement or printed material where the trimmer or cutter was off. In our case here, the billboard specs include the bleed.

Resolution on Demand

One other option you may want to look at for scaling images up is a program from Genuine Fractals (*www.lizardtech.com/solutions/gf/*). Some people swear by the ability of this program to scale images up with little degradation. Their web site claims they can "output any file size from a single encoded file, up to 600% without image degradation." It is reasonably priced and may be worth a look.

Using the Client's Image as a Position File

If supplied, use the client's file as a position file to build the image composition. Unless you are the one doing the complete design of the billboard, the client (or ad agency or design house) will supply you with a Quark file of the billboard layout. As discussed in Chapter 6, you can go into Quark and save the file as an EPS. Call that EPS file into Photoshop and use the file as your position file.

In the case of this motorcycle billboard, we'll be attempting to make the image look better at a large magnification, so I'll concentrate on that in this chapter.

Use the Transform→Scale tool, as shown in Figure 7-7, to manipulate the image until you have the image in the correct position and size.

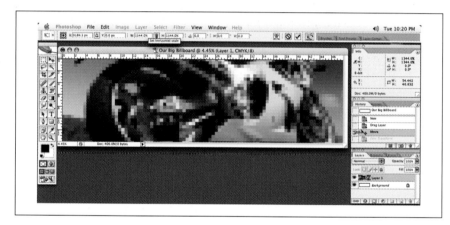

Figure 7-7. Image resized to fill the billboard (wow, 1344%!)

Looks pixilated at this point, but once we accept the transformation, the image will look like Figure 7-8.

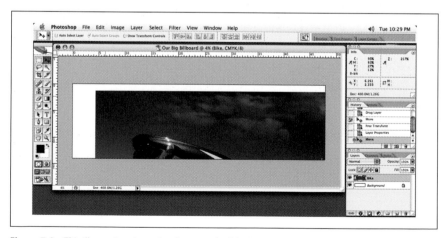

Figure 7-8. This illustration shows just how much of the image is extending beyond your canvas

If you find the image size is getting too large, keep in mind that at this point, the image you just pasted, repositioned, and enlarged is extending well beyond your canvas size, and Photoshop knows that there is much more image available than what you see. You can drag the image around in your canvas, as in Figure 7-9, to see that the image has not been lost just because you scaled it up beyond the canvas size.

If you are pushed for size, you can reduce the size of your file by cropping the image (with the Crop tool) or flattening the file at this point. Make sure that if you use the Crop tool, you don't crop into the live area of your image. I usually flatten the file, as I've done in Figure 7-10. Remember that once you crop, you lose the ability to move the image around. When building large files though, proper positioning should have been determined well before you have gotten to this stage!

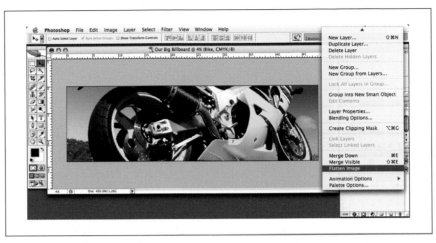

Figure 7-9. Moving the image around displays the portions of the image that are hidden

Figure 7-10. I have chosen to flatten the file at this point

Figure 7-11. A soft-looking image area

Improving the Image Through Retouching

Now that we have our image at the correct size, or close to it, and we know how much of the image we need to concentrate on, we can know get down to the business of improving its appearance. Improving low resolution–looking files is probably the most time-consuming retouching one can do. You'll have to be patient.

There are basically four areas of concern when an image is blown up. It can look soft, as in Figure 7-11; have aliasing issues, as in Figure 7-12; appear grainy, as in Figure 7-13; and/or have blotchy areas, as in Figure 7-14.

Figure 7-12. This portion of the image has the jaggies or staircasing

Figure 7-13. This portion of the image looks grainy, particularly the light areas

Figure 7-14. This portion of the image looks blotchy

Let's break down each problem area and see what can be done to minimize or eliminate these artifacts. Basically, there is no magic button to eliminate these artifacts, so I rely on some basic techniques to help reduce these problems. They are all handled in a similar fashion.

Figure 7-15. Image from Figure 7-14 cleaned up with the Clone tool

Figure 7-16. The background of the image; the trees can be blurred to help minimize the amount of retouching you have to do on nonessential areas

Preliminary Adjustments

Once an image has been sized up to a large degree, I typically look over the entire image and clone out any noise and smooth the image out, as in Figure 7-15. I do this regardless of whatever else I'm going to do to the image. It would be the first step when scaling up images to a large degree to make them look better. This was accomplished by using a low opacity Clone tool brush and massaging the area with my Clone tool, constantly changing the position of the brush settings so that there are no repeat patterns on the image.

You may want to fix the background or a non-focal point of the image with one overall correction before getting into the nuts and bolts of the image.

For instance, if your image has a generic type background—in this case, the trees in the background in Figure 7-16 that are not the focal point—then you can mask off the focal point of the image to protect it—in this case, the motorcycle—and then add an overall Gaussian blur to the background, as in Figure 7-17.

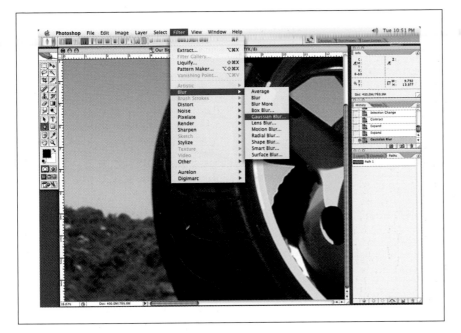

Figure 7-17. A Gaussian blur is added to the background

Then add a small amount of noise to break up the softness of the background. As you can see in Figure 7-18, this makes a couple things happen. It helps the main focal point of the image stand out a little more, and it reduces the amount of work you have to do to the image, particularly if a lot of the background of the image is showing and isn't considered the focal point of the image. Blurring the background helps reduce any jaggedness or pixilation that may have occurred during the enlarging process. You can then concentrate your efforts on the main focal point of the image.

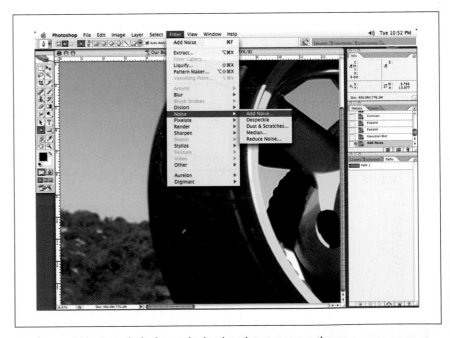

Figure 7-18. Add noise to the background to break up the extreme smoothness

Dealing with Specific Image Problems

Once the cleanup or background work is done, continue with the remaining changes.

Figure 7-19. No Unsharp Masking

Sharpening Image Details

If the image looks soft in the main focal point of the image, you can try and add Unsharp Masking to the image, the before and after of affects of which you can see in Figure 7-19 and Figure 7-20. You may sharpen the image to a small degree, but you will also introduce noise to the image. Start by adding Unsharp Masking and experiment with different variables to see if you achieve an effective result. If not, you'll need to use masks and the Clone tool to produce sharp edges on your object. Typically, Unsharp Masking isn't very effective because the blurred image edge is too wide to sharpen.

Figure 7-20. Unsharp Masking added to image

I have found that the best option is to painstakingly draw in paths around the various troublesome areas, as I've done in Figure 7-21.

Once the masks are drawn, adjust the softness of the mask enough that the object gets sharper, but not so it appears as though it is cut out and stuck on the page. Figure 7-22 shows the image with not enough softness added, while the softness in Figure 7-23 is just right.

Figure 7-21. Draw masks around the troublesome soft or grainy areas

Figure 7-22. Too little softness; notice hard edge when brushed

Figure 7-23. The right amount of softness added

Then, using the Clone tool, brush up to the selection. Once you finish one side of the selection, invert the selection and brush the other side until the object is completed. In the end, we've gone from Figure 7-24 to our completed image in Figure 7-25.

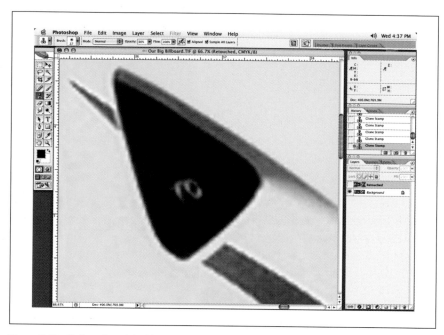

Figure 7-24. Before: the original image

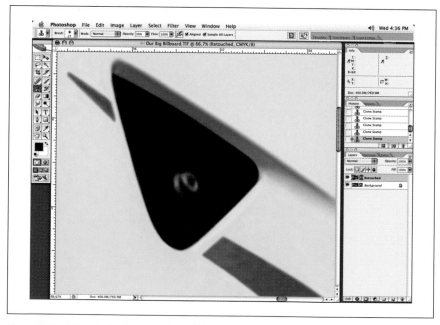

Figure 7-25. After: the final image after cloning up to my selection edges to create the look of a nice finished edge

Repeat this process for all problem shapes and objects in the image. There is no quick way to fix an image in this condition. As I mentioned, fixing large scaled-up images is a very time-consuming process that will test your patience.

Fixing Staircasing or the "Jaggies"

Sometimes an image suffers from staircasing edges or the jaggies, as in Figure 7-26. There are two methods I use to fix this. The first is using the Smudge tool at 50% opacity and drawing around the staircased edges, as in Figure 7-27.

If the object lines are straight, I use my Shift key and mouse clicks to make my way around the object. You may have to use the Smudge tool and go back and forth over the area edge until the desired effect is created. Play around with your opacity settings on the Smudge tool. I usually start off with 50% opacity and go from there. The Smudge tool softens the edges of the object. You may want to add some noise to these areas when you have completed the Smudge tool corrections.

Figure 7-26. The image before the Smudge tool

Figure 7-27. Using the Smudge tool to smooth out the staircasing edges

Another option is to use the Clone tool to fix jagged edges, like the ones in Figure 7-28. Set the tool to a very low opacity, typically 20 or 30%, and then brush along the edge of the object and massage the area back and forth until the area loses the jaggedness, as shown in Figure 7-29.

Figure 7-28. The area with jagged edges before the Clone tool brushing

Figure 7-29. The area after the jagged edges have been cloned and massaged with the Clone tool

When employing this technique, change the position of the brushes often so you don't get any repeat patterns. Again, as with other methods described here, add noise to the area to break up the extreme, unnatural smoothness of the brushing.

Fixing a Grainy Image

One option for dealing with a grainy image is to look at the various color channels and see if one of the channels is causing more noise then some of the other channels. The yellow channel is not typically anything to worry about because it is so light; it's the other channels you have to worry about.

For example, the image in Figure 7-30 has a very grainy area. It turns out much of that graininess is in the cyan channel. If you display the cyan channel, as in Figure 7-31, and add a Gaussian blur to that channel only, it dramatically helps the graininess. (You could also clone or brush only that one channel to get rid of the blur.) This way, you don't soften the whole image by blurring all channels, just one channel. This effect can make a big difference and is worth a try, because you are blurring only one or two channels and you are not diminishing the quality of all channels. It also makes the blurring effect less noticeable. Figure 7-32 shows the final results of this technique.

Figure 7-30. Here is a grainy-looking area of an image

Figure 7-31. The cyan channel has the bulk of the grain

Figure 7-32. Final result of blurring the cyan channel only

Another technique I use to clear up grainy or blotchy areas is to redraw the area. I start this process by masking off the area that needs to be repaired, as in Figure 7-33.

Figure 7-33. Draw a mask around poor-looking areas and shapes

Add a new layer and set its attributes to normal, as in Figure 7-34.

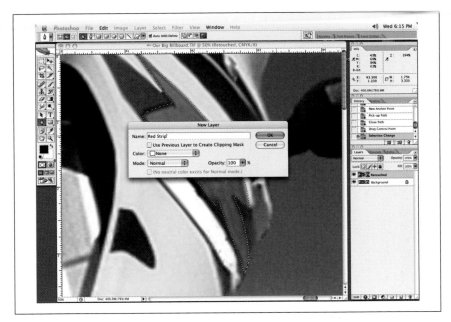

Figure 7-34. I don't want to paint directly on my image, so I'll create a new layer for each newly painted section

> **NOTE**
>
> *Take constant readings of the original color with the Eyedropper tool to ensure that you are brushing in the right color.*

With your Brush tool, begin by brushing in color in an attempt to replicate what was there before. With my Eyedropper tool, take readings of the current shades of color that make up the area you wish to repaint. The idea is not to change the color or the way the area is shaded or shaped, just repaint it so that it appears smooth and looks as though it has a higher resolution. Think of it as repainting that old bicycle or car with a fresh coat of paint! Nothing nicer than a snazzy-looking fresh coat of paint!

With the Brush tool, repaint the area shape. Continue this process of making shapes with the Pen tool, making selections, and creating new layers. Take readings of the original color that makes up the shape, and then brush it in to try and match the original shape, but of course with a much smoother, refined look to it.

An image that started out like Figure 7-35, when you have brushed the entire area, should look something like Figure 7-36.

Figure 7-35. The original unpainted look of the image

This is a great way to fix an area that is in rough shape. It does take some practice, though, and you must constantly take readings to change the color that you are brushing in. Solid objects are easier to fix than complex shapes; you'll have to work up to them. As with any brushed-in surface area, you should add a small amount of noise to these areas. Adding noise helps break up any banding that may occur and reduces the overly smooth surfaces you have just created.

Figure 7-36. The final look of the painted-in shapes on the image

Color Areas of the Image Look Blotchy

If areas of the image look blotchy, this is usually because the color is breaking off hard, like the image in Figure 7-37. You could use my favorite Clone brush tool to soften the area, but you may want to try and color correct with the Curves adjustment first. It may save some time.

Call up your Curves adjustment tool. With the Eyedropper tool, take readings of the dark and the light side of the color break. If you have your Curves adjustment tool on one of channels and you click on the image area with the Eyedropper, you will get little indicators on the Curves tool as to where that color sits on the color curve of the tool. Once you determine the light and dark areas of your breakup area of your image, put a marker point at these two points, as shown in Figure 7-38. Marker points are created by clicking with your cursor on the individual channel curve lines at the various points on the curve line where you wish to mark, create, or lock a point.

I will also add other marker points outside of these two point so when I make a change to the curve, the outer ends of the points don't swing out as depicted in Figure 7-39.

Figure 7-37. An image where the color is breaking off and looking rough

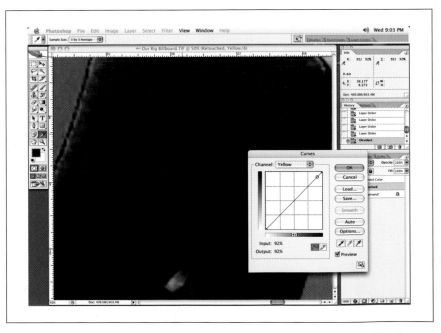

Figure 7-38. Read and mark the curve adjustment with your light and dark rough image area

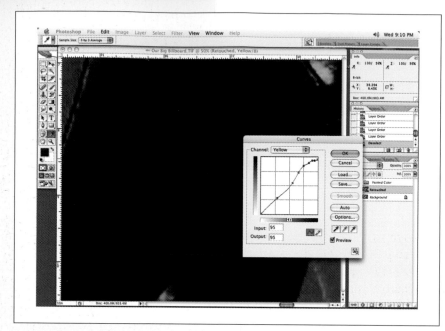

Figure 7-39. The curves tool with additional marker points outside of the dark and light marker points

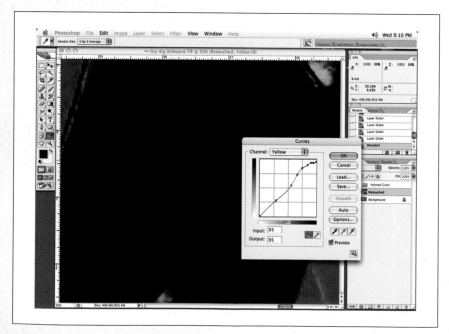

Figure 7-40. The final result of our curve efforts

Do the same thing for any or all of the channels affected. Next, adjust points on the curve until the level of roughness disappears. Add extra points if you find you are not targeting the right area, as I've done in Figure 7-40. Repeat this process for each channel, if other channels are affected.

What you are trying to do is create a smooth transition between the hard dark area and the lighter area by adjusting points that may fall in between the original light and dark areas that form the rough area.

Once you are happy with the changes, accept the change. If you had made a selection of the area, that's great. Or, you can take a History snapshot of the change, undo the change, and paint the correction into the affected areas, as described in Chapter 3. Repeat this process on all affected areas.

Preparing Images for Newsprint

Preparing images for newsprint is a challenge all of its own; just look at a local newspaper to see how flat and poorly prepared most of the images are. But there are many options available in Photoshop to create terrific looking newsprint images. In this chapter, I will discuss the basic specifications required for both color and black and white images intended for use in newspapers. I'll discuss the retouching techniques I use to prepare images for newspaper so they really stand out.

I think much of the poor image quality found in newsprint results because people preparing images for newsprint have no concept of what really happens when an image hits the paper. Let's look at some common mistakes that appear to happen to many newsprint images.

- The image looks too full.

- The image looks too flat and lacks contrast.

- The detail in the image is lost.

- The color is lifeless.

- The image looks soft.

- The shadows are too full.

Newspaper image quality had been a big issue for a company I started working with years ago, when the client threatened to pull the account if something could not be done to improve the quality of the images that printed in the local newspapers. After the images were prepared, the client was initially taken aback by the look of the images. The images were much sharper, more open, and had much more contrast than what the client was used to seeing. The client was, of course, happy when they saw the final print in the newspaper, however, and they gained confidence regardless of how the raw images looked to them ahead of time.

Start by Understanding the Process

To prepare your images in Photoshop for newsprint, you'll need to understand the process. Lets take a few steps back and see the progression of an image to newsprint. Although some images are intended for use exclusively in newspaper, typically images used for other ad placements are repurposed for newsprint. An image may start as a magazine ad and end up in a newspaper.

The first thing to understand is that coated paper stock is typically used in quality magazines is not very absorbent, and therefore higher line screens and higher ink densities can be used for the images. Newsprint stock or paper, on the other hand, is very absorbent, so fine-line screens and full, rich images will not print well.

Fine screen values printed on newsprint stock fill in very quickly when the ink hits the paper, and full dense areas and shadow details completely plug up or fill in. Subtle lines and details also become soft because the lines and details spread due to the nature of the paper stock.

> **NOTE**
>
> *Drop a droplet of water on a tissue and watch how quickly it spreads. The same effect happens with ink on newsprint.*

One thing you may want to get your hands on is a specification sheet from your local newspaper printer, like the ones shown in Figures 8-1 and 8-2.

3.0 requirements for optimum reproduction

Below is a list of production specifications required to achieve optimum reproduction. Artwork must be created to follow these specifications.

If these specifications are not followed Generic Newspaper cannot guarantee reproduction.

Images

 Instructional PDFs on how to correct colour and grayscale images based on the following specifications can be downloaded at www.genericnewspaper.com.

- **Image Resolution (Colour and Grayscale)** . 200 dpi

- **Image File Format** . TIFF, EPS or JPEG preferred

- **Monochrome Images (Graphics and Line Art)** . 1200 dpi
 This does not mean grayscale (bitmap) images.

- **Colour Mode of Colour Images** . **CMYK** (for colour ads)
 Images in any other colour mode will automatically be converted to CMYK. Any PMS Spot colour is automatically converted into PMS specified CMYK separations. The Globe and Mail is not responsible for any shifts in colour due to the automatic conversion to CMYK.

- **Colour Mode for Black and White Ads** . Grayscale

- **Dot Gain** . **midtone gain, 26-28%**
 (Refer to the chart below for approximate dot gain in other dot percentages, based on ISO specifications)

Dot %	Amount Dot Will Gain By	Printed Dot Size
10%	11	21%
20%	19	39%
30%	24	54%
40%	26	66%
50%	26	76%
60%	24	84%
70%	20	90%
80%	14	94%
90%	7	97%

Generic Newspaper ◆ Spec Book page **14**

Figure 8-1. Specifications supplied by a typical newspaper printer for black and white ads

Setting Up Your Image to Meet the Client's Specs

Let's look at some of the specs mentioned and see how we can apply them.

- Make sure the image is not too full overall and the ink densities are not too high in the darker areas of the image. Because of the nature of newsprint, the ink spreads, so a dot that starts off at 50% will gain and may end up being 60 or 70%. You will have to compensate for this by opening up and sharpening the image a fair amount.

- Take note of the dot gain information to see just how much the values measured in your image file will gain when the same image is printed on the newsprint. This will be covered shortly in this chapter so you can optimize your image properly.

- Check the image resolution. Supplying an image at 200 pixels per inch (dpi) is fine. Make sure, though, that the image is the correct size of the ad placement at 200 ppi. Supplying the image at higher resolutions makes for a larger file, and the newspaper may charge you to reduce the size of the file if you supply them with a file that is much larger than necessary.

- Make sure you have applied plenty of sharpness to the image so that detail and edges within the image are held. Although the specifications in Figure 8-1 make suggestions as to how much sharpening to add, you'll want to experiment with these values, as the recommended values may not suit images of different sizes.

- **Maximum Total Ink Coverage** . **240%**
 A 4-colour black should be produced with 59% cyan, 45% magenta, 41% yellow, and 95% black, as per ISO standards.

 DISCLAIMER:
 When the ink coverage is above 240%, Generic Newspaper will adjust the ink density without notification, by applying a profile specific to Generic Newspaper presses and print environment in order to meet the 240% specification.

 This is essential for Generic Newspaper in order to limit ink offsetting onto other pages. **(For more information regarding Generic Newspaper's ICC Profile please refer to** Page 17)

- **Reproducible Dot Sizes**
 Maximum Reproducible Dot . **90%**
 (Any dot larger than 90% will fill in to a solid)
 Minimum Reproducible Dot . **3%**
 (Any dot lower than 3% may be lost)

- **Recommended GCR** . **Maximum GCR**

- **Black Ink Limit** . **95%**

- **Scaling and Cropping of Images** . **in Native Application program**
 Scaling and Cropping **should be done in the image program**, such as Adobe Photoshop, and not in the layout program, such as QuarkXPress. If cropping or scaling is done in the layout program, this can cause delays in processing the file and problems at the RIP.

- **Sharpening Images**
 Use **"Unsharp Masking"** in Photoshop

 Recommended Settings in Photoshop for newspaper:
 - Amount . **350-450%**
 (depending on desired results)
 - Radius . **1**
 - Threshold . **3**

 NOTE: The values are based on an image at its final size.

- **Duotone Images** . **must be CMYK**
 Duotone images must be created out of CMYK (not RGB or Spot color). If not they will automatically be converted. Generic Newspaper is not responsible for any shifts in colour as a result of this conversion.

- **Images Tagged with an ICC Profile**
 The possibility to attach an ICC profile to an image gives our preflight staff a good understanding of how you prepared the image. This will help preflight to validate the colors in the image and guide them in preparing it for optimal results for Generic Newspaper printing standards

 If a supplied proof is in conflict with the end result based on our colour proofers the images will be matched to the supplied proof.

Generic Newspaper ◆ Spec Book page **15**

Figure 8-2. Newsprint spec sheet from a typical newspaper printer for color images

- For color images, total ink density is the amount of ink in the darkest part of an image when you add up all the CMYK values. They should add up to no more than 240 for newsprint. This will be covered shortly in this chapter.

- Clients are not used to seeing images properly prepared for newsprint on a proof prior to being printed. Clients may look at the image and think that it is too light, open, or sharp when an uncompensated proof is made, but rest assured that the printed image will fill in, get fuller, and reproduce well if prepared properly.

Using Photoshop Tools to Simulate a Newspaper Press

Try to get an ICC profile from your local newspaper that you can load into Photoshop to check you images and to simulate press conditions. Figure 8-3 shows you the process through which to use the profiles in Photoshop. Prior to using the profiles in Photoshop, though, you'll have to copy the supplied profile into the following folder: On you main hard disk, go to Library→Application Support→Adobe→Color→Profiles→Recommended.

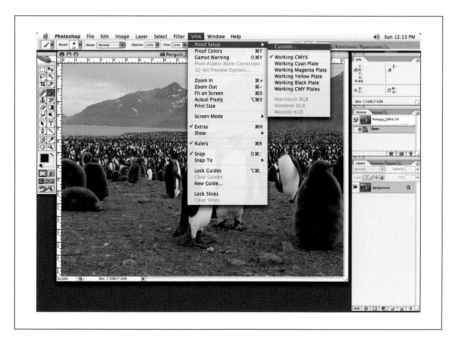

Figure 8-3. Set up a custom profile to meet the client's spec sheet

To load the profile to view your file, go to View→Proof Set-Up→Custom. The Customize Proof Condition dialog box will come up, as shown in Figure 8-4.

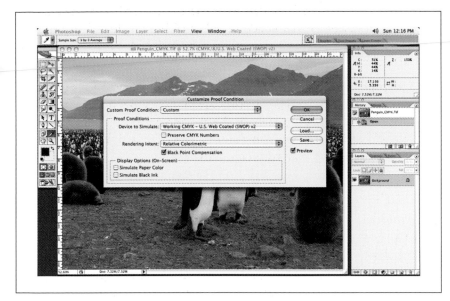

Figure 8-4. The Customize Proof Condition dialog box

Under Device to Simulate, you will want to load the newspaper profile the newspaper company supplied you with. Figure 8-5 shows the options that come up on my computer.

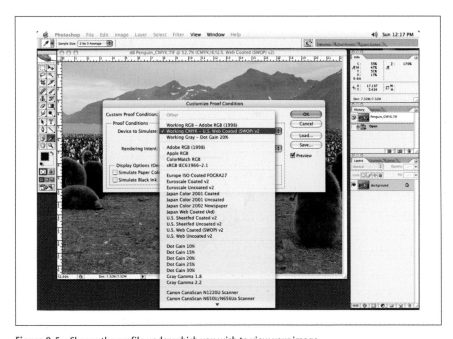

Figure 8-5. Choose the profile under which you wish to view your image

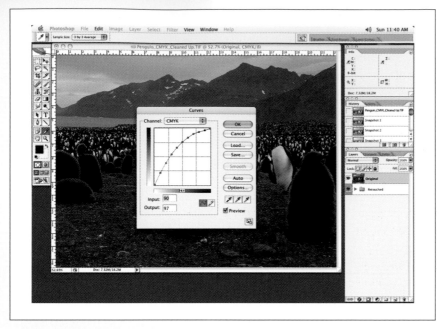

Figure 8-6. A sample compensation curve using the Curve tool in Photoshop, based on the dot gain specifications supplied by the newspaper company or printer

When the image you are to correct for newspaper is open and you wish to get an idea of how it may look in the newspaper, simply select View→ Proof Colors or Command+Y. You can now toggle between your original image as it was and what it is suppose to look like as the newspaper will print it!

Creating a compensation curve in Photoshop, as shown in Figure 8-6, may also be useful. You can then use the compensation curve you create to check your images as you plot along with the changes you make. You would never apply the curve, it would simply be used as a guide to show how the image may look when printed.

To create the newspaper compensation curve based on what the newspaper specs suggest, open your image. Go to your Photoshop menu and select: Image→Adjustments→Curves. You will be presented with the Curves palette. With the CMYK Channel mode selected, the default, click anywhere on the curve line and a dot will appear. Look at the bottom of the dialog box to your left, and you will see that numbers appear in the Input and Output boxes. The input number is the actual place on your curve line where you placed the dot. The output number represents a change made to that number.

Look at the numbers supplied to you to see how the ink gains from the newspaper. Place a dot on the curve line that represents each of the numbers. Then type in a gain value in the Output box for each dot you place on the curve line.

For instance, if you place a dot on the curve line that reads 20, and the newspaper says that a 20 gains to 30, then type 20 in the Input box and 30 in the Output box. Keep adding dots and type in the both the input and output values for each dot until you build a curve like the one in the example.

The techniques described in this chapter will apply to both black and white and full color images. I'll talk about full color images because there are more steps involved, but the changes are applicable to any color mode.

Preparing a CMYK Image for Use in Newsprint

Let's start off with a typical request. Clients often take images used for color or magazine ads, then repurpose them for use in color or black and white newspaper ads. Typically all retouching would have been done to an image already, so all that's left is to prepare the image for newspaper specifications so it will print well.

There are two typical scenarios you'll encounter when working with a color file: a client may ask you to take an image and spec it for use in a color ad in the newspaper, or you may be asked to convert the image to a grayscale image to be used in a black and white newspaper ad.

In either case, assuming I receive a color image to spec for newsprint, I always make sure I spec both a color image and a grayscale image for newsprint, regardless of what I was asked to do. I say this because there have been occasions when the client has asked to spec a supplied color image that will be changed to a grayscale image, only to come back at a later date to say that they now require a color newsprint image! It just makes your life a little easier if you have both on hand. Having a color image spec'd for newsprint also makes the conversion to grayscale a little easier.

Adjusting the Total Ink Values

Let's assume you have a CMYK image. (If you have an RGB image, I'll discuss the transformation to CMYK shortly.) Start off by making sure the Information palette is open. Open the Information palette preferences, bringing up the dialog box shown in Figure 8-7, and set the right side of the information box to display your total ink densities and the left side of the dialog box to display the Actual Color. The Info palette is customizable. Click on the little palette arrow on the top right of the palette dialog box and select Palette Options. You will be presented with the Info Palette Options box. Under First Color Readout, use the drop-

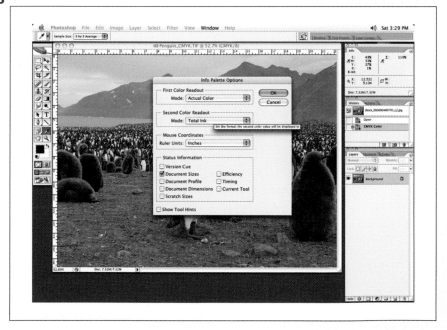

Figure 8-7. Set up your Info palette to supply the necessary information

down menu option and select Actual Color, which will display your actual color read-out on the left side of your Info dialog box. On the Second Color readout, set the Mode to Total Ink, which will display the total ink densities on the right side of the Info palette display. Say OK to the selections, and the Info palette will now display your new selected options.

Figure 8-8. Our original image reads a total of 292: 75 cyan, 69 magenta, 65 yellow, and 85 black

With the Eyedropper tool, look at the image in several areas and read the densities, as shown in Figure 8-8. For newsprint, the maximum total ink densities for a color image in the darkest areas of your image should read around the 240 to 260 area, depending on the newspaper. The 240 or 260 values represent the total ink density when you add up all the CMYK values for a given area. For example, if the CMYK values for the darkest area of an image read Cyan 70, Magenta 60, Yellow 60, and Black 70, then the total ink density would be 260. For black and white images, the minimum dots will go from 3 to 90%

If the image reads less than 260, which is usually not the case, then we are through our first hurdle. If the image reads more than 260, there are a couple of ways to bring the image within the 240 to 260 range. The first option is to use your curves or the selective color correction tool and reduce the values in these dark areas. Open the Selective Color dialog box, shown in Figure 8-9, by choosing Image→Adjustments→Selective Color. Since the black areas of the image are the darkest areas, that's where we want to reduce the densities. Choose Blacks from the Colors drop-down box, and make adjustments to the sliders to get the readings—in this case, a total ink density of 240.

I will make changes with either correction tool and take readings with the Eyedropper tool until I get the readings I am looking for.

The second option to get your ink densities within specifications—particularly if the image is very full overall and the ink densities vary in many different areas—is to convert the image to RGB and then back to CMYK. Now, it's one thing to convert the image to RGB, but you have to have to have a good look at your color settings before any conversions take place—this is very important. I have seen many inexperienced operators simply convert images by choosing RGB, and then go back to CMYK or to grayscale without any thought as to the settings. If you share a computer with other people, the settings may be totally inappropriate for newsprint use, or any use for that matter—in fact if you haven't checked your settings lately, there's a pretty good chance they are not set up correctly at all!

— N O T E —

If you started with an RGB image, this is where you would start with this example.

Figure 8-9. Use the sliders to get the desired density

Let's look at my Color Settings dialog box and the settings I would suggest for newsprint. From the Photoshop menu bar, select Edit→Color Settings, and my Color Settings dialog box, as shown in Figure 8-10, pops up.

Figure 8-10. Choose the correct settings for newsprint in the Color Settings dialog box

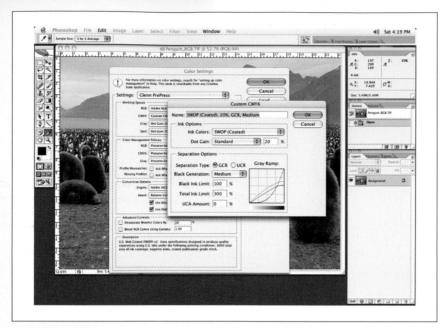

Figure 8-11. The Custom CMYK dialog box

Figure 8-12. After the conversion process from RGB to CMYK, the darkest areas of the image will be no higher in ink density than the set limit of 240 as you set out in your custom CMYK color setting

Under the Working Spaces section of the Color Settings dialog box, select CMYK→Custom CMYK from the menu list. You are then presented with the Custom CMYK dialog box, as shown in Figure 8-11.

Start by giving your new color setting a descriptive name, like Newspaper 240. For Ink Colors, choose SWOP Newsprint. Dot gain can be left at the default setting of 30%. Separation type is set to GCR – Medium. Set your black ink limit to 90% and the total ink limit to 240. UCA amount can be left at 0. Say OK to the changes, and you'll be presented with the Color Settings dialog box again. Give your new settings a name for easy recall the next time you need it.

Once the color settings are created and saved, convert your color image to an RGB image, if you haven't already. Once this is done, convert it to CMYK. (See Figure 8-12.)

Each time the image is converted from one color space to another, it will read the settings in your color settings and use values that have been set up. As you can imagine, the wrong settings could make a real mess of your image if not properly set up.

Let's take some readings with the Eyedropper tool of same dark area before and after the conversion with the new settings (set the tool to 3 by 3 pixels to get an average reading of an area).

As you can see, the image hasn't changed much in terms of its overall color because of the correct settings in the Color Settings dialog box. Because of the color settings, the ink densities in the darker areas have been reduced to newspaper specs. The cyan, yellow, and magenta have been reduced and replaced with more black. This now brings the image ink densities in line with newspaper specifications.

Watch Out for Some of the Original Colors

There are some things to keep in mind when converting images to different color modes like CMYK to RGB. I have received CMYK color images that have a black-only shadow, or other areas of color in the image that may only have one or two process values in them. For instance, there may be a red square in the image that is made up of magenta and yellow only. If you simply converted this image to RGB then CMYK, areas such as red squares, which are made up of one or two process colors, or an image with a black-only shadow, may now be made up of all four colors after the conversion from RGB to CMYK. This may be undesirable if, for example, a client expects to have these colors stay as they were supplied or if it is a corporate logo or something that shouldn't change in color. You may have to go back in and adjust these colors, or the black-only shadow areas, back to their original state.

For instance, let's say the client supplied the image in Figure 8-13 with a red bar across the bottom.

Figure 8-13. The original bar has 100% magenta and 90% yellow in it

Figure 8-14. The color has changed to 4% cyan, 99% magenta, and 77% yellow

— N O T E —

The Channel Mixer tool is discussed in detail in Chapter 3.

Converting the image to RGB, and then back to CMYK, yields the image in Figure 8-14. Notice now how the red bar has changed in color from 100% magenta and 90% yellow to 4% cyan, 99% magenta, and 77% yellow. This isn't drastic, but it is still off. Some conversions could be a bit more drastic, so be aware of this issue.

If you were to do a conversion as described above, but wanted to maintain a one-color shadow, you could make a copy of the original CMYK image so you have two identical images. Then, perform the CMYK to RGB to CMYK conversion to one of the images, and then copy the shadow from the black-only channel of my original image and paste it into the black channel of my newly created image. Finally, delete the color information from the remaining C, M, and Y channels where the shadow is of the original image so you end up with a black only shadow. Obviously, some masking may be involved.

If a client requests a black-only shadow and the image was originally RGB, duplicate the image. Change one copy of the image to CMYK by using the correct Color Settings for newsprint. Then change the other copy to a grayscale image. Finally, copy the shadow from the grayscale image to the black channel of the CMYK image.

If one or two color tints are involved, you may have to run through a similar process with these colors as well, correcting them to their original state through a mask, if necessary. I have found that the Channel Mix tool is a great way to swap colors around to get them back to their original state.

Adjusting the Color for the Color of the Paper

Let's assume that we now have an image that has its ink densities set correctly and any shadows and color tints corrected. We can begin the rest of the corrections.

The next step is to adjust the color before doing any other corrections. Newspaper stock is typically off-white to yellow in appearance. If you were to print the original, unprepared image in a newspaper, it would look dirty. You want to make the image as clean and bright as possible now, as it will become far less so when it appears in the newspaper. (If it is a moody or

artsy shot, making the image bright and colorful may not be the objective However, you would still want to clean up the overall color in the image by removing unwanted colors within the image.) For instance, if the image has a blue cast to it, remove some yellow from the blue. If the image is red, remove some cyan from the red. If there is a yellow cast, remove cyan from the image. The best way to illustrate this is by example.

Let's go back to our penguins and clean the colors up for newsprint.

First, let's try the Hue and Saturation. You can see from Figure 8-15 that the colors in the yellow are breaking off quite hard, which is unacceptable. Oh well, sometimes it works very well. No harm in trying! Stick with the Selective Color tool for making the yellows as bright as possible (as in Figure 8-16).

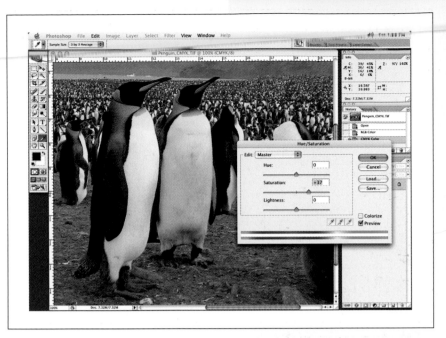

Figure 8-15. The Hue and Saturation tool works on occasion, but is not what we want here

> **NOTE**
>
> *Be careful if you use the Hue and Saturation tool, as it can do quite a bit of damage to an image if overdone. If the hue and saturation have been pushed too far, the image may start to look posterized. Posterization occurs when where the color starts to look blotchy.*

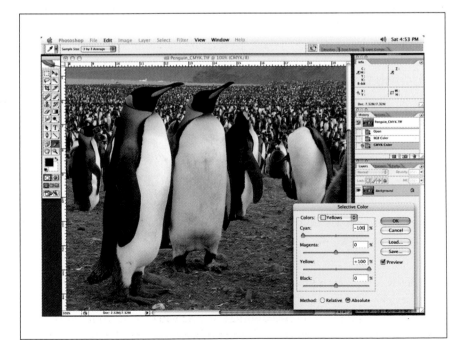

Figure 8-16. Take out any unwanted color in the yellows to make them as bright as possible

The idea is to make the color look almost cartoonish: bright and clean. If the color is too full of the unwanted colors or high in density, the colors will appear muddy and full when printed on newsprint. Figure 8-17 shows the difference before and after using the Selective Color tool. I have not changed my minimum or maximum dots in the image; I have just made the color cleaner and brighter looking.

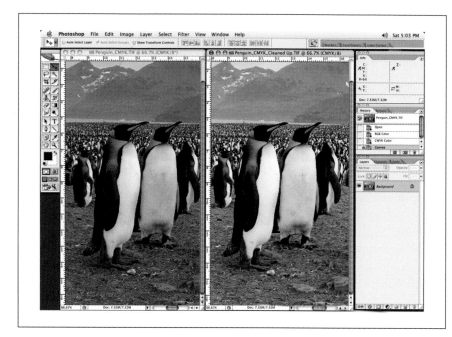

Figure 8-17. The before and after result of using the Selective Color correction tool

Adjusting the Highlight and Shadow Areas

After you have cleaned up your color, the next step is to check both the high-light and shadow values to make sure they are neutral in tone—assuming, of course, that the image contains areas that are to appear neutral. When I say neutral, I mean for the white areas and the dark areas of the image to look like white and black without any color casts to them.

Use the Eyedropper tool, with a sample size of 3 by 3, along with the information box to take readings of these two areas. In a white area, you should get something like a 4% cyan, 3% magenta, and 3% yellow. An exception to this minimum dot would be in areas that are called *spectral highlights*, such as a glimmering diamond or a wine glass with a bright flare or starburst coming from it; a dot isn't necessary in these cases.

Be careful when adjusting a minimum dot area: check the image thoroughly to make sure you haven't reduced a highlight area to the point at which a vignette or an area with a gradation breaks off abruptly. Figure 8-18 shows the way you want it to look; Figure 8-19 shows a highlight that has been reduced too much.

Figure 8-18. The way a smooth area should look

Figure 8-19. A gradated area breaking off because of a highlight that has been reduced too much

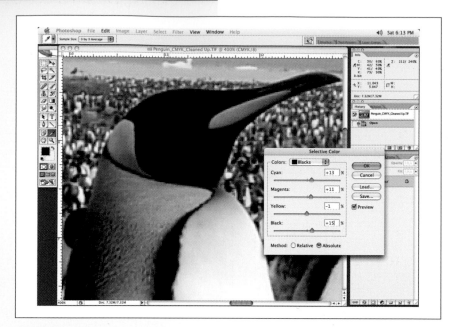

Figure 8-20. Adjusting the shadow area with the Selective color correction tool to obtain a neutral balance

As for the shadow areas, adjust the values to something like 60% cyan, 50% magenta, 40% yellow, and 90% black, as in Figure 8-20. That will give you a total ink density of 240. You'll notice that the yellow is down by 10% from the magenta (typically on a quality coated stock, to achieve a neutral tone, the yellow and magenta values will be the same); you need to reduce the yellow further for newsprint to compensate for the yellow look of the newsprint paper. The highlight are should be set to a neutral balance, as in Figure 8-21.

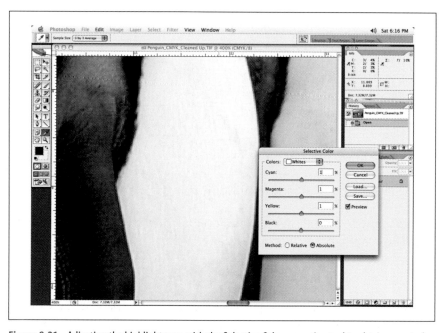

Figure 8-21. Adjusting the highlight area with the Selective Color correction tool to obtain a neutral balance

Adjusting the Midtones

Once you've established the neutrals, take a look at the overall fullness of the image. Both black and white and full color images typically have to be opened up a fair amount so that they will not become too dense when they are printed. You can use the Curve adjustment tool to open up an image in the midtone areas. A simple curve, as in Figure 8-22 should do the trick; the quarter tone (25%) and the three-quarter (75%) tone areas are also affected, but to a lesser degree. Again, it is tough to specify exactly how much the image should be opened up, and some experimentation is necessary.

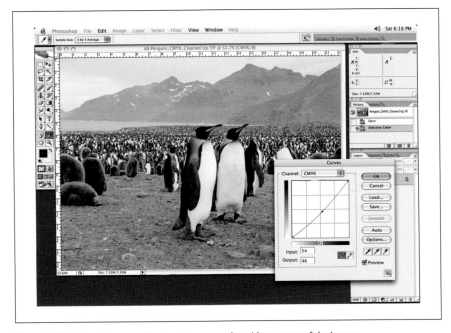

Figure 8-22. A simple curve adjustment opens up the midtone areas of the image

The image will look a little lean, and it should look that way prior to printing. The image will gain a lot on press.

Increase Sharpness

The next step in producing a quality image for newsprint is to increase the amount of sharpness. Again, when an image is printed in the newspaper, the ink spreads and makes the image look softer than it really is. To remedy this, use the Unsharp Masking tool and add a lot of Unsharp Masking to the image. You'll find this tool under Filter→Sharpen→Unsharp Mask.

It's difficult to explain how much sharpness to add, so some experimentation is necessary. Figure 8-23 shows an unsharpened image; Figures 8-24 and 8-25 show how sharpening can affect image quality.

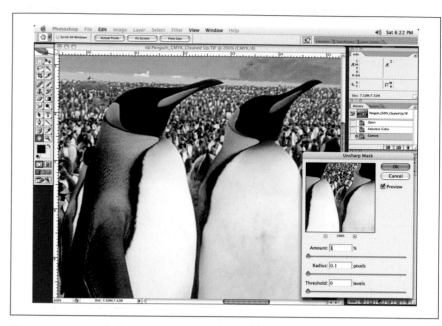

Figure 8-23. The original corrected image with no unsharp added

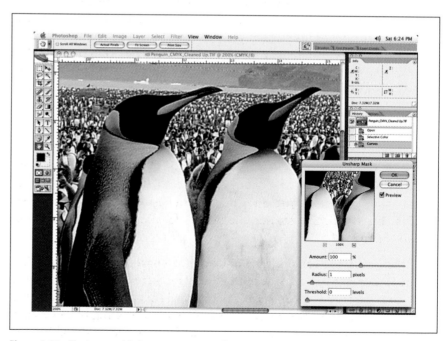

Figure 8-24. The image with the correct amount of unsharp added

Add enough of the Unsharp Masking to make the image appear noticeably sharper, and it should almost have a line shot or line drawing look to it; but too much Unsharp Masking makes the edges and lines appear jagged, and the image can start to look posterized.

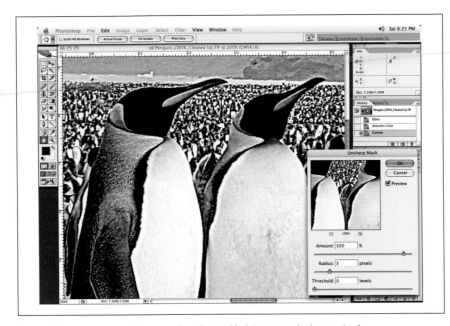

Figure 8-25. The image with too much unsharp added; it starts to look posterized

There seems to be a happy correlation between the various numbers you can type into the Unsharp Masking dialog box and how the image relates to these numbers. For instance, if you type in 200 for the Amount, then 2 usually works for the Radius. If you type in 150 for the Amount, then 1.5 works for the Radius; for 300, 3 is the Radius; and so on. Typing values in this way seems to work. I usually leave the Threshold at 0; there are enough variables between the Amount and Radius that I don't need to change the Threshold from 0.

Something else you can do when adding sharpness is concentrate or isolate the sharpening to the main focal point of the image. If the image contains a hard object, select the object or crop it out so it is on a separate layer, and sharpen only that object. You could also take a History snapshot and brush the Unsharp Masking effect into the area or focal point of the image you wish to change.

One other thing you can do, depending on the image, is throw everything but the focal point of an image out of focus a touch with a Gaussian blur, just so the sharpened object or focal point stands out even more. This adds some depth of field to the image. It doesn't have to be a big blur—even a 1 or 2 pixel Gaussian blur may do it. It shouldn't be very noticeable. You wouldn't want people to notice that the background was thrown out of focus. It should be more of a subconscious thing.

In this case, I'd mask the two main penguins (Figure 8-26) and blur the background. You can see a close-up of the background after the blur in Figure 8-27.

Notice how it makes the focal point stand out a little more? You don't have to blur every background you get, it's just a little tip that you may find useful!

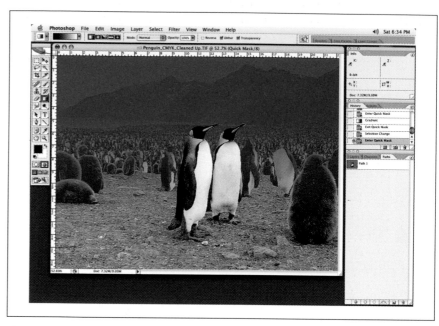

Figure 8-26. The red indicates the area we will be blurring slightly

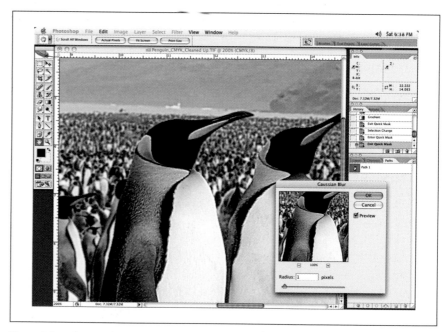

Figure 8-27. Blurring the background helps the center penguins stand out

Further Enhance the Main Object

Another option is to lighten or darken the background of an image so that the object you are trying to enhance stands out even more. In Figure 8-28, I've darkened the image foreground through a mask with a simple curve. Figure 8-29 shows the effects of lightening the foreground.

Figure 8-28. Darkening the foreground helps the penguins stand out

Figure 8-29. Lightening the foreground might also help enhance the key part of the image

Figure 8-30. A lightened background loses shadow to the point at which the object no longer appears grounded

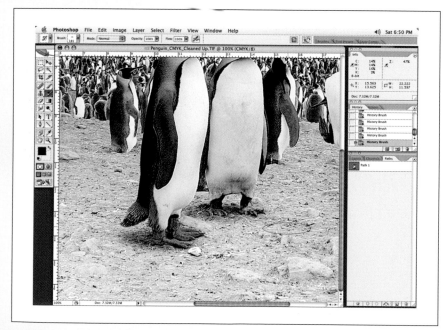

Figure 8-31. Brushing the shadow back in helps ground the object

Typically this may be useful if text or logos will be placed on this area, as it helps them to stand out or simply be legible.

Make sure that if you lighten a background, the object remains grounded. By this I mean the object doesn't look like it is floating because the shadow has gone too light due to your adjustment.

If the object is sitting on the ground with a shadow, make sure the object still appears that way when you lighten the background. See how the shadow grounding the penguins has faded to an unacceptable degree in Figure 8-30? You may have to go back in and darken or fix a shadow if you lighten the background. This can usually be accomplished by taking a History snapshot of the image prior to lightening, and then brushing the shadow back after the lightening of the background, as I've done in Figure 8-31.

One last thing you may wish to do is physically go in and brush either highlights or shadow edging around an object. Do this if the image element appears to be blending in or losing its edges or shape against the background. This helps an object(s) stand out better against the background. In some cases, you may want to go in and define the edges because they look soft or out of focus. Let's start with our familiar penguins, seen in Figure 8-32.

Start by preparing a crop mask of the object. Then create a highlight layer set to normal and a shape layer set to multiply. Select the paint brush tool and select both the highlight and shadow colors you will paint with. Choose colors for the highlights and shadows based on what is contained in the image: choose your shadow and highlight colors using the Eyedropper tool, so they match what is in the image already.

Start by brushing in the highlights. Using the brush tool, set the brush opacity to about 20% and begin brushing. You can see the "shape" alone in Figure 8-33.

You can see that the shape has emphasized the central penguins in Figure 8-34.

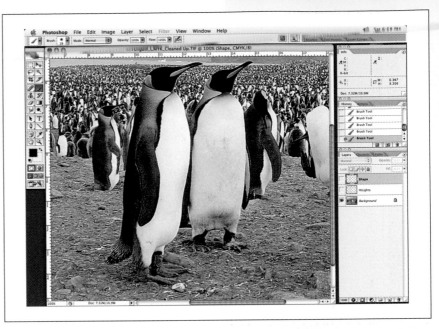

Figure 8-32. Before: no shape or highlights added

Figure 8-33. Highlight and shadow layers create shape and help the focal point stand out from the rest of the image

NOTE

Pay special attention to the brush you select. You do not want a brush with hard edges and little feathering if the edge of the image element is soft. Take a good look at the rest of the image to determine the correct brush attributes before you start brushing anything in.

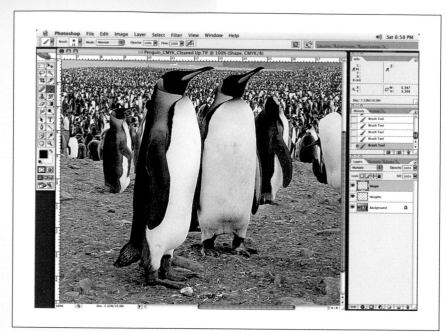

Figure 8-34. Here is the final look of the image after the highlights and shadows have been added

Putting It All Together

I usually don't tell the client I'll be making some of these changes. I'd rather have them say "Wow" without really being able to pinpoint what it is I have done. It works most of the time!

Let's look at the final results of all of the changes. Use the curve we made in Photoshop earlier based on the information the newspaper sent to test the before and after. Again, don't apply it to the image; simply use it as a guide to how the image may look when printed in the newspaper. Figure 8-35 is the original image, and Figure 8-36 uses the Photoshop curve to show what it would look like in the newspaper had we not made adjustments to compensate for paper quality and color.

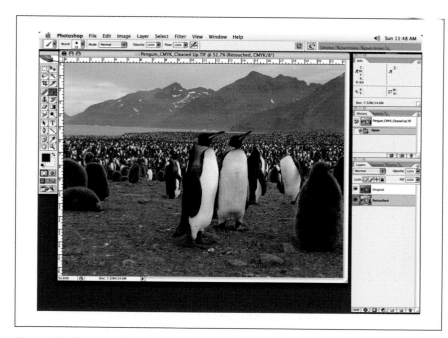

Figure 8-35. The original image submitted by the client for use in newspapers

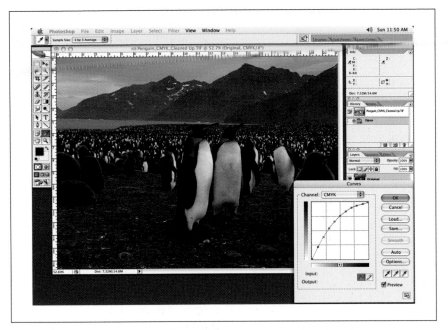

Figure 8-36. The image with the Photoshop newspaper curve applied, without adjustments

The compensated image we retouched is shown in Figure 8-37.

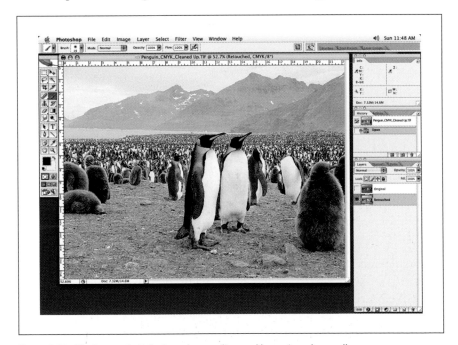

Figure 8-37. The image after all of our changes discussed here, viewed normally

Figure 8-38 shows the Photoshop newspaper curve added to it to simulate how it will print in the newspaper. Notice how it compares to our original supplied image. It looks fairly close to it, doesn't it? Our retouched image does look a bit sharper, though, and a touch brighter. It should print very well in the newspaper.

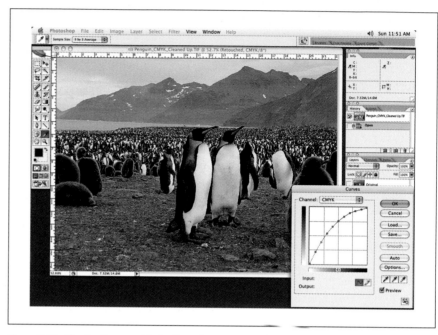

Figure 8-38. The final image with the Photoshop curve applied to simulate how it will look in the newspaper

Preparing a Color Image for a Black and White Newspaper

For black and white or grayscale images, you would basically follow the same steps as for the color images. Obviously you would not have the color issues to worry about. With the exception of the color issues related to a color image, you would still want to follow the previous outlined steps in producing the grayscale image.

You would also try the Photoshop newspaper curve created on each of your images set for newspaper to see how they might print. For a grayscale image, you will have to create a new newspaper compensation curve because you would no longer be in the CMYK color space, so the CMYK curve you created earlier would not work with the grayscale image.

However, one thing to be careful of when you receive a color image and you are asked to generate a grayscale image is how the color changes to grayscale when you convert.

The obvious way to create a grayscale image from a color image is to go into your main menu bar and select Image→Mode→Grayscale to convert an image from color or RGB to grayscale. This is fine to do, and I do it myself to convert color images to grayscale.

The problem when doing this is that some colors in a full color image convert and become very dark or lose detail from the conversion process to grayscale. There is sometimes a lot of information or color in the image, and naturally Photoshop adds up all of this color and can produce a pretty dark grayscale image. Some colors simply don't convert well. Take the example in Figure 8-39.

To convert the original image to a grayscale, choose Image→Mode→ Grayscale; you can see in Figure 8-40 that much of the detail is lost.

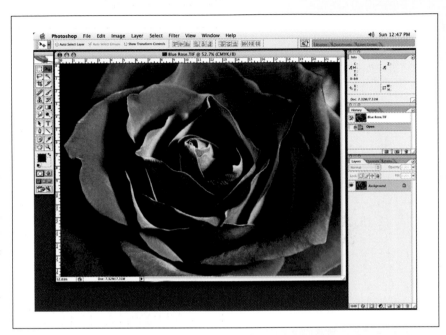

Figure 8-39. Here is the original color image of the blue rose

Figure 8-40. The result of the grayscale change; notice how the newly converted image looks very full and how the detail has been lost

To fix the problem, take the same original image and do a color correction first with the Selective Color correction tool. If the color is blue, take down your blue. If the image is red, take down the red. Adjusting an image this way strips it down and adds a lot of shape. Of course, it varies with each image, but you'll generally get a great look.

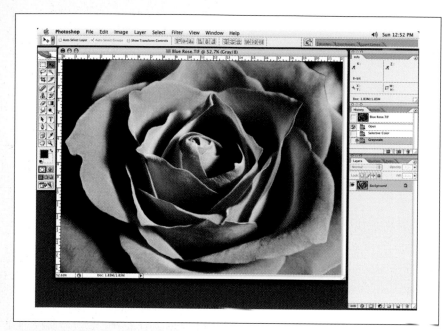

Figure 8-41. Color correcting the image before grayscaling it opens up the detail

Figure 8-41 shows the color corrected image after conversion to grayscale. Notice how it is more open and the darker tones are not as filled in. You now have an image with lots of room to make adjustments, if you wish to.

Don't be afraid to try any number of corrections to the color image prior to the conversion. Although I favor the Selective Color option as just illustrated, curves work well too. Anything you can do to add lots of shape and contrast to the image will help you achieve a superior looking image when the conversion is made to grayscale.

All these effects may seem rather drastic, and the image may look over the top, but these effects will be muted once the image appears in newsprint. Your client may initially balk at the final look of the image with these changes, but after your client sees the results, that should put them at ease and allow them to trust you.

It's a good idea to check the results of your efforts when the newspaper prints your images, and to make further adjustments if you feel that it is warranted. Stay on top of the results and keep reference files of your work when you see results that you and your client are happy with. The next time you need to correct an image for newsprint, you can use your reference files as a guide to match to on screen.

Keep in mind that some newspaper publications can run tests for you of your images, and it may be worthwhile to take advantage of this.

> **NOTE**
>
> *One last thing: when saving your files, make sure you give them descriptive names. I personally add BW_News or 4C_News to my file so that anyone picking up the files will have an idea of what they are.*

Preparing Images for Use on Packaging Materials

9

One area that appears to have a bright future for Photoshop users is preparing images for use on various print mediums. This may include packaging and carton work, and printing on various substrates, plastics, large format posters, and prints.

Printing on various materials is typically done using a *flexo* press. Flexo printing allows you to print on a variety of odd materials. Flexo printing requires images to be prepared properly in Photoshop, and can be rather limiting in terms of the color range of the image because of the print specifications required. If you can prepare images for flexo printing, you can prepare images for just about any other print medium.

> **NOTE**
>
> *Printing on some packaging material can be done with traditional litho printing, which is how quality magazines are printed. The print quality is much better when using a litho press, but the types of materials a litho press can handle are limited.*

The machines that print large format posters and billboards are typically large, specialized, and expensive. They usually print backlit posters or on fabric-based materials for use in stores, bus shelters, or billboards. The images printed on these machines need to be prepared to print well on the different materials used. Using quality profiles, if available, and properly calibrated printers can help you get fairly consistent results. However, even with the right equipment, these machines tend to print inconsistently, which makes Photoshop work a tough go with many images coming back for color adjustment tweaks until the client is satisfied.

> **NOTE**
>
> *There are a few programs specifically for preparing packaging files, from companies like Barco and PackEdge, to name a few, but I still rely on Photoshop to prepare the images to feed these programs.*

Many Photoshop people out there who retouch and color correct images for your average magazine, newspaper, or flyer are not prepared to handle a job for packaging. (I use the work *packaging* throughout this chapter to refer to images being printed on a variety of unusual materials.)

While I have found that more and more people, agencies, and larger companies with in-house art departments may be doing their own in-house image work in Photoshop, they are ill prepared for packaging work. Packaging work is one area of the retouching world that is expanding and may hold the key to long-term retouching careers for many people, as it is still considered to be a specialized form of work.

Packaging work may not be the most glamorous work out there, as it can be rather technical and not terribly creative. It isn't like working on high-end agency work, but it may guarantee you a long-term, full-time career and a well-paid position. Right now, there are few people out there who are comfortable with and have the knowledge to do packaging work properly.

I hope to cover some of the basics in this chapter. While I will not cover all the specialized programs and substrates, I will tell you the step-by-step processes involved in a typical packaging job, which you can then apply to any situation.

The Image You Have Versus the Image You Need

Typically an image will come in a couple of different varieties for a packaging job. The image may be supplied as an Illustrator file that you have to bring into Photoshop and rasterize or a new scan or digital image that you can call up in Photoshop to make changes. If the image has been created in a program like Illustrator, it could be completely made up of or created from hand-drawn elements, shapes, vignettes, and so forth, and may or may not include a "real" four-color image imbedded in it. If the file includes an embedded image, it is usually in the client's files and can then be adjusted in Photoshop and re-embedded in the client's Illustrator file and updated.

On occasion, a client supplies a final Illustrator file only, with no image. If this is the case and that file is all the client can provide, you'll have to open the file in Photoshop and rasterize it.

Regardless of what elements the image is made up of, it will have to brought into Photoshop to be adjusted. The only time the image or file may not have to be adjusted is if the person preparing the Illustrator file has prepared the file properly for packaging, which is very rare.

When you open an Illustrator EPS file in Photoshop, a dialog box, shown in Figure 9-1, opens, asking you for a size and resolution of the file before it begins to rasterize. Check your specifications to make sure that you rasterize it to the correct size and resolution.

We want to open the file in Photoshop because we have to make some color adjustments to the image before it can be used as a packaging image.

Just about every Illustrator file I have seen has been produced by a creative person who has no concept of, or who may not even care, how the final file will be printed. As long as her client is happy with the final image, her job is done. The problem with many of these files is that they may be made up of many, many special colors (I have seen 16 special colors on one job!) and many, many layers. Typically, the file you want to end up with will have to be a collapsed file with maybe one or two special colors, or a file that is made up of as little as two or three plates of colors. This is a far cry from the multitude of colors of the original file. One would think that you could go back to the Illustrator file and have the designer redo the file, but this would be like pulling teeth—typically unheard of! Many designers have no concept of the print process, and as such, they don't build files that are print friendly.

Figure 9-1. Photoshop Rasterize dialog box when importing an Illustrator file

Now that we have our image in Photoshop, we can begin to check the image and perform the necessary corrections.

The Spec Sheet

The first thing you should do is get a hold of the specification sheet from whoever will be printing the final job. This specification sheet will list the print parameters for the particular file you'll be working on.

A spec sheet typically looks like Figure 9-2.

Figure 9-2. Spec sheet from a carton printer

Figure 9-2 is a typical spec sheet from a printer that prints on various kinds packaging material. Here's the information we should be concerned with:

- The printer has indicated a curve; we will investigate this later on.

- They can print a variety of colors; this would mean that a number of special colors could be used. It is very typical to use special colors in packaging work because companies that sell goods on store shelves want to attract your attention to their boxes and bags!

- The print process is flexo, or *flexographic*, which is a type of press that can print on various packaging material, folding cartons, plastics, and bags.

- Substrates indicate the material to print on, such as a bread bag. You probably won't care what material the image is going on, but you will want to know what the specifications are for the image so that it prints properly.

If we skip through the rest of the specifications in this example, you will want to be aware of the following things:

- What the press does to the image; this is very important.

- The dot gain curve. We'll cover the dot gain curve in a minute.

- The minimum dot required for an image. If you have anything less than the minimum dot anywhere in the image, the press will drop any dots less than the minimum and they will not print. If you have a soft gradation in a shadow or vignette, you may be disappointed to find out that it breaks off where the minimum dot drops off.

- You may or may not be concerned with the trap values. If you are doing the trapping in Photoshop then yes, you would be concerned with trapping. Trapping is typically done with specialized software designed for trapping or packaging. Trapping is covered in Chapter 5.

- The line screen required for the image. No point working on a very large file at a high resolution if you're only going to be using the image for the one job. You'll save processing time and move around a little faster in Photoshop if your file is smaller as well.

- Bleeds will be a concern for you. Bleed is the amount of extra image you will need to have around the perimeter of the image that extends out beyond the "live" area of an image, or what will be seen when the final job is done. Extra image or bleed allows for any shift when the printed job is cut or die-cut out of a printed sheet. For example, when you see an ad in a magazine, it probably had 1/8 inch or so of bleed around it, and the final magazine you see was trimmed back or cut to the final magazine page size. If no bleed is added, the page is trimmed to the cor-

rect size by a cutter, and the cutter happens to trim the sheet or paper just outside your image area, you'll have a line where the printed material or paper pokes out along the edge where the cut was off or where the image was offset when it was printed.

The rest of the specifications have more to do with the film output or running the file directly to the printing plate and are directed to the people who will be outputting the final files.

Understanding the Dot Gain Curve

One very important specification to look at and obtain is the dot gain curve that will occur during the printing process; this is crucial to producing a good-looking final image. The look of the image can change drastically when printed because of the way the press prints; this is reflected in the dot gain curve, like the one in Figure 9-3, which is a typical example of dot gain curve guide that you might receive from a carton printer.

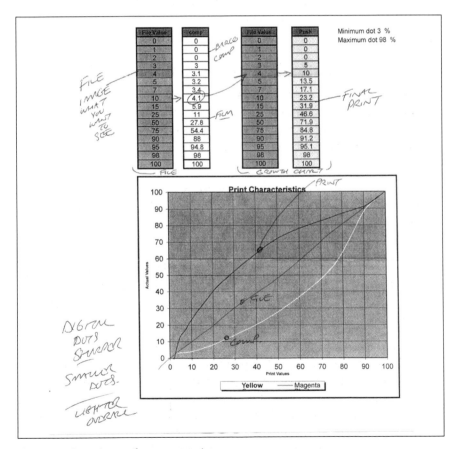

Figure 9-3. Dot gain curve from a carton printer

Some explanation of the dot gain curve is necessary. You'll see that there are four columns with numbers in them. Let's start with the column that is second from the right. This column represents the dot percentage values that exist in the image file that is ready to be printed.

The column on the far right represents the dot percentage values after your image has been printed on the press. As you can see, if your original image had a 1 or 2% dot in it, these dot values would drop off and not print on the press.

Notice how a 10% dot gains to over a 23% dot! Unlike newsprint or newspaper images, which of course gain too, the gains that are typical on carton and packaging printing are not all that consistent, and the gains are quite heavy. Some are even worse than the example in Figure 9-3! This is one of the better ones!

So you can see that you have a quite a challenge in front of you to produce a good-looking image that will print well on press.

There are a few ways to help you see what you'll get on press prior to going to press so that you can adjust your images accordingly.

One method is to use a proofing system to simulate press conditions. The first column on the far left represents the original image file values. The second column from the left is the same file after having been *scooped*. What I mean by scooped is that the image is basically taken back with a curve in the opposite direction in which it gains. The image is taken back in this manner so that when the press gains, (the far-right column) the image is basically brought back to the way it was originally, which is desirable.

This is typical of a workflow for a flexo press and a packaging proofing workflow. Images are prepared in such a manner that they are flexo press ready, as will be discussed shortly. The images are then placed in a Quark or Illustrator file, and then the entire file is scooped by special packaging software in the hope that the file will gain back that information and produce a proof or printed piece that basically looks like your original file. This is the hope.

NOTE

Unfortunately, many of the presses that typically print packaging work are not state-of-the-art machines. Much carton work is now printed overseas, and many of the presses are old and not all that consistent. It isn't always the case, but something to keep in mind.

At the bottom of Figure 9-3 is a visual curve representation of the gain curve. The straight line in the middle of the curve running from the bottom left to the top right of the curve represents your original image, or the image you have corrected in Photoshop. The curve to the bottom of the straight line is the scooping of the image that would occur after the file has been assembled as a final file, and the line above the image line is the gain incurred during the printing process.

A little later in this chapter, I'll explain how to make a curve in Photoshop with the Curve adjustment tool that will mimic the press gain you can expect from the printing press. You won't ever apply the curve to an image, but you can use it as you go along to see how your corrections are reflected in the final image.

Back to the image at hand, shown in Figure 9-4, which shows the image to be used on a package in Photoshop—we have a print specification sheet from our printer and the dot gain curve.

Figure 9-4. A CMYK image ready for corrections for packaging

Preparing a CMYK File

Let's suppose we are going to print our image in CMYK with no special colors. (We will add a special color later.)

If the image is a layered file, then at this point you should leave it a layered file, as this could save you time having to remake masks of the various image elements. If the image is a flattened file, you may have to create masks and layers of the various image elements to be worked on. In either case, you should be ready to continue.

The first thing to look at is the minimum dot called for. Typically this can be anything from 2 to 10%, depending on the type of press that will be used for printing this job. A minimum dot area would be the lightest area of your image. If you have an image with a pure white background or a solid tint background, and the background contains no vignettes or images that blend themselves into the white or tinted background, then you wouldn't need to worry about a minimum dot in this background, as it is carrying no dot in the white, or the tinted background contains values that are above the minimum dot value.

If an area or the background of an image has a vignette or images that blend into the background, you may need to add a minimum dot to the background so that when the image is printed, the images blend into one another or the background smoothly without any transitions or areas where the lack of a minimum dot breaks off because the printing press could not hold the dot or lack thereof.

In Figure 9-5, the lightest area in our ice cream is cyan 1%, yellow 1%, magenta 1%, and black 0% (there is no black). These values are too low for our specified print specifications, and are unacceptable. We'll have to figure out how to get a 3% minimum in this white area. In our blue background, we have cyan at 47% and magenta at 13%, so as mentioned, we do not have any minimum dot issues with the background, and the values are well above the minimum.

Figure 9-5. We need a 3% minimum black to meet spec

If the minimum values—in this case, 3%—are not present in an area of the image, you will have two choices: put a minimum dot in the image area with a simple curve or selective color adjustment or take the color right out of the image area. If you print the image without regard for the minimum dot, you will get a hard break where the dot gets chopped off during the printing process. And don't forget that dot gain makes the break or drop off in a vignette even worse as the difference between the minimum dot and the gained dot is enhanced. If you decide to keep a color and it needs its minimum dot value increased to meet the specifications, remember that the color will gain and you will have to live with the results, although you'll have to do your best to make it work with the image.

Taking a Reading of the Minimum Dot of an Image

Once the minimum dot has been established, we must look at what that minimum dot will gain on press. For instance, if a 3% dot grows to 5% or more, then you have some decisions to make. A 3% dot in the ice cream may look OK now, but if it grows or gains to 5% or more, as will all colors with a minimum dot, will it then look too full?

One way to determine the final look is to create a simulation gain curve based on the dot gain curve information you got from the printer. Use this curve on the image you are working on to simulate what the press may do to your image as a visual cue. You can see the effects by comparing the images in Figure 9-6 and Figure 9-7. (Of course, do not save the image with this curve, as it is used purely as a visual check.)

Another great option is to get a profile of the press on which the job will be running. This may or may not be an option because it may be very difficult to get the information needed to build such a profile from the printer, especially if they are overseas as mentioned earlier. If you can get a profile, you are in luck. You can then use this profile in Photoshop. You can use View→Proof Setup→Custom (as we did for the newspaper profile in Chapter 8). Once the profile is loaded in this way, you can hit Command+Y to toggle between your original image and the simulated press output. Nice to have if you can get you hands on the profile.

You may find that when all the dots gain, the look of the image is unacceptable and appears far too full, which you can see in Figure 9-7 is in fact true in the case of this ice cream image.

Figure 9-6. The original image viewed without a gain curve

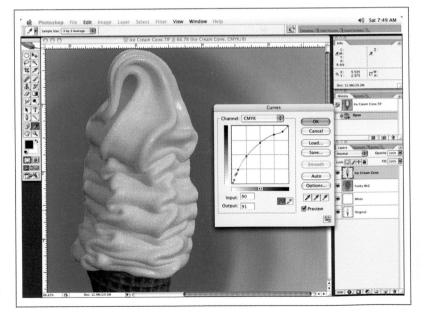

Figure 9-7. The image viewed with a gain curve

NOTE

Using a proof setup is an effective technique for any output device you may be printing to. Whenever you can, try and get your hands on the profile for the device to which you will be printing.

What can we do to fix this? All the colors make the ice cream too full when the press gain is factored in. The first thing to do is reduce or take out some of the other colors. Obviously, if you take out one of the CMY channels, you will get an unwanted color cast, assuming that the ice cream is supposed to be plain old vanilla! You could make the ice cream out of the black channel only and delete all the other channels out of the ice cream portion, leaving the rest of the process colors in the rest of the image.

Do this by going in and physically make crop masks of each area (if it hasn't been done already) of the image that needs to have its color adjusted. It can be a rather tedious process, but a necessary one. Once you have your masks made, create a layer for each part of the image you will change. In this case, start with the ice cream and go from there. Figure 9-8 is our image with the ice cream on a layer.

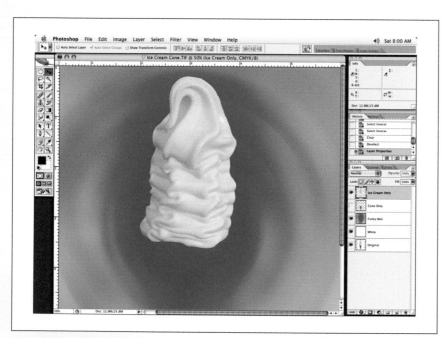

Figure 9-8. Isolate the ice cream on a layer

First, look through the color channels and see if any of the channels have any decent shape that will look good if used on its own. If not, duplicate the image and create a black and white of the image with the Image→Mode→Grayscale function. (See Figure 9-9.)

Let's look at the newly created black and white image and take readings of the ice cream in various areas to see if we have a minimum dot that the specifications ask for. (I may use my dot gain curve or profile to look at the image as well to make sure it looks acceptable as I make subtle changes.)

If you need to bump up the highlight area to increase the minimum dot value required (Figure 9-10), use the curve adjustment and move the zero point until you get the minimum dot reading. If the midtone area of the image looks to full, adjust that as well with the curves and bring it down. You will probably have to go back and forth a few times between corrections and the Photoshop dot gain curve until you get the look you are after. Obviously, some experimentation will be necessary.

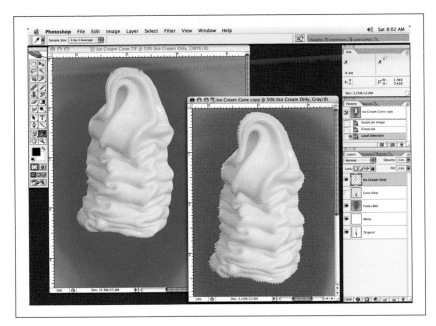

Figure 9-9. Duplicate the image and create a black and white copy

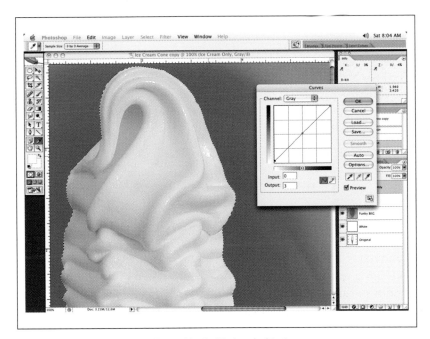

Figure 9-10. The highlight dot observed in the black and white image

Once you have the look you're after with the grayscale image, copy the ice cream portion and paste it into the black channel of the four-color image, as in Figure 9-11. Then go through the remaining channels—the C, M, and Y—and delete any information in them so you're left with a black-only ice cream.

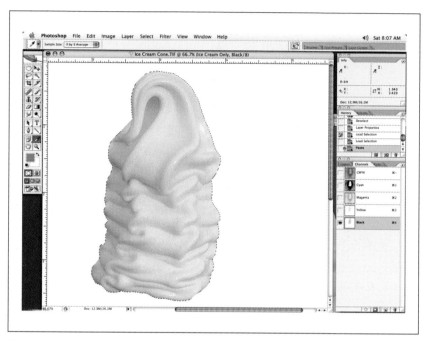

Figure 9-11. Copy the ice cream only and paste it into the black channel of the four-color image

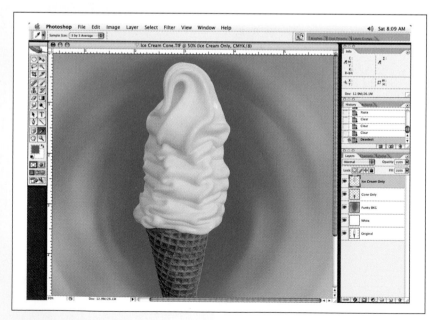

Now paste the ice cream into the full-color image in the black channel, and delete all other color channel information in the ice cream area, as shown in Figure 9-12.

Figure 9-12. The final look of the new black-only ice cream, ready to be copied and pasted to the black channel of the full-color image

Then we can apply the curve to see the simulated results, shown in Figure 9-13.

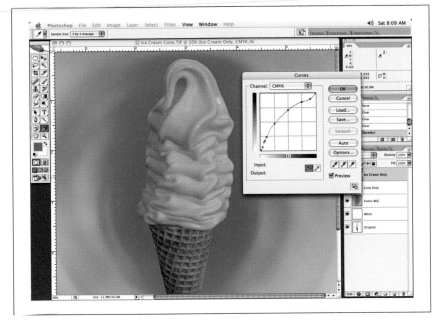

Figure 9-13. The same image with the gain curve added to see how the final printing will affect the image

You can use the same process for each area of the image. You must go through the image systematically and repeat this process for each element. You have to decide if having all color channels in a particular area of the image is good or bad for the image.

As I mentioned before, you have two choices when you adjust an image for flexo printing. Either keep a color channel in the image, make sure that the minimum dot for that color is there, and accept the look when the color gains on press, or delete the color entirely and make it work with one or more of the channels. Clients tend to find this situation rather hard to accept, but it's the way it is.

Here are some variations of pasting the ice cream into the other color channels and applying the gain curve to see how the final print will look. For instance, Figures 9-14 through 9-16 show the various effects of pasting the ice cream into the yellow, magenta, or cyan channels, respectively, and then applying the curve to see how it will look.

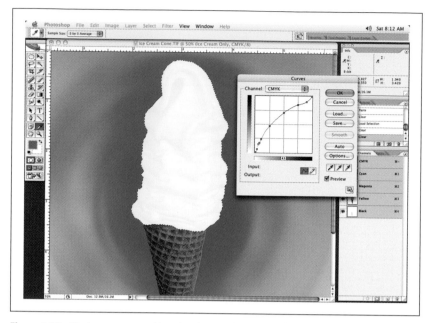

Figure 9-14. The ice cream pasted into the yellow channel, and the gain curve applied to show how the final printing will look

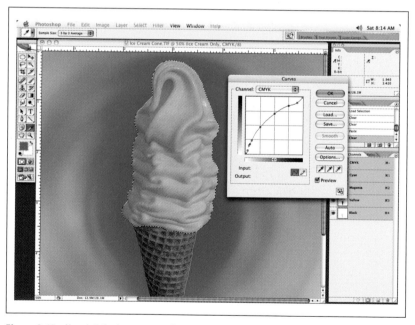

Figure 9-15. Here it is in the magenta channel: not bad if we want strawberry ice cream!

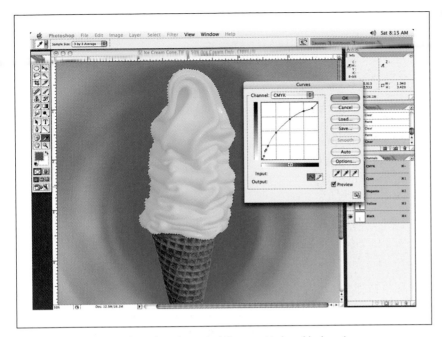

Figure 9-16. In the cyan channel: again, not bad if we want to have blueberry!

Unfortunately, it doesn't appear to be working out all that well with the process colors for the light-colored vanilla ice cream we are looking for. Let's explore other options.

Make a Cleaner Image by Using Fewer Colors

An option that you can use to make images appear much cleaner for packaging is to use fewer colors. Fewer colors? Well, what if we were to eliminate the black channel altogether? We would no longer have to worry about our black channel gaining to ruin our image. This is terrific for food images, as food shots typically need to look bright and cheery. Who wants to see a peach or ice cream with black running through it?

You accomplish a three-color (CMY) image by creating a new color setting in CMYK for this purpose. Call up the Color Settings dialog box the same way you did when we created a new newsprint color setting to set our ink density settings. The settings to use for the Custom CMYK dialog box are shown in Figure 9-17.

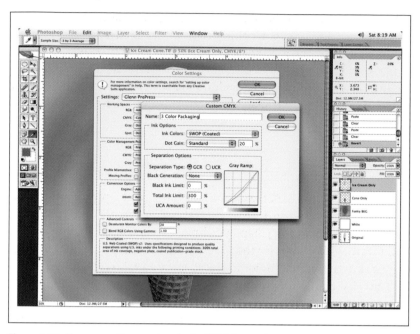

Figure 9-17. You can use these settings in the CMYK Custom dialog box

Once you've accepted the settings in the Custom CMYK dialog box, you are presented with the Color Settings dialog box. Give the new settings a descriptive name for easy access the next time you need them.

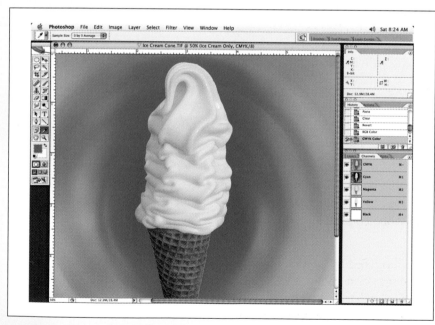

Figure 9-18. The three-color image with the simulated gain curve applied

Go through the process of converting the image from CMYK to RGB, and then back to CMYK so that the image reads the new three-color CMYK color setting and converts the image to a C,M,Y file without the black. Figure 9-18 is the result.

This is a great way to handle some images. With no black to worry about, this may make your life a lot easier. This technique may even save your client some money if they no longer have to run a black plate on press, assuming that a black ink isn't used for type or some other area of the printed file. I use this technique often.

Don't be afraid to delete other channels of color completely from your file in this same manner if you don't think they will be beneficial to the image. For instance, if there's an area of your image that has very little color in one particular color channel and it doesn't seem to have all that much effect on the overall color of the image, eliminate it. This is especially true if unwanted colors exist in the image. Unwanted colors were discussed earlier in this book.

Another Option: Creating a Special Color

If your choice of color is not working, another great option available to you and your client is to use a single special channel in place of the CMYK channels, like we learned in Chapter 5. Imagine choosing a light beige or a very light brown PMS color for the ice cream. Even if it prints a 10% dot in the highlight or a solid 100% dot in the shadow end, it is still a light color, just like real ice cream! Let's suppose that the black-only ice cream looks too dirty or is unacceptable, or the three-color option still isn't working. Assuming you can't change the ice cream to strawberry by swapping the black information of the ice cream from the black to the magenta channel, you can choose a special PMS color for the ice cream.

If it is cost effective to use a special color, use the information you created for the black channel ice cream for use in a special PMS color. Then go back and delete any CMYK information so that the special color makes up only the ice cream information. Using special colors for packaging work is very typical. In fact, it is common to have many special colors in one image or package. There is another compelling reason to use special colors in a packaging image: registration.

Have you ever picked up a carton or package and noticed that the colors or picture elements don't butt up to one another? Or there is a white or clear line between elements because they were misaligned? This is because the printing press was unable to lay down each color channel exactly on top of one another in the exact same position it is supposed to be in.

A slight shift has occurred as the material ran through the press. Now imagine that you have to line up four colors or more! If you were to use special colors, you would have to worry about only one color. It's pretty tough to misalign one color!

The selection of a special color is usually determined by looking through a Pantone color swatch book and deciding on the best color to use. Clients may ask to have a few different PMS colors run at the same time on a proof, and then decide on the best color to use. The colors have numbers associated with them and can be viewed in the Color Picker within Photoshop. You

may want to test a few different Pantone special colors until the right color is determined. In Figure 9-19, our ice cream now has a color all its own.

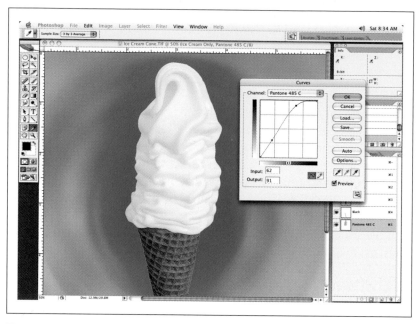

Figure 9-19. Here is our ice cream image with a PMS color used for the ice cream instead of any process colors

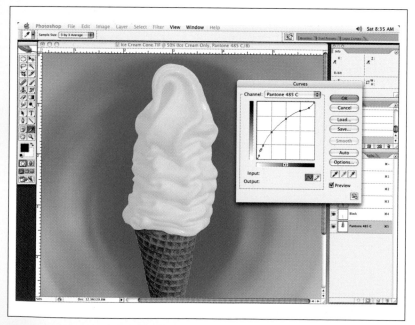

Figure 9-20. Hungry for ice cream?

Let's add a little more contrast to our ice cream image, just to give it a bit more shape. Figure 9-20 shows the results of our efforts. Now try the gain curve on the image just to see how it might look after printing. We have a winner! The image has all the qualities we desire, and the specifications are met. I think it is ready to print.

Make sure the name of the Pantone color is correct when you create a new spot color in your channels. If you print your final file to a digital printer and the spot channel is not in the printer's profile, which is a setup function of the printer, the color may not print at all, or it will be substituted with another color that the printer may make up.

┌─ **N O T E** ───────
Quark can have an issue with the special color name as well. The operator may be using the same spot color in another area of the file, but with a different name. Quark will see your special color, assume it is a different color, and create another output channel just because of a different name. This is something to keep in mind.

Trapping on Special Packaging

As I mentioned earlier in Chapter 5, when printing on various packaging materials, it can be difficult for a press to register all the colors. Imagine a plastic bread bag material traveling through a press, and you might get the picture. The end result is that the picture elements of different colors or various bits and pieces of the image printed on different printing plates may not line up or register properly with one another. This misalignment results in the background of the material showing through parts of the image, or one color bleeding over another with a gap on the opposing side. You have probably seen this effect.

In an effort to correct this problem, a certain amount of extra image surrounding a picture element is added, called *trap*. Trap is added to picture elements so that if a shift occurs, the gaps are prevented because the trap between elements fills in this potential error (Figure 9-21).

┌─ **N O T E** ───────
Keep in mind that you may want to check with the people preparing the final packaging files prior to adding trap. Many high-end packaging programs will allow the packaging operator to add trap on their end, making it unnecessary for you to do so. However, you may be asked to add trap, although this isn't typical. Trapping is covered in Chapter 5.

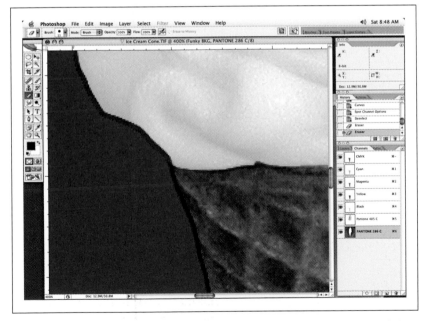

Figure 9-21. The look of a trap on the ice cream image (exaggerated here so you get the idea)

When all your color issues and trapping have been looked after, it is typical to get a proof done of your files. Proofs are generated on high-end output devices and may have built-in curves to simulate what may happen on press so that everyone gets a good idea of what to expect when the job is finally run on press. The high-end proofing systems can include all special colors and be prepared on a number of various substrates to again match what can be expected on the final press output. When the proof comes back for a final inspection, it is at this point that adjustments are made. It can be typical to have several proofs made until the desired results have been achieved. Of course, in an ideal world, the image will be perfect the first time through. This is the goal, and it would save everyone a lot of time and money on the job, but it is rare!

> **NOTE**
>
> *It is typical to have someone at the press who is associated with the job on hand to approve the press run. This is called a press approval.*

Once the final proof has been approved by the client, a press run is made of the job. Small adjustments in color can be made at the press run, but only overall color changes. Press time is expensive, so you want the press process to run smoothly. Any errors that you or the client have missed up to this point that are caught on press, whether they are image errors or type issues, can be very expensive to fix. A printing press waiting to get reissued files for reprinting at this point can be charged to a client or the person(s) responsible for the errors, and people can be charged upward of $500.00 per hour to have a press on hold. This is something anyone would want to avoid, for sure!

Index

Glenn Honiball comes from a long line of artistic family members. His grandfather was a cartoonist and a painter, and his father was a very talented artist involved in advertising. In 1985, Glenn started in the pre-press industry, was trained on the million-dollar HELL Chromacom system (which, along with Scitex, was the only proprietary retouching system around), and worked on it for nine years. He also worked on a Silicon Graphics machine running Barco Creator and Alias Eclipse retouching software. Glenn migrated to Photoshop after considerable experience on high-end systems coupled with a good pre-press background. He has worked with several versions of Photoshop and found them easy to learn, having come from a background where string commands were the norm.

Colophon

Our look is the result of reader comments, our own experimentation, and feedback from distribution channels. Distinctive covers complement our distinctive approach to technical topics, breathing personality and life into potentially dry subjects.

Philip Dangler was the production editor for *Commercial Photoshop Retouching: In the Studio*. Linley Dolby was the copyeditor. Ann Schirmer was the proofreader. Philip Dangler did the typesetting and page makeup. Genevieve d'Entremont provided production assistance. Adam Witwer and Claire Cloutier provided quality control. Johnna VanHoose Dinse wrote the index.

Mike Kohnke designed the cover of this book using Adobe Photoshop CS and Adobe InDesign CS, and produced the cover layout with InDesign CS using Linotype Birka and Adobe Myriad Condensed fonts. The cover photographs are from iStockPhoto.com.

David Futato created the series design using Adobe InDesign CS. This book was converted from Microsoft Word to InDesign by Joe Wizda. The text and heading fonts are Linotype Birka and Adobe Myriad Condensed; the sidebar font is Adobe Syntax; and the code font is TheSans Mono Condensed from LucasFont. The illustrations and screenshots that appear in the book were produced by Robert Romano, Jessamyn Read, and Lesley Borash, using Macromedia FreeHand MX and Adobe Photoshop CS.

Better than e-books

Try it FREE!

Sign up today and get your first 14 days free.

safari.oreilly.com

Search

inside electronic versions
of thousands of books

Browse

books by category.
With Safari researching
any topic is a snap

Find

answers in an instant

Search Safari! The premier electronic reference library for programmers and IT professionals.

Keep in touch with O'Reilly

Download examples from our books

To find example files from a book, go to: *www.oreilly.com/catalog* select the book, and follow the "Examples" link.

Register your O'Reilly books

Register your book at *register.oreilly.com* Why register your books? Once you've registered your O'Reilly books you can:

- Win O'Reilly books, T-shirts or discount coupons in our monthly drawing.

- Get special offers available only to registered O'Reilly customers.

- Get catalogs announcing new books (US and UK only).

- Get email notification of new editions of the O'Reilly books you own.

Join our email lists

Sign up to get topic-specific email announcements of new books and conferences, special offers, and O'Reilly Network technology newsletters at:

elists.oreilly.com

It's easy to customize your free elists subscription so you'll get exactly the O'Reilly news you want.

Get the latest news, tips, and tools

www.oreilly.com

- "Top 100 Sites on the Web"—PC Magazine

- CIO Magazine's Web Business 50 Awards

Our web site contains a library of comprehensive product information (including book excerpts and tables of contents), downloadable software, background articles, interviews with technology leaders, links to relevant sites, book cover art, and more.

Work for O'Reilly

Check out our web site for current employment opportunities:

jobs.oreilly.com

Contact us

O'Reilly Media, Inc.
1005 Gravenstein Hwy North
Sebastopol, CA 95472 USA
Tel: 707-827-7000 or 800-998-9938
 (6am to 5pm PST)
Fax: 707-829-0104

Contact us by email

For answers to problems regarding your order or our products:
order@oreilly.com

To request a copy of our latest catalog:
catalog@oreilly.com

For book content technical questions or corrections: **booktech@oreilly.com**

For educational, library, government, and corporate sales: **corporate@oreilly.com**

To submit new book proposals to our editors and product managers:
proposals@oreilly.com

For information about our international distributors or translation queries:
international@oreilly.com

For information about academic use of O'Reilly books:
adoption@oreilly.com
or visit:
academic.oreilly.com

For a list of our distributors outside of North America check out:
international.oreilly.com/distributors.html

Order a book online

www.oreilly.com/order_new

 ®

Our books are available at most retail and online bookstores.
To order direct: 1-800-998-9938 • *order@oreilly.com* • *www.oreilly.com*
Online editions of most O'Reilly titles are available by subscription at *safari.oreilly.com*